D0602881

capturecincinnati

FOREWORD

Dear Greater Cincinnatians,

What kind of impact can one simple idea and a group of dedicated young professionals have on the Greater Cincinnati and Northern Kentucky region?

That simple idea was Capture Cincinnati and the response was overwhelming. With over 5,700 participants (photographers and voters), 11,891 photographs and 333,211 votes cast, the numbers speak for themselves.

Capture Cincinnati is an innovative community-driven project that allowed users to submit photos, vote online, win prizes and end up in this book. Our hope was that people would dig deep into the people, places and spaces that make this town great. We were committed to creating a channel for Cincinnatians to express the beauty and culture behind our Queen City. This collaborative effort of C-Change, CiN Weekly and Cincinnati.Com engaged, educated and motivated our community to get out and experience Cincinnati.

Our project group of 20 energetic individuals was brought together by a program called C-Change. C-Change is a leadership development program offered by the Cincinnati USA Regional Chamber which empowers the future leaders of our region with opportunities to connect, develop and lead. Our team seized the opportunity to engage our entire region in Capture Cincinnati and produce this book for the people and by the people of Greater Cincinnati.

Hopefully, you will be inspired by one the following photos and will seek out your own way to make Cincinnati a better place to live, work and play.

PHOTO BY DAVID SORCHER

Sincerely,
C-Change Class 2: Michael Prus & Dacia Snider (Capture Cincinnati Co-Chairs), Melanie Burden, Jeff Button, Brock Denton, Jason Farler, Meghan Fedders, Michele Fronckiewicz, Meghan Galvin, Kim Glenn, Doni Jessen, Shanon Kammerer, Kirsten Lecky, Monica McPeek, Dave Ostreicher, Jennifer Spieser, Tara Stopfel, Maggie Ungers, Darin Vilano, James Zimmerman

Copyright© 2007 • ISBN: 1-59725-107-0

All rights reserved. No part of this book may be reproduced, stored in a retrieval system or transmitted in any form or by any means, electronic, mechanical, photocopying, recording or otherwise, without prior written permission of the copyright owner or the publisher. All photographers retain full rights of their photos that appear in this publication.

Do not use or copy any images from this book without written permission from the photographer. Note: photos may appear in different chapters than they were submitted.

Prize awards were not affected. For more information on the Capture Cincinnati Web site, please contact Pediment Publishing (books@pediment.com).

Published by Pediment Publishing, a division of The Pediment Group, Inc. www.pediment.com printed in Canada

TABLE OF CONTENTS

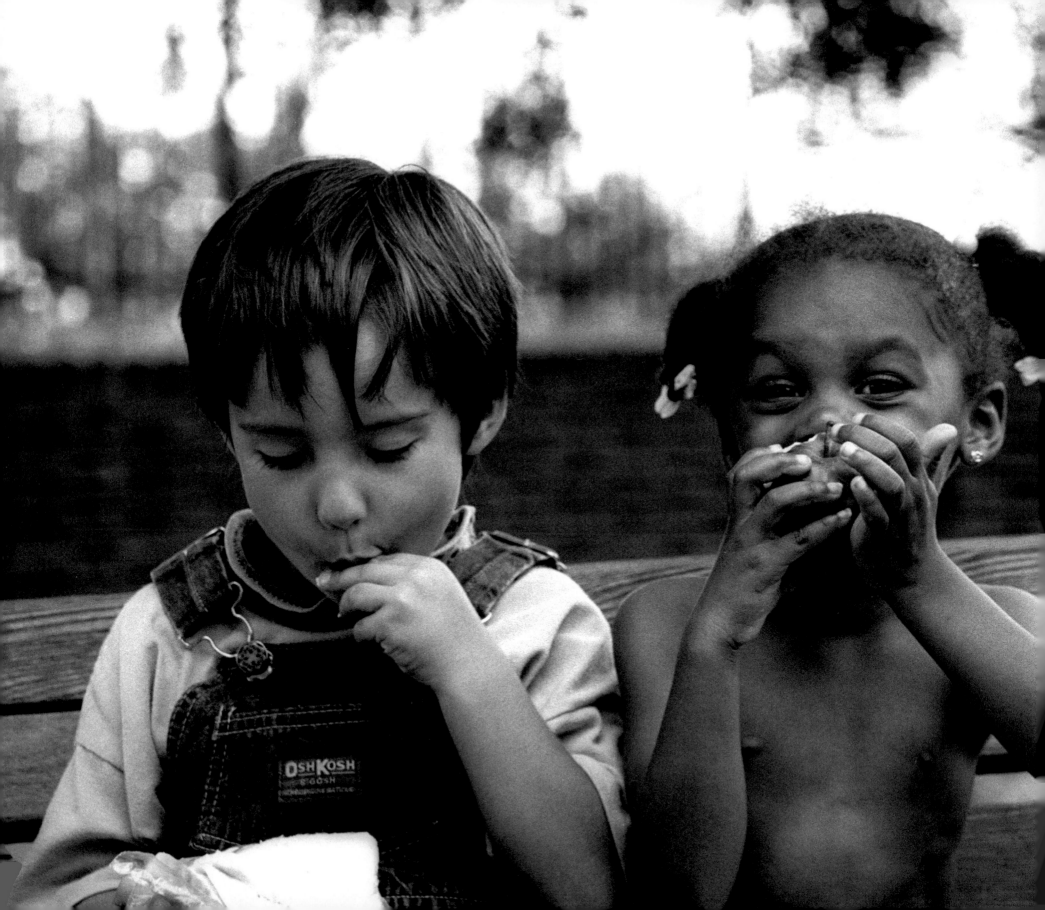

PEOPLE OF PORKOPOLIS

Just look at the faces of our community in all their glory: Happy, sad, pensive, stoic, familiar, anonymous. They tell the story of our region as much as anything because in these photos, you can see yourself, your family and your neighbors.

It's easy to look at the expression on a grandfather's face and feel the heartache of sending a grandson off to war. The same goes for a man saying good-bye to his wife and son just before shipping out to Iraq.

It's marvelous to smile at photos that capture the wonderment in the eyes of children, not to mention their laughter and their confusion.

It's a joy to watch kids at the zoo, playing in the water, playing sports or playing with friends, expressing themselves with a lack of inhibition you only dream about as an adult.

The photos in this chapter capture all that and more. They tell the story of our challenges and triumphs, our cultural diversity and our relationships. Mother and son. Grandfather and granddaughter. Friends. Co-workers. It's all about who we are.

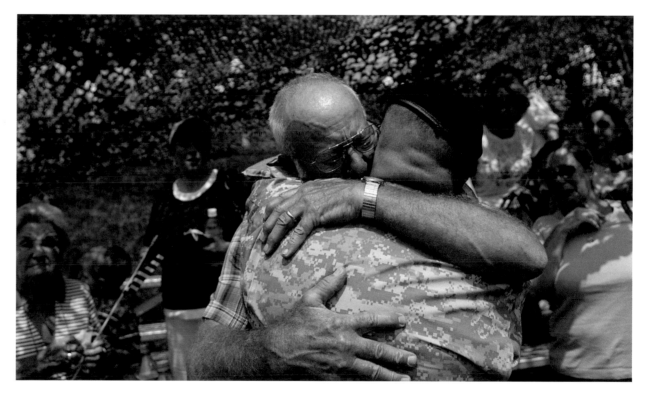

ABOVE ■ Deployment: Michael Jenkins gets an emotional hug from his grandfather Charles Jenkins, of Falmouth, Ky., before leaving for his first deployment for a mission to support Operation Iraqi Freedom. This was after a May 24, 2007, deployment ceremony for the Army Reserve's 478th Engineering Battalion, based in Fort Thomas. Five generations of Jenkins' family were in attendance to support him. Included were his great-grandparents, Harold and Midge Emminger, his grandparents, Charles and Connie Jenkins, his father and stepmother, Casey and Robin Jenkins, his mother, Christina Oaks, his wife, Mandy Jenkins, and his two children, Gabriel Jenkins, 5, and Lydia Jenkins, 1.
PHOTO BY MEGGAN BOOKER/THE ENQUIRER

LEFT ■ Lunch in the Park. PHOTO BY KEITH NEU

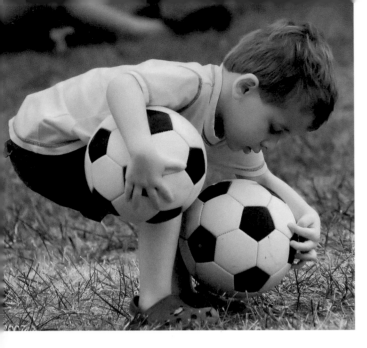

ABOVE ■ I Got It: Grandson in action at a Finneytown soccer game. PHOTO BY LARRY FOSSE

RIGHT ■ Cooling Off: On a hot summer day, while playing with the sprinkler water, this image just showed up. PHOTO BY RAVI RAMACHANDRAN

TOP RIGHT ■ Christopher Gajus, a poignant moment before the lens of his mother's camera. He is an artist who finally admits it—a University of Cincinnati graphic artist student. PHOTO BY AIMIE WILLHOITE

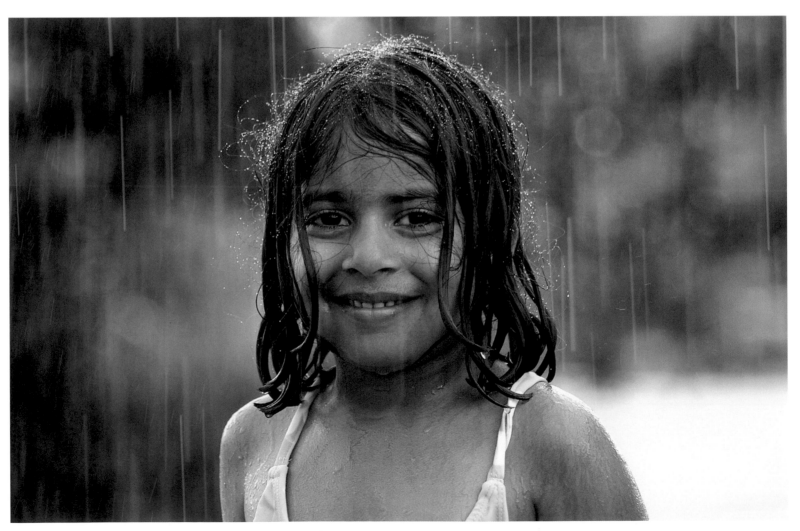

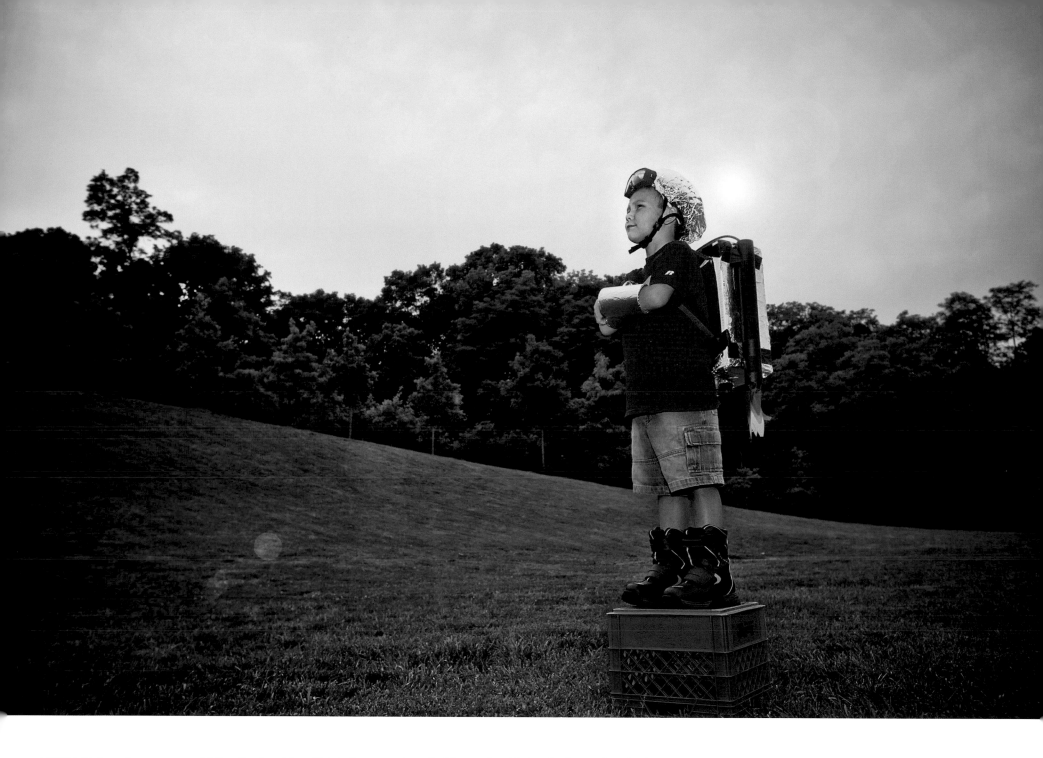

ABOVE ▪ I am Superman, and I Can Do Anything: This is from a series called "Launchpad," the idea being that the dreams and imagination of our children are things to foster, cull and allow to take off. This is just one shot from a series of pictures with kids in their "spaceman" costumes, and parents watching and gathering around (to symbolize family and community support or affirmation). It was fun ... there was quite a crowd gathered around us. We shot at a park inside a nature amphitheater (tall, wide grass hills). I used just a flash and diffuser on this. PHOTO BY PAUL ARMSTRONG

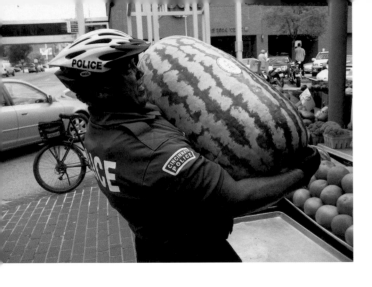

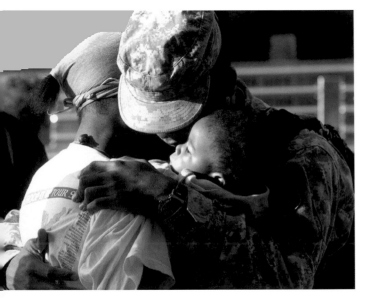

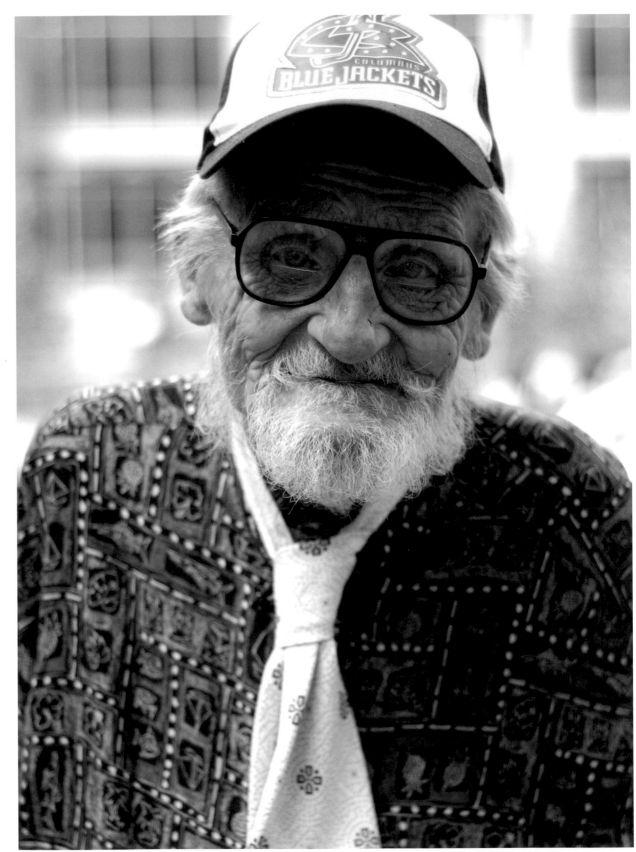

TOP ■ Police Workout: That watermelon weighed 120 pounds! Picture taken at the farmer's market across from the Kroger Building on Court Street downtown.

Photo by Jerome Strauss

ABOVE ■ Shipping Out: Private Marc Conyers, of the Army Reserve 478th Combat Engineer Battalion, hugs his wife, Johnnae and son Lamarjae, 9-months-old, as his unit leaves Fort Thomas for deployment to support Operation Iraqi Freedom. Photo by Patrick Reddy/The Enquirer

RIGHT ■ Harold: Taken on Sept. 5, 2007, Harold was kind enough to stop and pose for my camera as I strolled along Fountain Square on this beautiful day.

Photo by David Williams

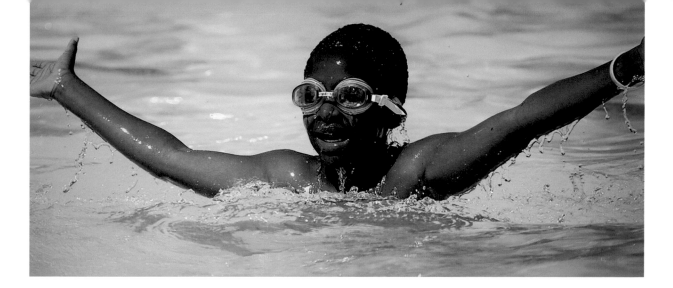

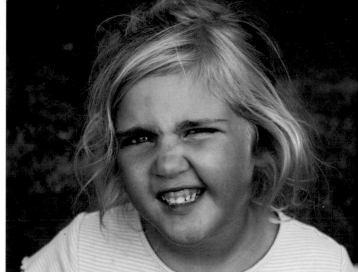

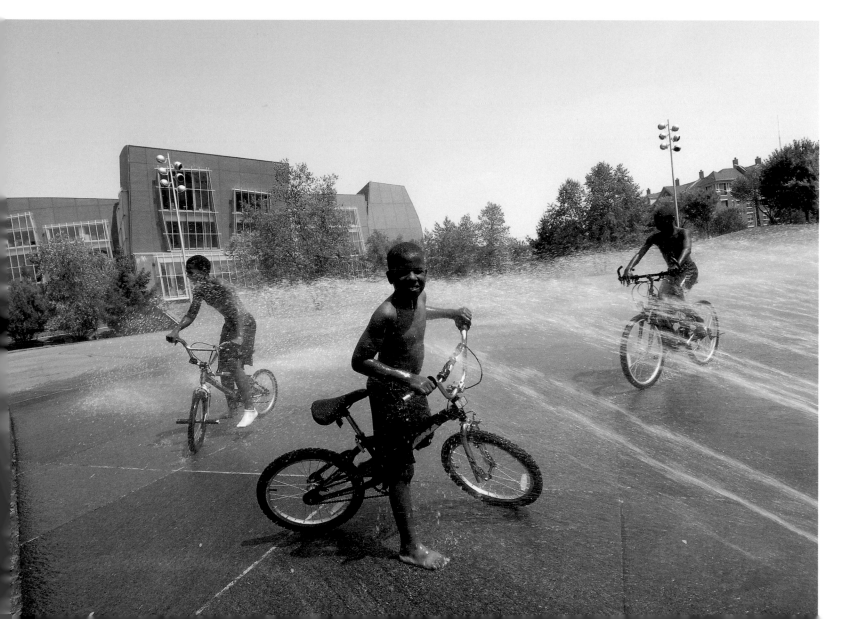

ABOVE ■ Molly: I'm sure if you are a parent, you, too, have received this look.

PHOTO BY AMANDA POWELL

TOP LEFT ■ Summer in the City: A young boy enjoying the summer at the Norwood YMCA.

PHOTO BY KYLIE J. WILKERSON

LEFT ■ Neighborhood Kids: Clifton kids cool themselves on a 98-degree day by riding their bikes through the fountain located behind the University of Cincinnati's Vontz Center for Molecular Studies. One of the riders stopped to check out the man with a camera.

PHOTO BY DANIEL DAVENPORT

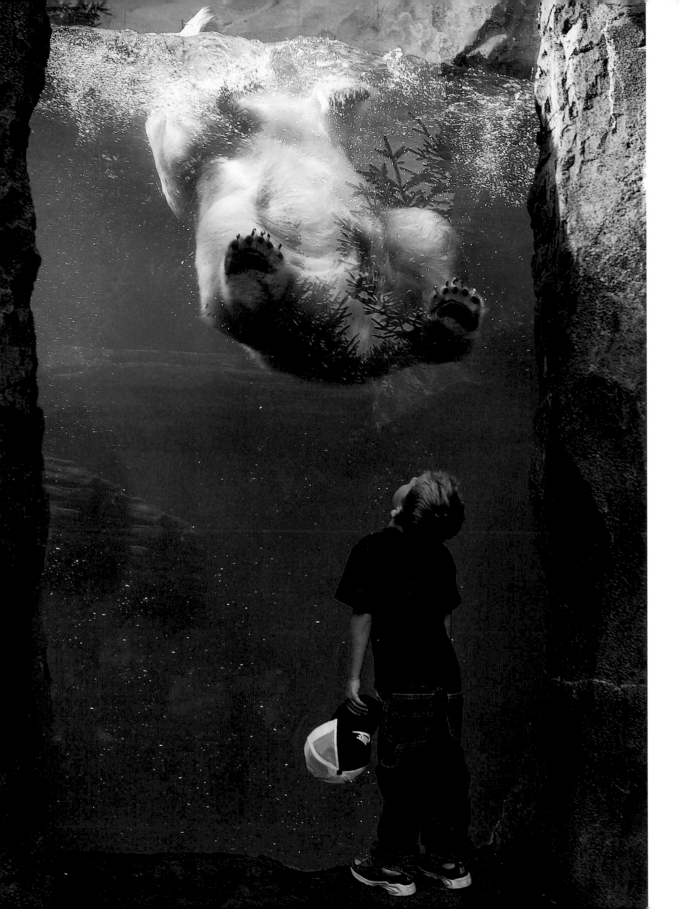

PREVIOUS LEFT ■ Jake and the Bear: This is Jacob, my grandson, on an outing at the Cincinnati Zoo. Photo by Mike Wehrman

PREVIOUS RIGHT ■ Friends: Anna and Jack Kinasewitz with their buddy, Owen Speelman, at Sawyer Point. These three are just so much fun together! Photo by Melissa Speelman

RIGHT ■ Keeping Cool in the City: These kids on the corner of 12th and Clay streets found a way to beat the sweltering heat and the mother was having fun as well. Photo by Paul Lynch

BELOW ■ Bob and His Hat: My adopted Grandpa, Bob, is one of the kindest of souls. A dear friend who has seen my family through the best and the worst of times. Photo by Keith Neltner

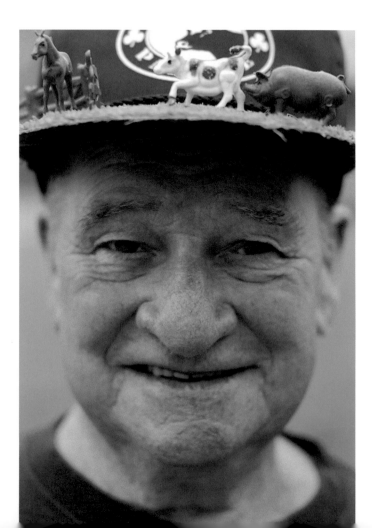

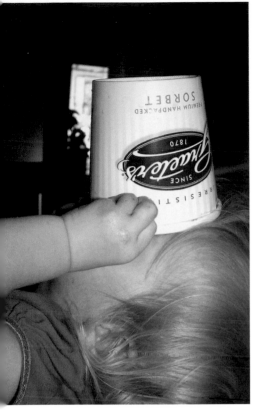

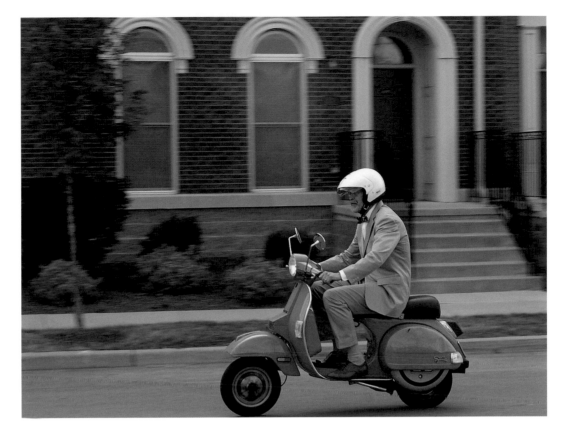

FAR LEFT ■ Graeter's Addict Already?: Thea and her ice cream.
Photo by Julie Young

LEFT ■ Speed Racer: Albert and Deborah Pyle live in the West End. They like the convienience and proximity to downtown. He often rides a scooter to his job downtown and she walks to Music Hall.
Photo by Michael E. Keating/ The Enquirer

ABOVE ■ Max's first Reds game. Photo by Dan Brue

LEFT ■ Sister's First Communion: Steven and Matt patiently wait outside while their older sister gets ready for her first communion at St. Gertrude's church in Madeira. Photo by Randa Menkhaus

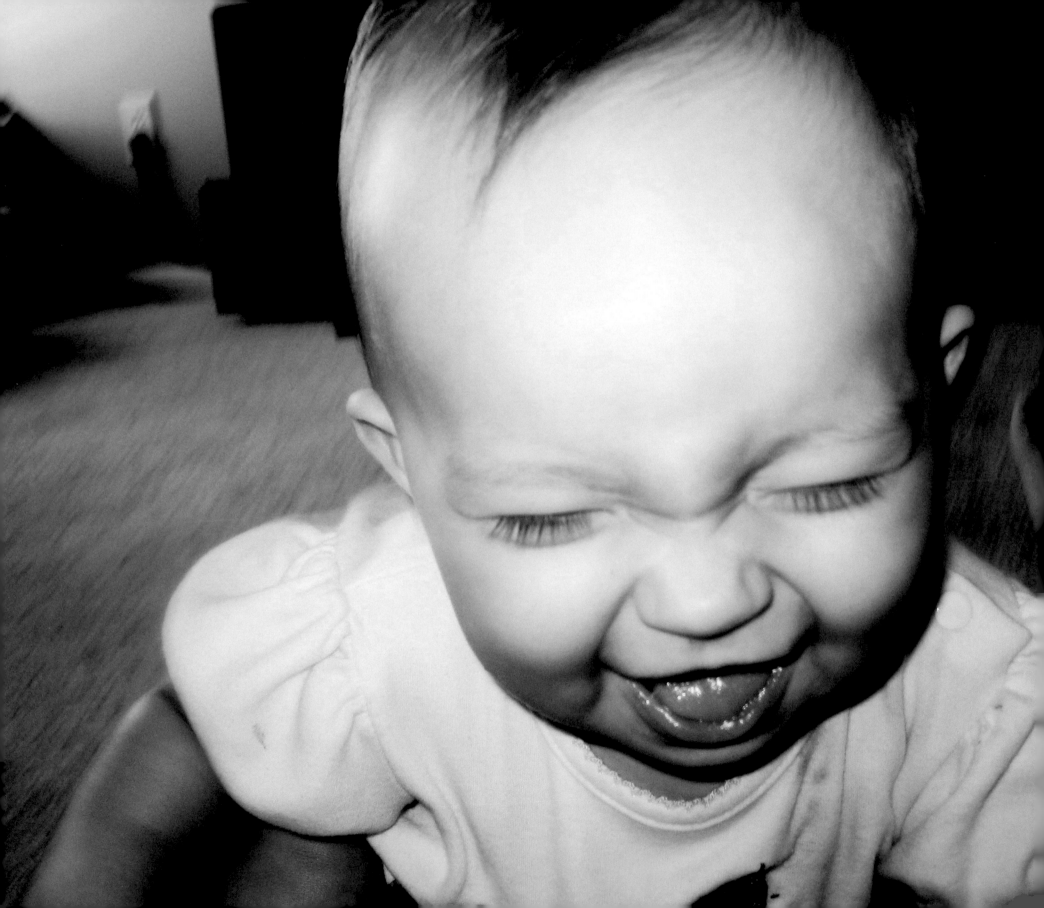

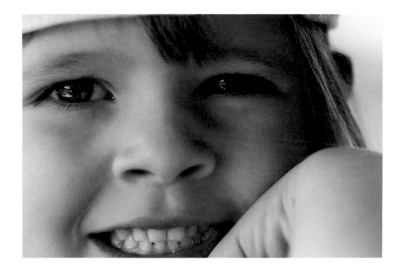

ABOVE ■ Bright Eyes: My daughter, Riley, enjoying an early summer day Photo by Scott Dungan

RIGHT ■ Thar Be Gold: Aargh, me matey ... this ripe young lad at Pleasant Vineyard summer camp be keepin' 'is eye on ya!

Photo by Lance Webel

BELOW ■ Sick of Modeling: Two-month-old Mason Wilder is already tired of posing for Dad, who has taken 1,500 plus photos of him at this point in his life. Taken at home in Liberty Township.

Photo by Brian Wilder

OPPOSITE ■ A Good Laugh: All in a good day's babysitting.

Photo by Jackie Herb

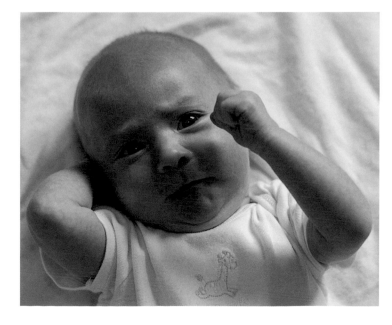

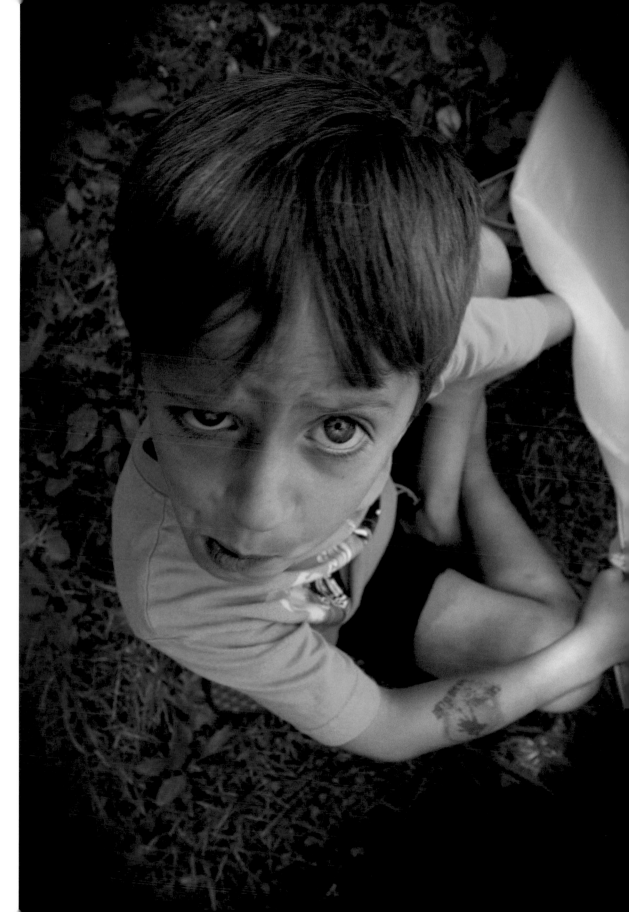

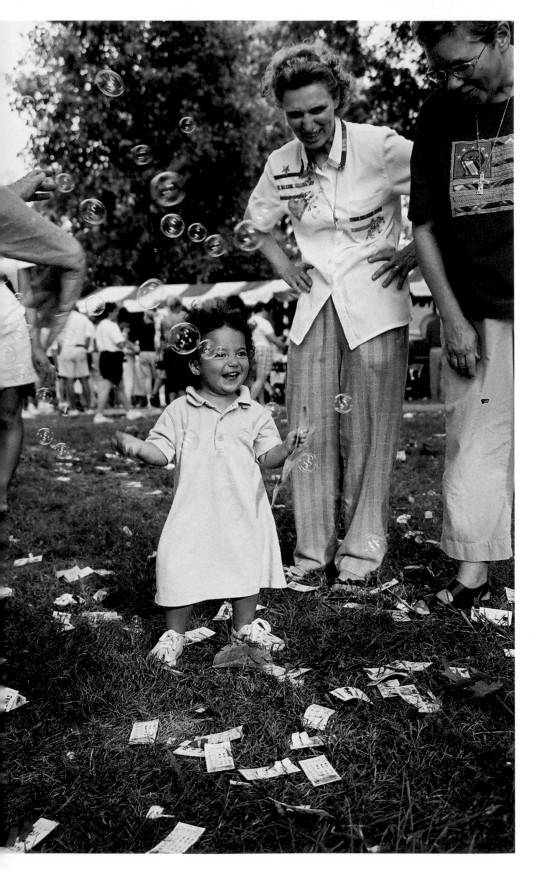

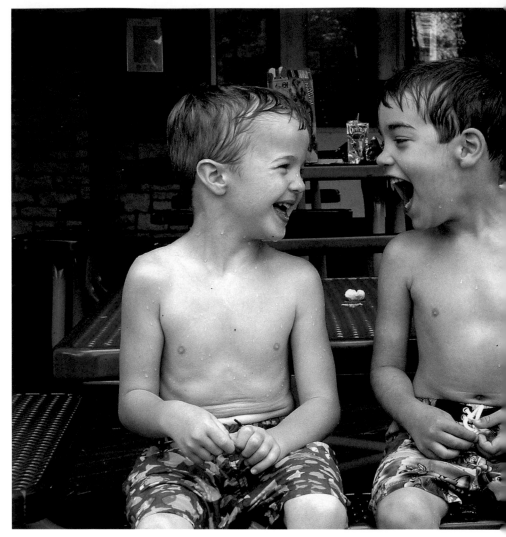

ABOVE ■ Best Friends: Seth and Will enjoying the water at Sharon Woods. PHOTO BY HOLLY EMMOREY

LEFT ■ Fourth of July: My niece, Teana, enjoying her first visit to the Sisters of Notre Dame annual Fourth of July Picnic.

PHOTO BY LINDA AVERBECK

RIGHT ■ Sling Shot: Nick Evans, of Milford, learns how to shoot a sling-shot at the Boy Scout Twilight Camp at Lake Isabella in Loveland.

PHOTO BY AMANDA DAVIDSON/THE ENQUIRER

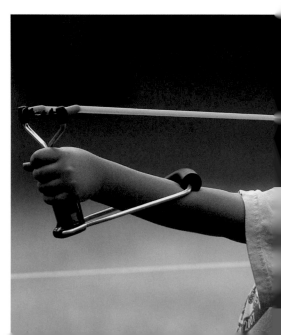

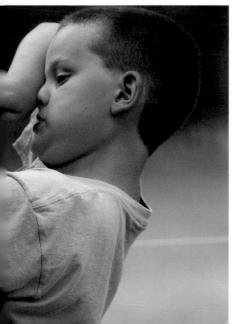

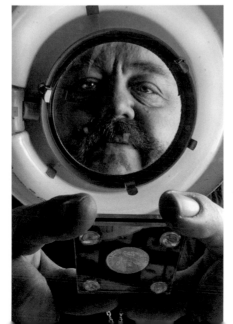

ABOVE ■ Team Oak Hills Back and Neck Care Center: My co-workers, family and friends after completing the Cincinnati Walks for Kids at Coney Island on Saturday, Oct. 13, 2007.

PHOTO BY KYLIE J. WILKERSON

FAR LEFT ■ Gold: Garry Perkins of American Trading Co. The Original, uses a magnifier to look at a $5 Liberty gold coin one morning in his Colerain Township shop.

PHOTO BY GLENN HARTONG/THE ENQUIRER

LEFT ■ Shirtless. PHOTO BY NICHOLAS KEIL

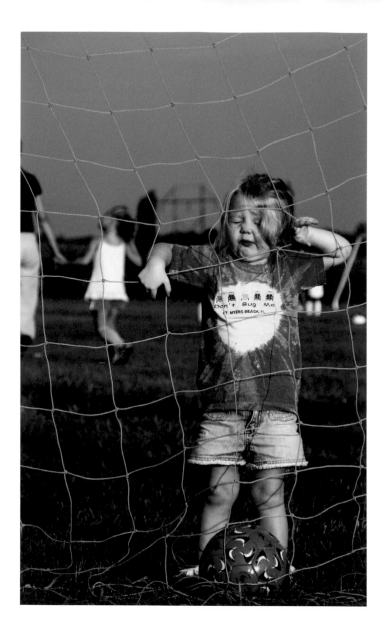

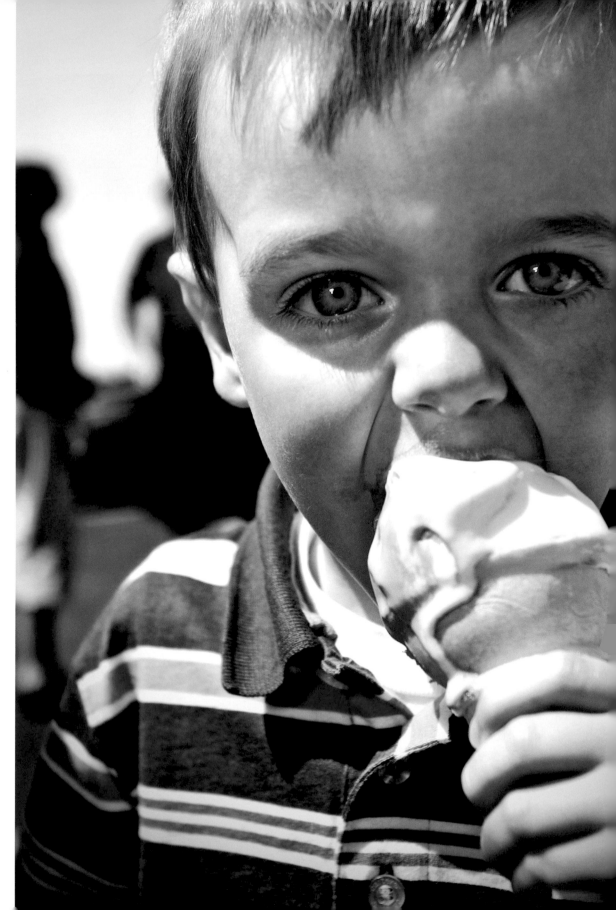

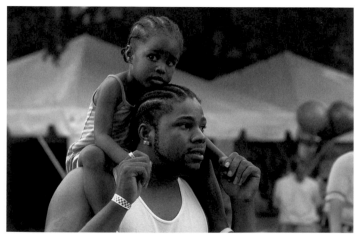

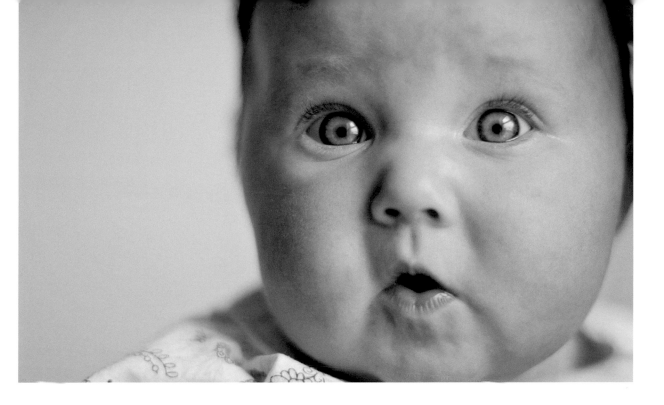

ABOVE ■ It's a Hard-Knock Life: Life's tough when you're a kid. Kaelyn's pouting on the stone wall where the Mount Adams incline used to be. Photo by Steve Carr

PREVIOUS TOP LEFT ■ What a Tangled Web We Weave: While watching a soccer game, I caught this little gal getting a wee bit tangled. I really like the irony of her shirt which says, "Don't Bug Me."
Photo by Rick Stegeman

PREVIOUS BOTTOM LEFT ■ Riding High: A father gives his child a ride at Coney Island Photo by Dennis Camp

PREVIOUS RIGHT ■ I Scream, You Scream: Delicious (free) soft serve from The Cone. Photo by Paul Armstrong

BELOW ■ Holding Tight: DeaArron Anderson, 19-months, holds tightly to his mother, Lynette Johnson of Price Hill, as they cool off at Concourse Fountain in Sawyer Point. The fountain was full with children trying to enjoy the high temperatures, August 2007.
Photo by Cara Owsley/The Enquirer

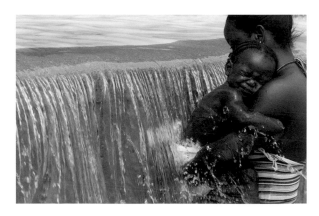

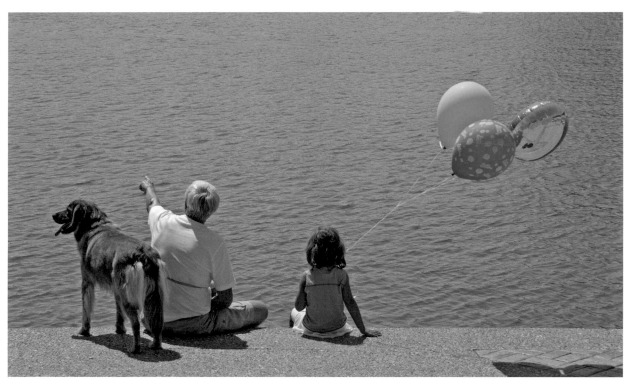

TOP ■ Chubby Cheeks: Abby Kinasewitz, 3-months-old, at her home in Mason. Photo by Melissa Speelman

ABOVE ■ Sitting with Granddaughter: Grandpa and granddaughter sitting on the riverfront wall. Photo by John Michell

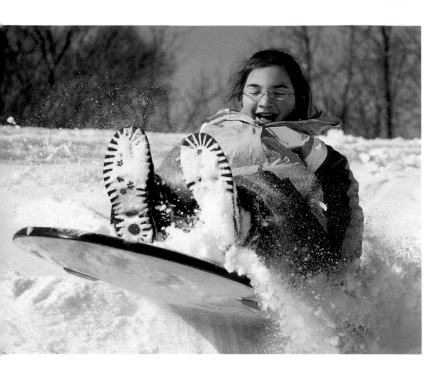

ABOVE ■ Snow Day Fun: This perfect snow day found Hayley Huge bouncing up a spray of white powder as she descends a hillside at Blue Ash Golf Course. PHOTO BY TERRENCE HUGE

RIGHT ■ Jim Dandy: Then Vice Mayor Jim Tarbell at the July Fourth parade in Northside. PHOTO BY DAVID SORCHER/CiN WEEKLY

BELOW ■ New Exhibit at the Zoo: A diver at the Cincinnati Zoo couldn't resist having some fun with a youngster. He made a good exhibit! PHOTO BY CAT PENTESCU

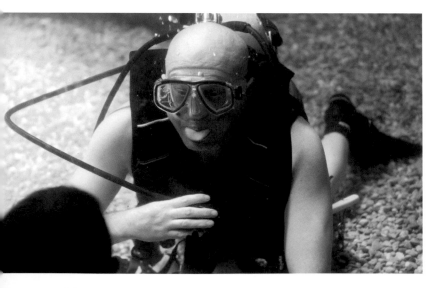

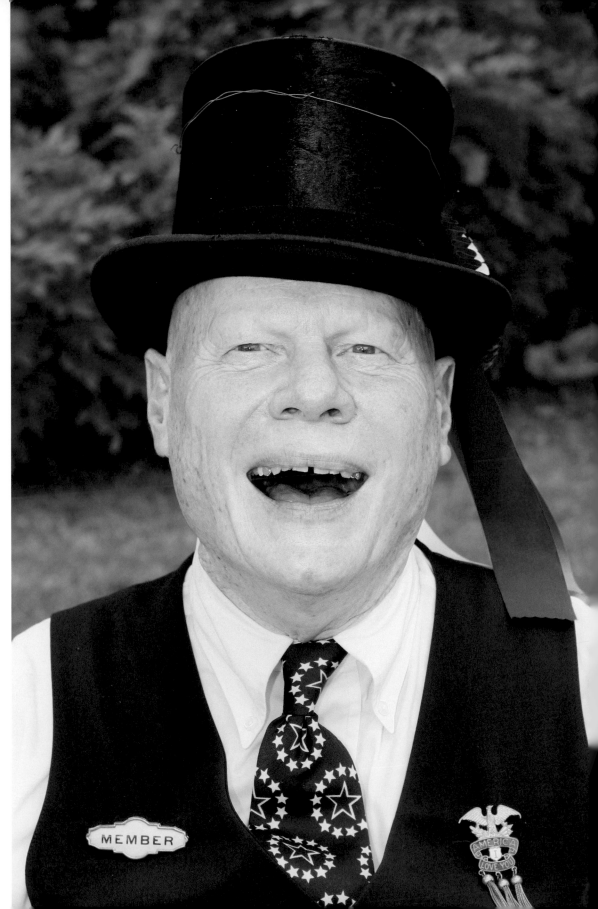

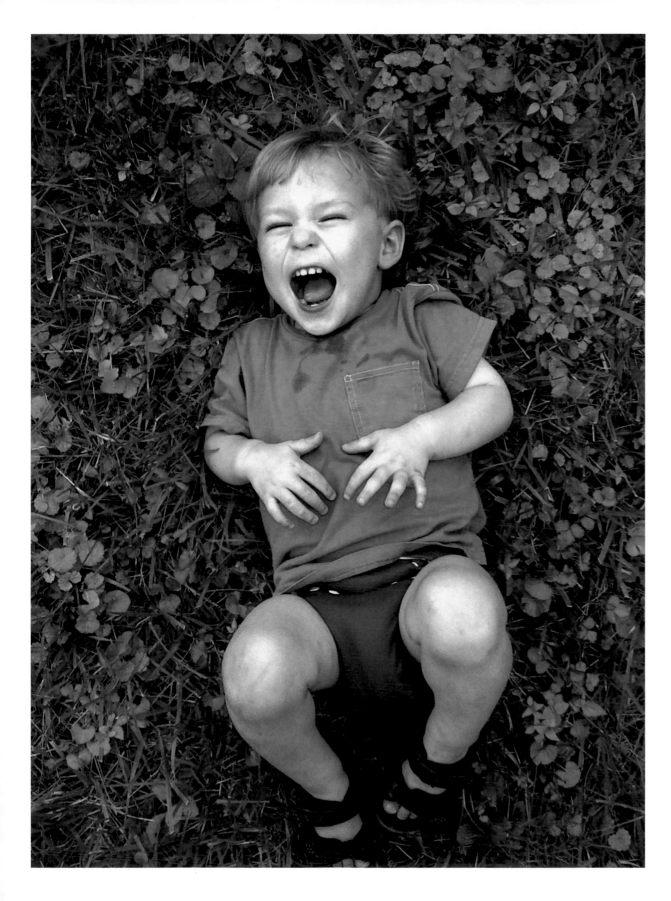

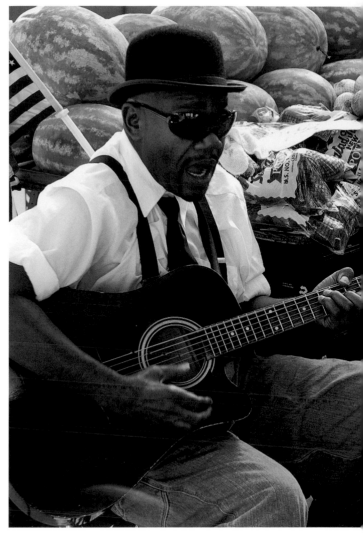

ABOVE ◼ Market Rate Entertainment: This fella always gives me a chuckle when he's entertaining the kids by the produce stands at Findlay Market.

PHOTO BY GEORGE CRAWFORD

LEFT ◼ Joelie's Joy of Life: Lying in the green grass on a fine summer afternoon, what a life! PHOTO BY JOEL R. HALL

ABOVE ■ What a Cutie: A young camper at Pleasant Vineyard summer camp displays a joy and wonder in her eyes that can bring a smile to anyone's face.

PHOTO BY LANCE WEBEL

RIGHT ■ Water Fun: Albert Li of West Chester giggles as he sprays his sister at Parky's Ark playground in Winton Woods. PHOTO BY MALINDA HARTONG/THE ENQUIRER

BELOW ■ Reflections: My boys love to play at Sharon Woods. This stainless steel slide is always a favorite. The reflections inside make it seem like you are slidng right through a kaleidescope. PHOTO BY MELISSA SPEELMAN

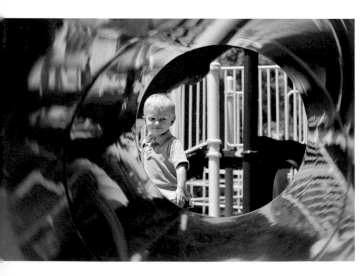

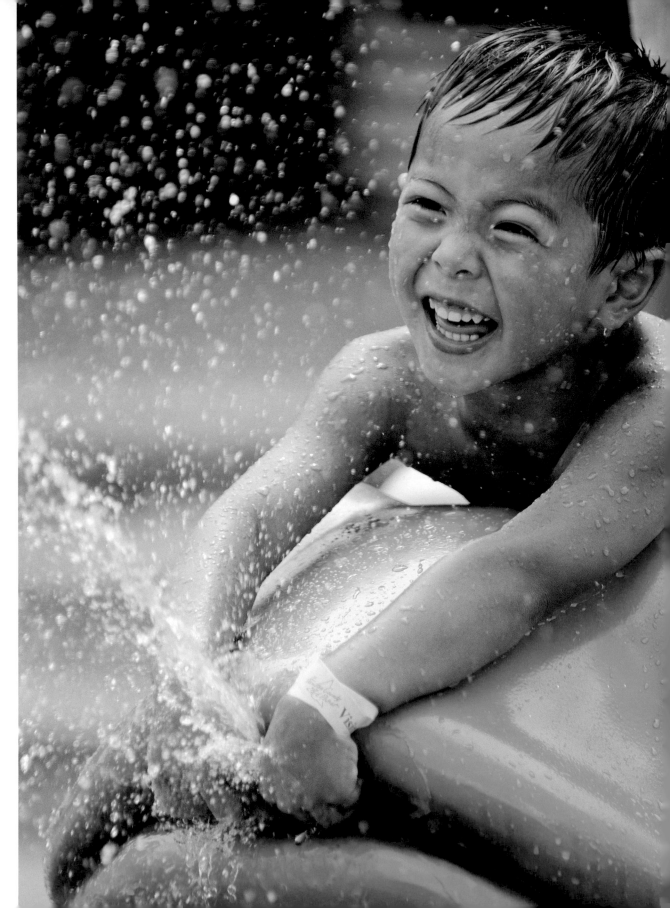

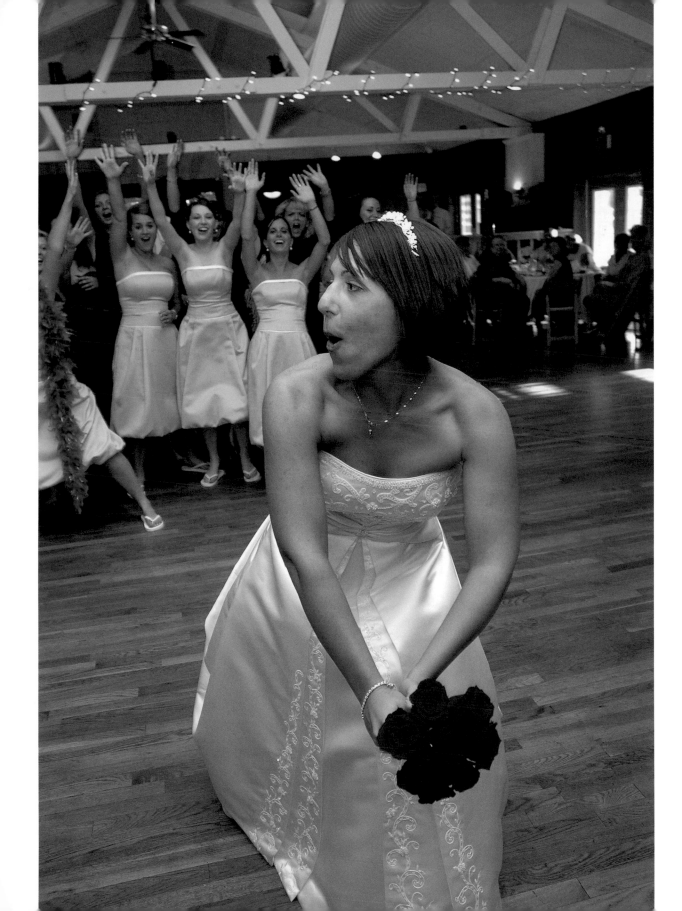

LEFT ■ Catch: A wedding reception at Molloy's on the Green in Greenhills. Photo by Kerri Haley

BELOW ■ American Pride: This is Kelli showing her American pride. Kelli was my girlfiend and now she is my wife. Photo by John McNamee

BOTTOM ■ Graduation Day: Laughing it up at a back-yard graduation party. Photo by Dale Doyle

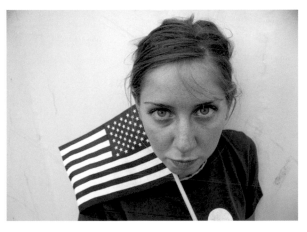

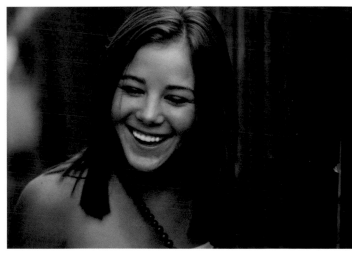

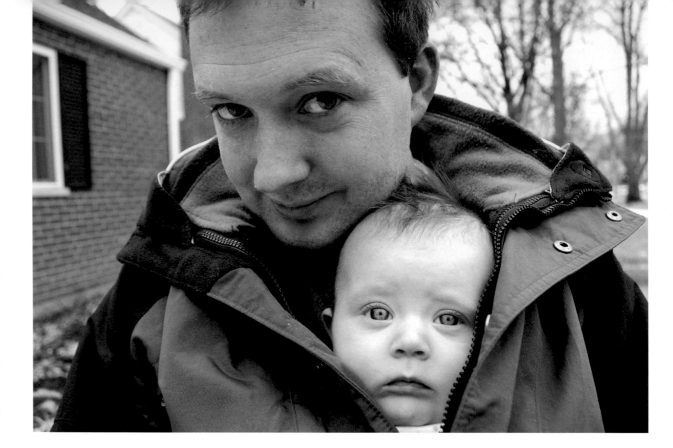

RIGHT ■ Coat For Two: Trying to keep warm during a cold Cincinnati morning. Photo by Ryan Mecum

BOTTOM RIGHT ■ Over the Edge: On a sunny morning I watched as this window washer went over the edge to keep Cincinnati looking shiny and new. Photo by Liza Druck

OPPOSITE ■ End of Summer: A favorite summer hat. Photo by Lucrecer Braxton

BELOW ■ Dominic is looking for the perfect tree at a Hyde Park Christmas stand. Photo by Ed Allie

BOTTOM ■ Wide Angle Smirk: On a Springtime walk in my neighboorhood. Photo by Amber Dale Sapp

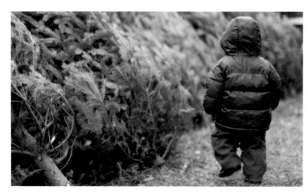

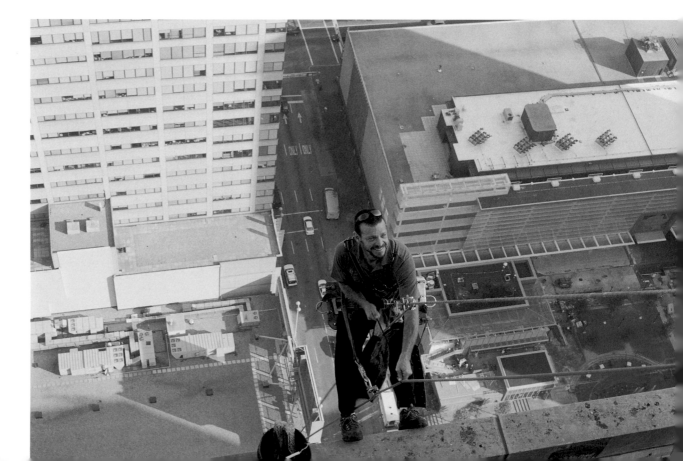

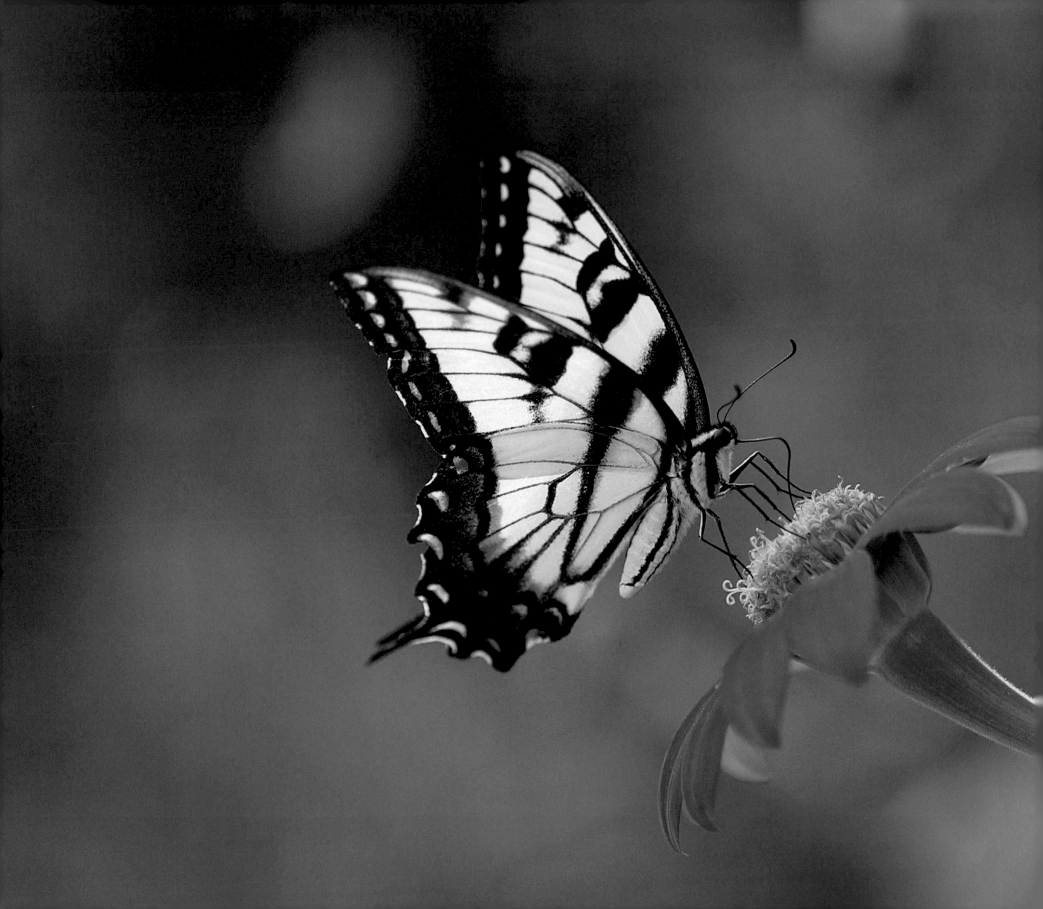

PETS & ANIMALS

Is there any way to go wrong with photos of cute puppies and kittens? Of course not.

This chapter is so much more than that, though. Pets certainly are a part of the section. But the primary sources of these great photos are the Cincinnati Zoo and Botanical Garden and the great outdoors.

Primates and peacocks and elephants, oh my! All of those come from our fabulous zoo, one of the area's most popular attractions. Even a shark from the Newport Aquarium got into the act.

From nature, you'll see butterflies, dragonflies, frogs and flies. There's a ladybug on a lone leaf and a grasshopper on the remains of a corn stalk. There are a variety of birds and an artistic look at dead cicadas (yuck!). There are even several pictures for horse lovers.

These photos are either going to make you smile or make you say "Wow." Maybe both.

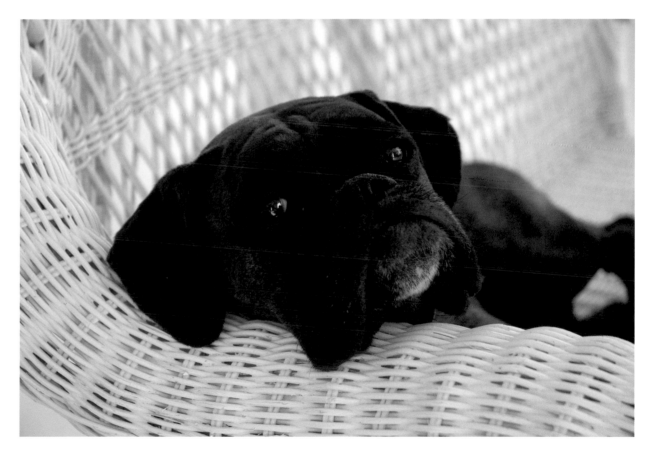

ABOVE ■ Gypsy is caught relaxing on a wicker chair on the porch of her New Richmond home. PHOTO BY MEG FITE

LEFT ■ Ault Park Tiger Swallowtail. PHOTO BY KEITH NEU

RIGHT ■ I found this irresistible combination in the water feature by the back garden. The little guy was surprisingly patient as I got closer and closer to take a few snaps.

PHOTO BY RICH CAMPOAMOR

BOTTOM RIGHT ■ The Robber: Bearded Robber Fly, captured at Winton Woods.

PHOTO BY DOUG GILHAM

BELOW ■ Shetland and Silhouette: In February of 2007 I went out looking for "nature" shots because of the beautiful ice and snow we received. I got lucky and found this shot at Cain-Tuckee Acres Farm in Independence, Ky.

PHOTO BY TRACE DEATON

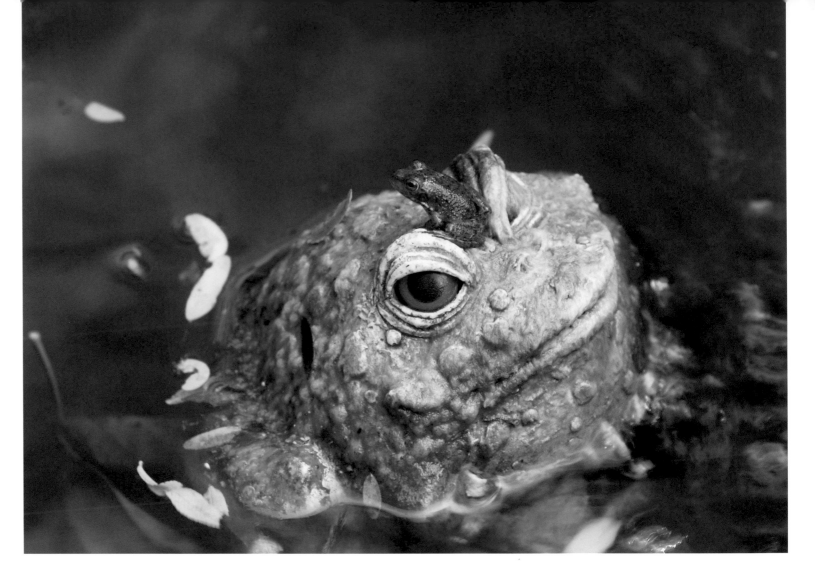

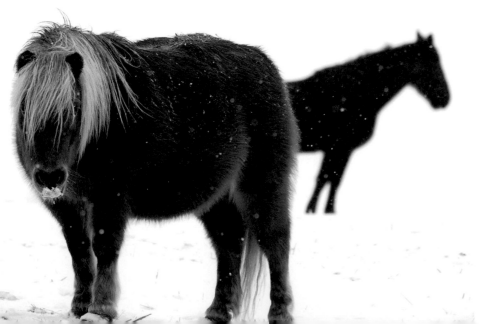

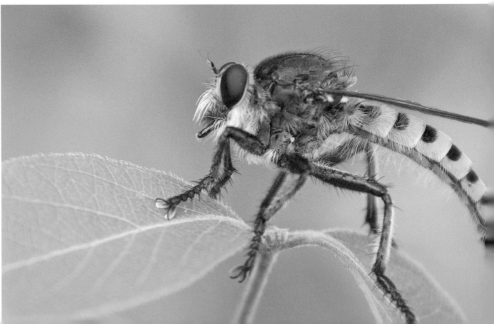

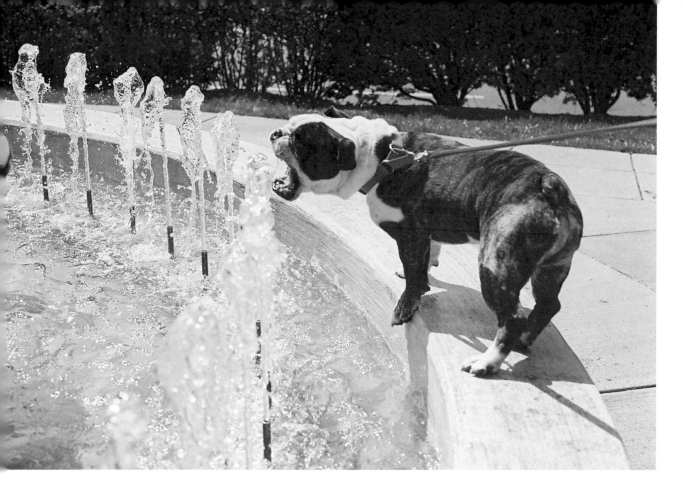

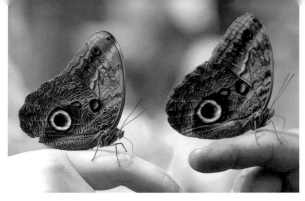

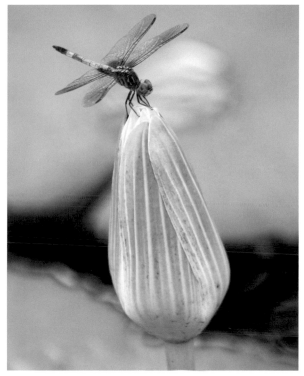

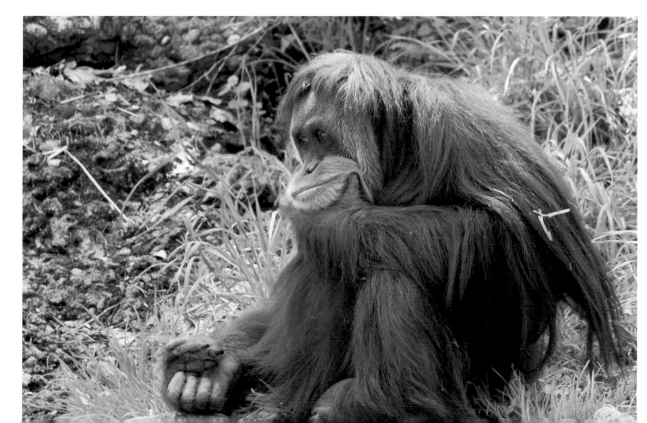

ABOVE ■ Dragonfly and lilly blossom.
PHOTO BY STEVE HORTON

TOP ■ Twins: Taken at the Cincinnati Butterfly Show at Krohn Conservatory. PHOTO BY PETE FOLEY

TOP LEFT ■ Guido: I photographed this dog walking around Hyde Park biting every single stream of water. His name is Guido and he is crazy about water. His owner grew tired of Guido's obsession but was ecstatic when I showed him the photos. PHOTO BY MATT MOORE

LEFT ■ Contemplation: Cincinnati Zoo & Botanical Garden. PHOTO BY KABIR BAKIE

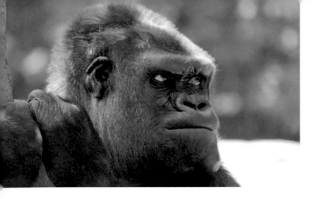

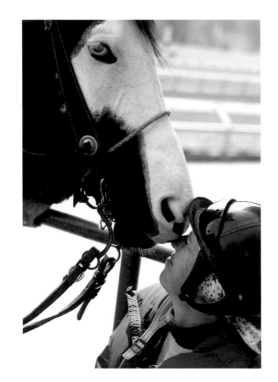

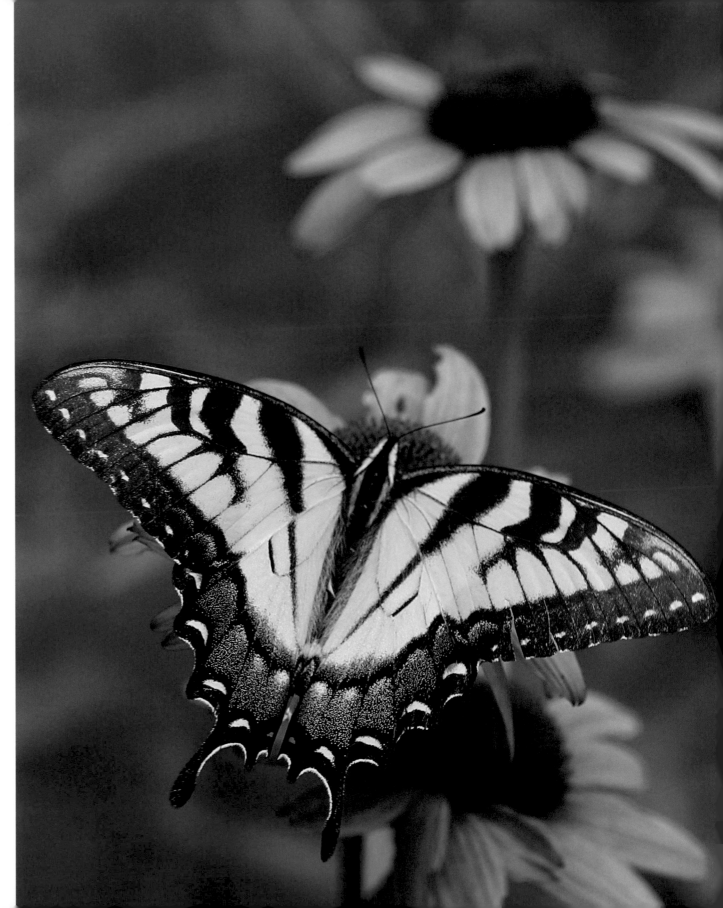

ABOVE ■ Kisses: Kim Martin, of Independence, Ky., gets a kiss from a horse at the races at River Downs.
PHOTO BY AMANDA DAVIDSON/THE ENQUIRER

TOP ■ Always a fun subject at the Cincinnati Zoo, gorillas can make you feel like you are there for their entertainment. PHOTO BY PAM SCHRENK

RIGHT ■ Yellow butterfly on pink coneflowers. PHOTO BY STEVE HORTON

OPPOSITE ■ Ladybug at Ault Park in the spring of 2007. PHOTO BY PETE FOLEY

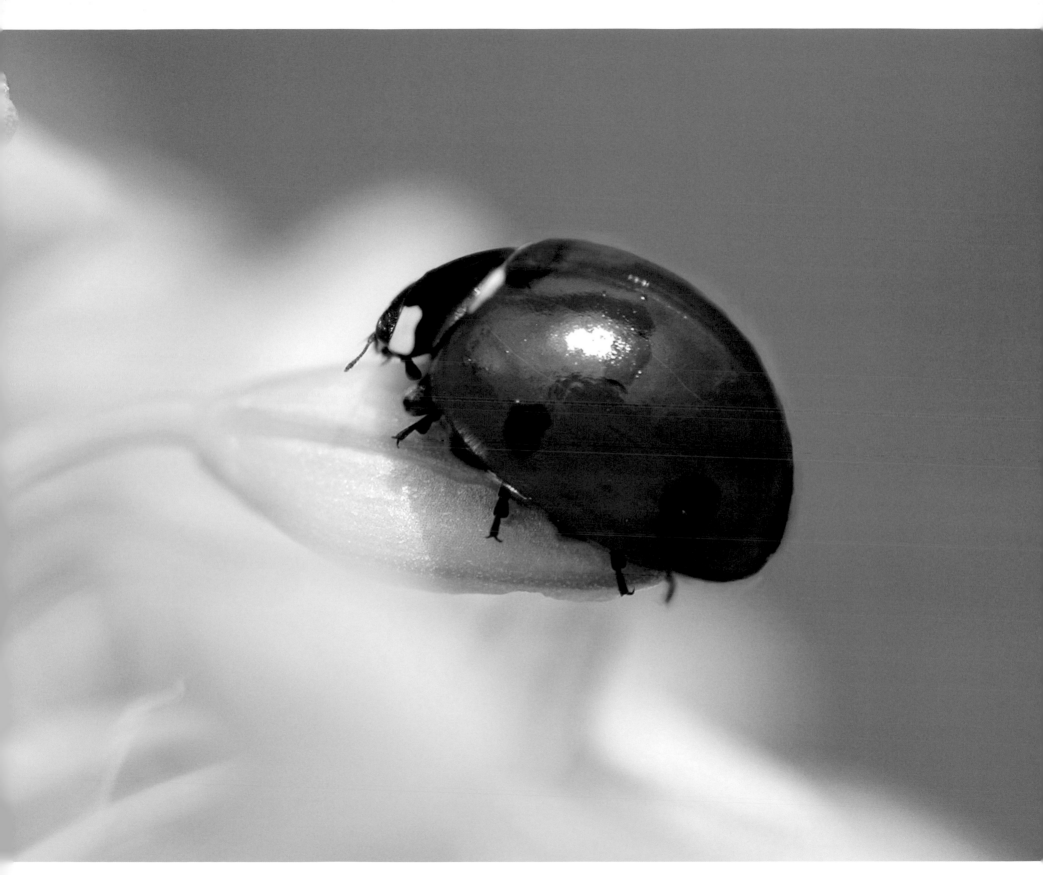

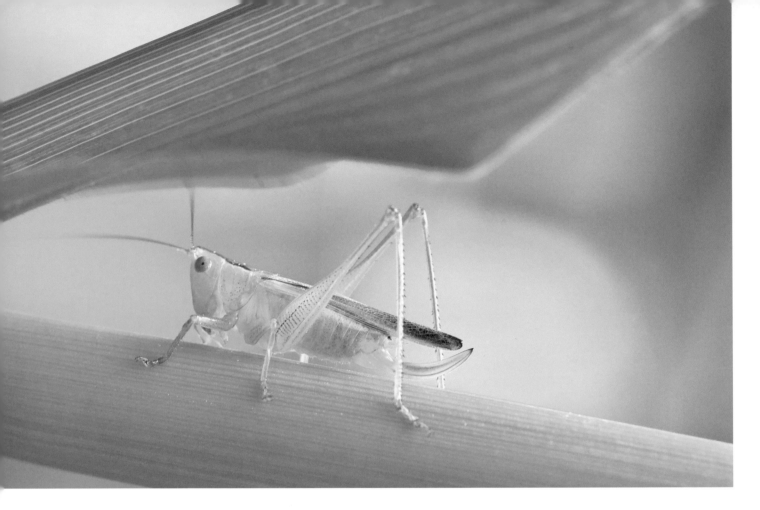

ABOVE ■ Grasshopper: The corn didn't produce because of a drought this year, but the leaves were a haven for grasshoppers. PHOTO BY LINDA ERHART

RIGHT ■ Jimmy Buffet wannabe? Pugfest, 2006. PHOTO BY PATTI NEEDHAM

FAR RIGHT ■ Six-week-old Emma Marie taking a nap in her favorite spot. PHOTO BY JASON NEAL

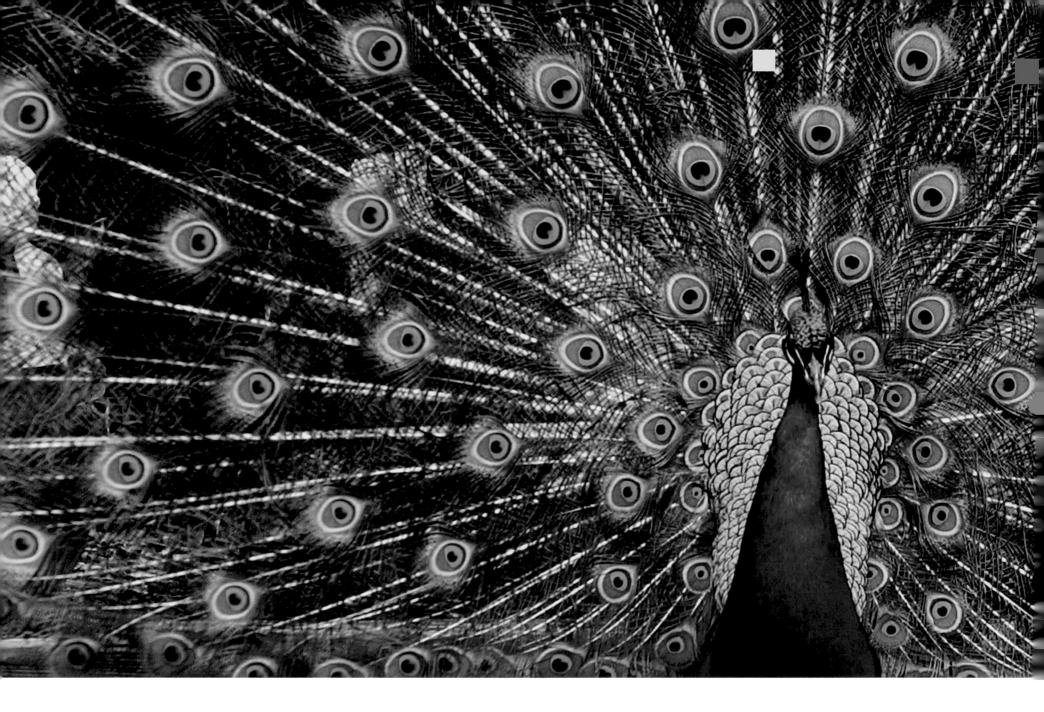

ABOVE ■ A peacock spreads its tail as it walks around the front entrance of the Cincinnati Zoo & Botanical Garden. Photo by Ernest Coleman/The Enquirer

LEFT ▢ Kittens in a Cup: We took in a stray cat who was pregnant. She had a litter of about 10 and these two I kept for myself. This photo was taken the day after they were born, eyes still shut. They made great cats (Hades and Hermes). Photo by Matt Moore

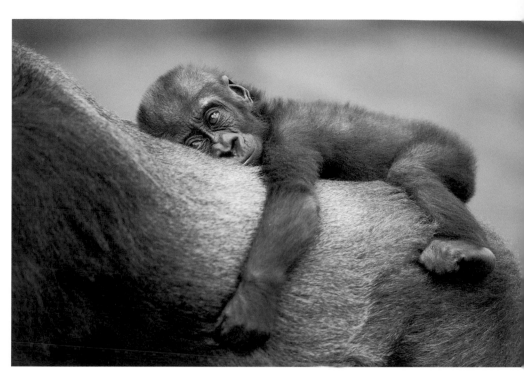

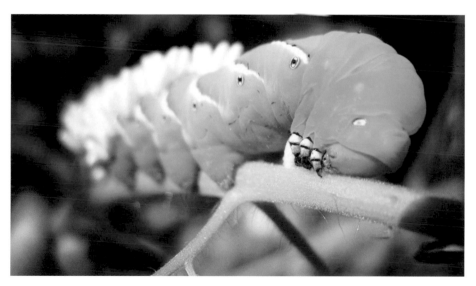

ABOVE ▪ Parasitized Tobacco Hornworm: The white things on the caterpillar's back are the cocoons of the braconid wasp. A wasp lays eggs on the caterpillar and when the eggs hatch the wasps eat the host. Photo by Rob Ireton

TOP ▪ This is Muke and her new baby, shot at the Cincinnati Zoo. Photo by Mike Wehrman

LEFT ▪ Illegally cute puppy! Photo by Julie Hucke

FAR LEFT ▪ My girl Lace in her favorite window. Photo by Charles R. Wetzel

ABOVE ■ A pool of dead cicadas float in Mirror Lake toward the end of the cicada invasion. PHOTO BY J.P. PFISTER

RIGHT TOP ■ Snubbed: This miniature horse is convinced that Savannah Jones has some treats to share. PHOTO BY MARK JONES

RIGHT BOTTOM ■ The Sun Feels Good, Cardinal: During an ice storm in February 2007, a cardinal landed on my Hydrangea bush and basked in the sun. As I clicked away my camera from inside my house, he tilted his head to locate the sound. He finally looked straight ahead at me and I captured this photo.
PHOTO BY PATTY BAMBER

FAR RIGHT ■ Cincinnati Zoo: I think this guy just woke up. His hair was a mess!
PHOTO BY MARK HERRMANN

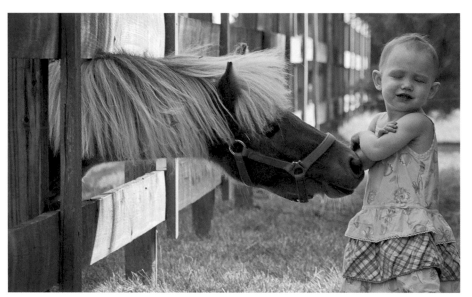

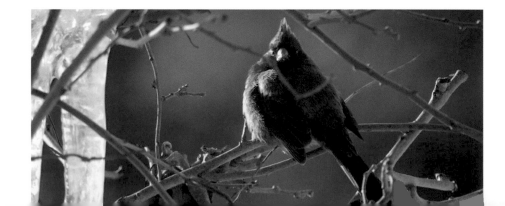

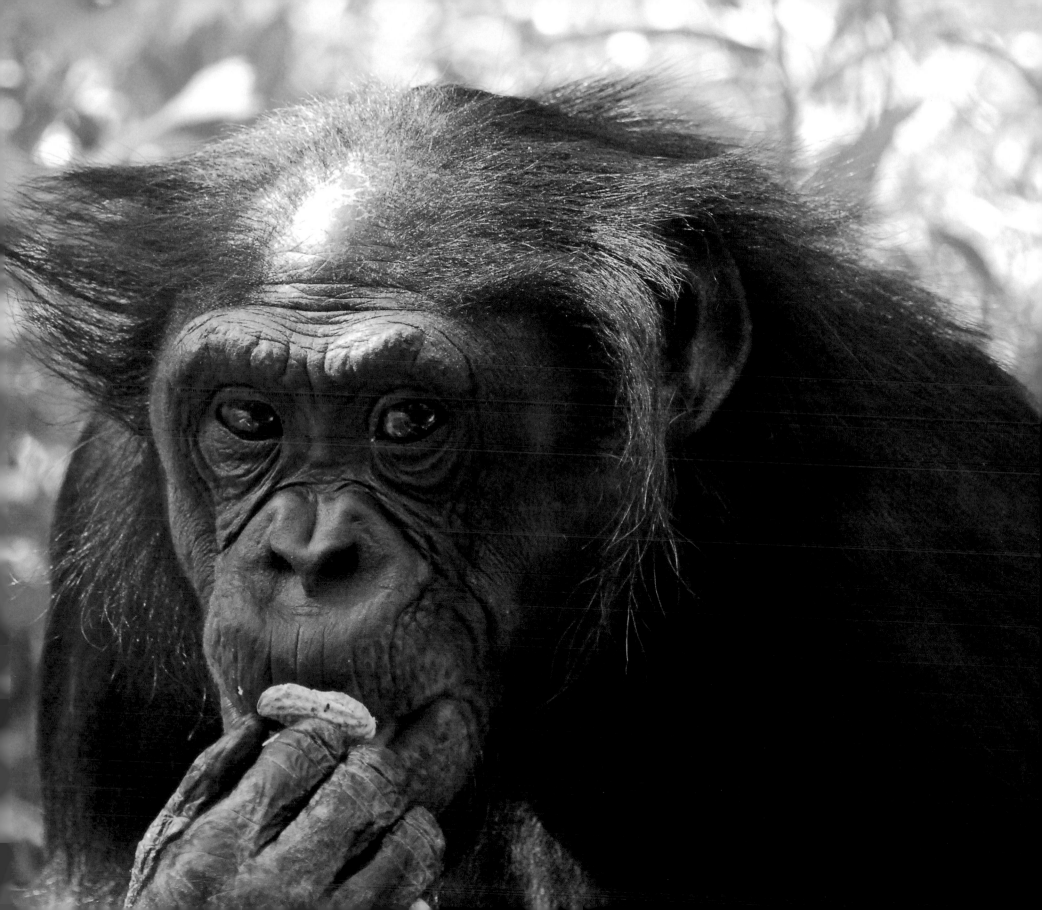

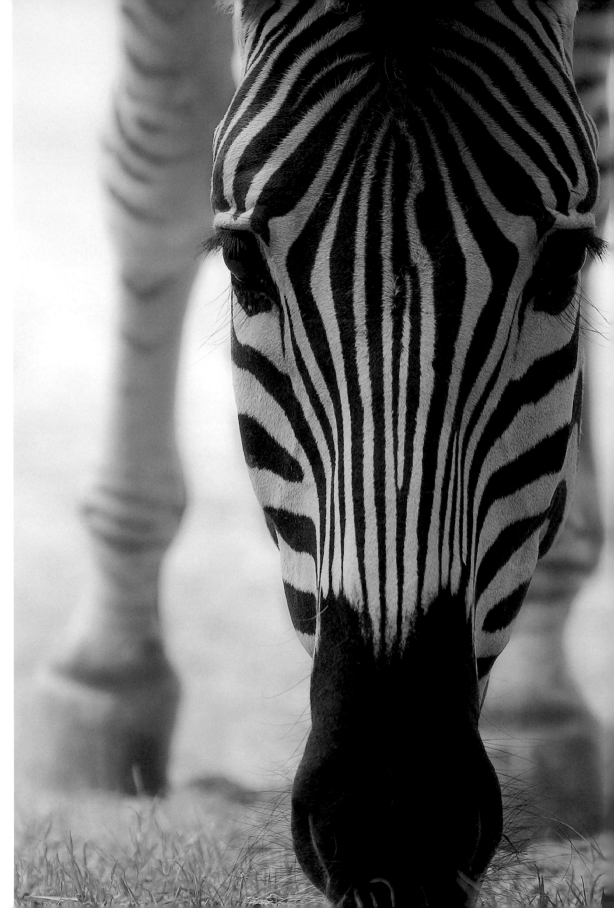

RIGHT ■ Eye to Eye: Shot on a recent visit to the Cincinnati Zoo. Photo by Mike Wehrman

BELOW ■ Fence Rooster: A Barred Rock rooster, a breed authentic to the period of Heritage Village in Sharon Woods, stands atop a picket fence in the village. Photo by Malinda Hartong/The Enquirer

BOTTOM ■ Blue Dragonfly: Dragonfly on Parrot Feather water plant in fish pond, New Richmond. Photo by Derek Rillo

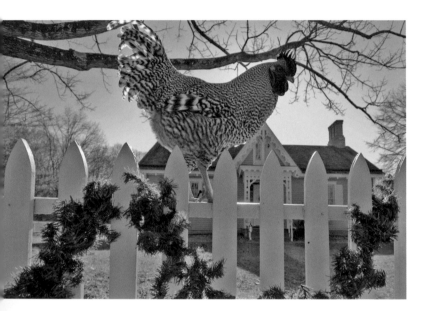

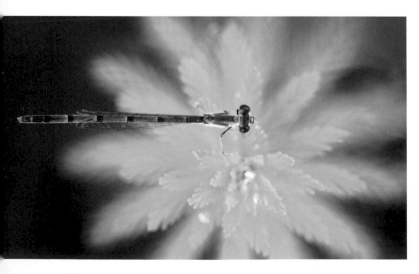

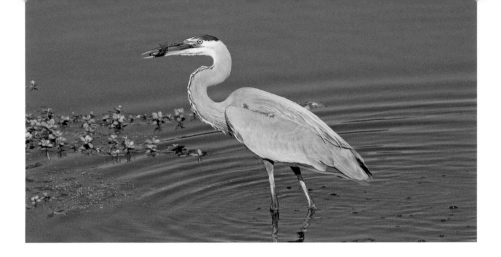

ABOVE ■ Great Blue Heron in Deerfield Park. PHOTO BY DOUG GILHAM

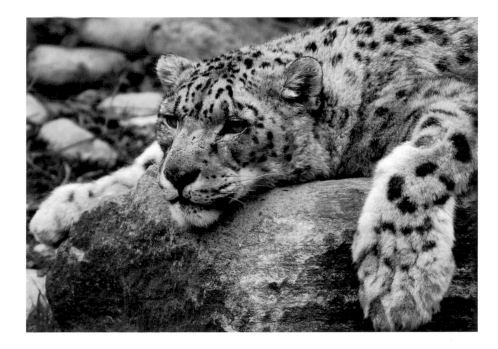

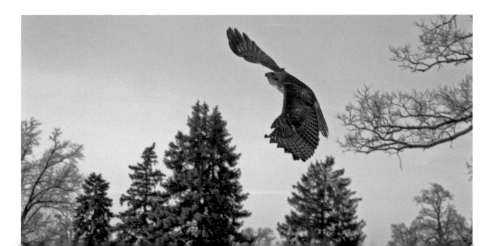

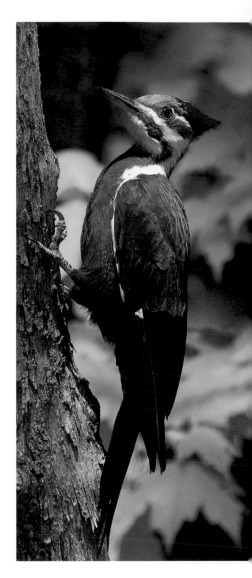

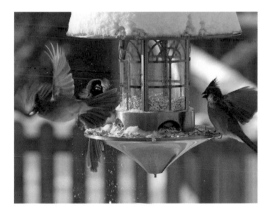

TOP ■ Funny Cat: Cat #483 from SPCA Cincinnati—one of many cats there looking for a home. PHOTO BY AMY HARTMAN

ABOVE LEFT ■ Feeder Flurry: An icy cold February morning finds these cardinals enjoying a feeder of safflower seeds in our Blue Ash side yard. PHOTO BY TERRENCE HUGE

ABOVE RIGHT ■ The largest woodpecker in North America, the Pileated Woodpecker, makes its home all across the Cincinnati area. Taken in our Maineville, Ohio, backyard. PHOTO BY JASON HUSBAND

MIDDLE LEFT ■ Snow leopard caught in a lazy moment. PHOTO BY RAVI RAMACHANDRAN

LEFT ■ Hunting Hawk: St. Joe's Cemetery is one of my favorite places to take photos. One sunny afternoon I was fortunate enough to see this hawk soaring above searching for his dinner. PHOTO BY MICHAEL SHELTON

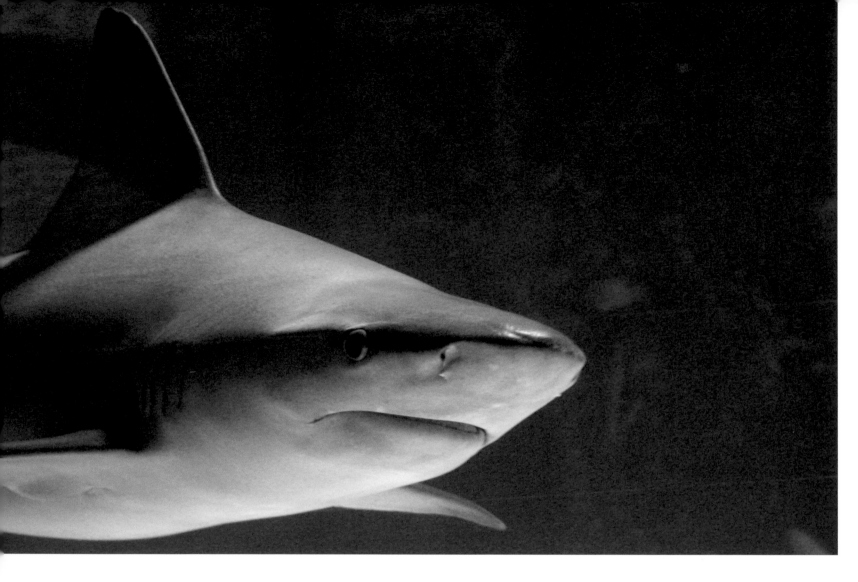

ABOVE ■ Sharks Alive!: Close encounters with sharks at the Newport Aquarium.
Photo by Steve Horton

RIGHT ■ Two elephants watch as their photo is taken. Photo by Scott Stanley

FAR RIGHT ■ Well, Hello: Petting farm on Princeton Road, north of Cincinnati. Photo by Jana Rude

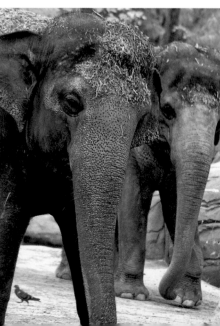

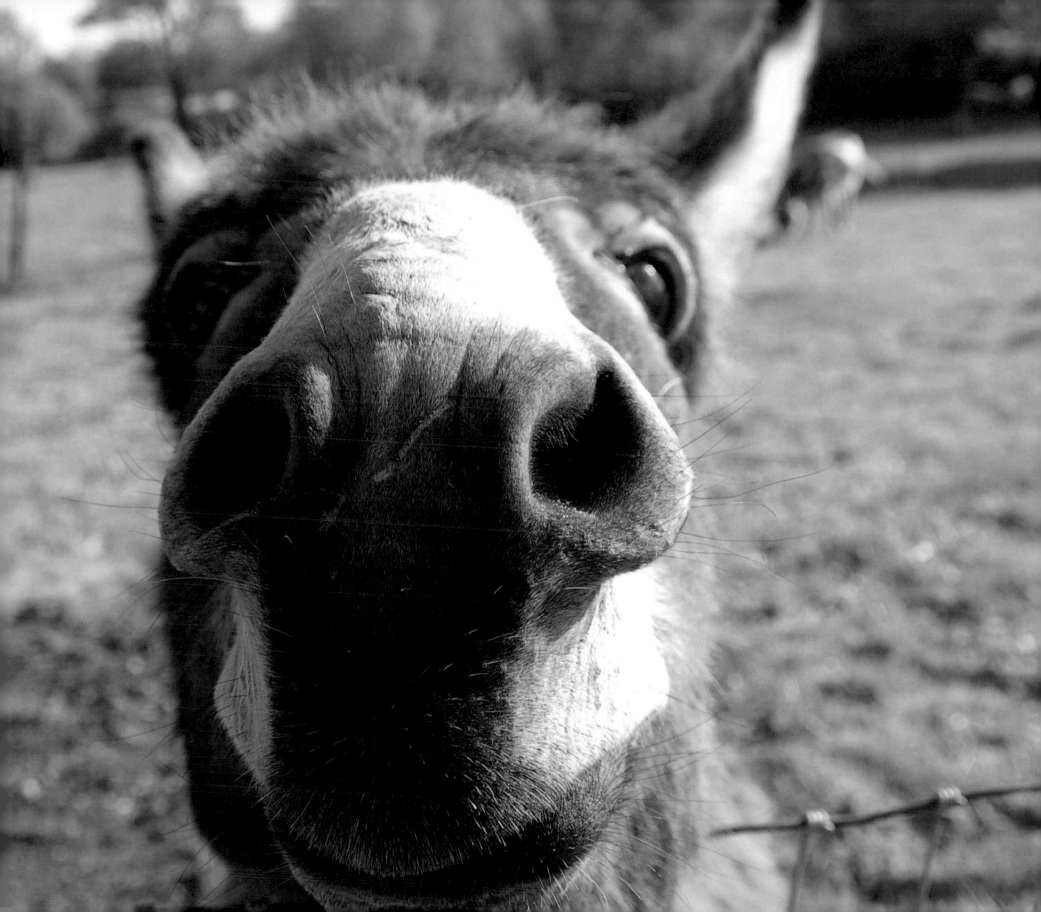

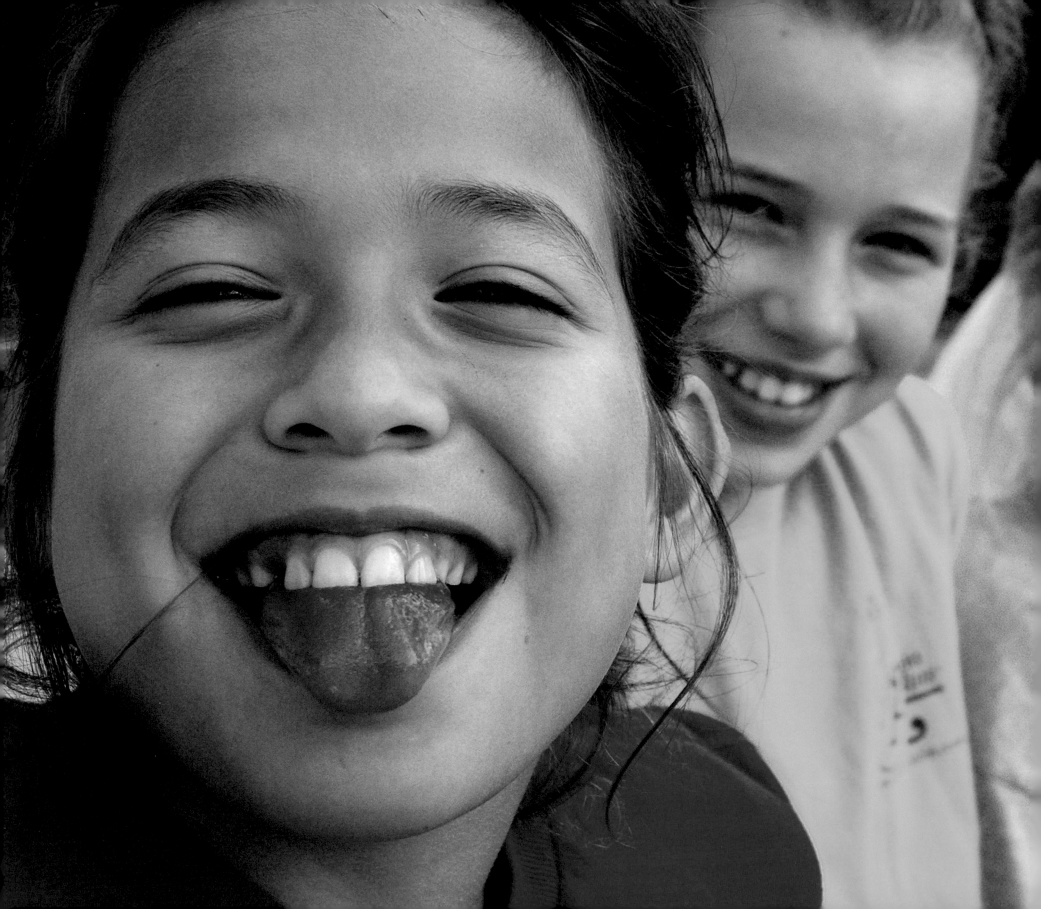

SCHOOLS

School means different things to different people. For some, it's about sports, extracurricular activities, spirit and pride. For others, it's about the buildings in which learning takes place. It can be about developing relationships with professors or friendships with classmates.

These photos remind us about the first-day-of-kindergarten jitters, as well as the joy of graduation. A Turpin student anticipates dissecting a frog. Four Little Blue Devil cheerleaders ride in the Reading High School Homecoming parade. A UC professor and graduate student show how cool research can be.

This chapter captures a bus ride, a crowded cross country meet and the cheering on of the ol' alma mater from the stands and the sidelines. We take you to Ohio and Kentucky – to grade schools, high schools and some of the wonderful colleges that call our area home.

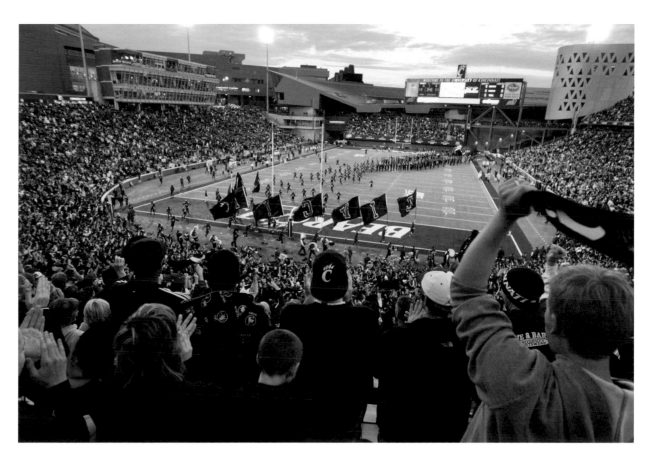

ABOVE ■ With football frenzy at an all-time high and Nippert Stadium sold out, the University of Cincinnati's Homecoming weekend was one of the biggest in its history. Photo by Lisa Ventre

LEFT ■ Red Tongue: Marissa Shoji, a 7th-grade student-athlete at Cincinnati Hills Christian Academy, shows some sass at her team's first-ever 6th, 7th, and 8th grade combined cross country practice. Photo by Lance Webel

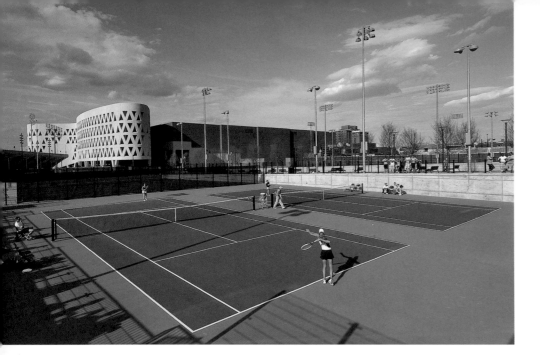

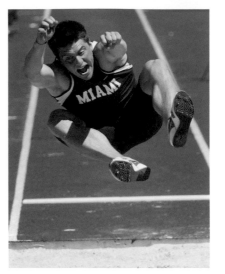

LEFT ■ Mitch Reynolds, of West Chester Township, a sophomore at Miami University, competes in the long jump event at University of Cincinnati's Gettler Stadium. The All-Ohio Track and Field Championships in April attracted top collegiate athletes from around the state. Mitch is a Lakota East grad majoring in mechanical engineering. PHOTO BY TERRENCE HUGE

BELOW ■ On the Bus: Anthony Brown rides Larry Dempsey's bus on his way to Sharonville Elementary in the Princeton School District.

PHOTO BY CARRIE COCHRAN/THE ENQUIRER

ABOVE ■ University of Cincinnati women's tennis vs. Xavier.
PHOTO BY ANDREW HIGLEY

RIGHT ■ Super Saturday Youth Ministry. PHOTO BY CARISSA MCKENZIE

BELOW ■ Xavier fans paint themselves blue for the big game. PHOTO BY GREG RUST

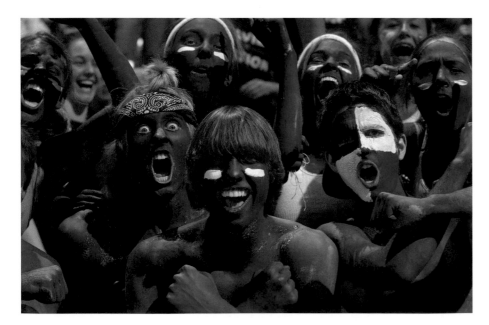

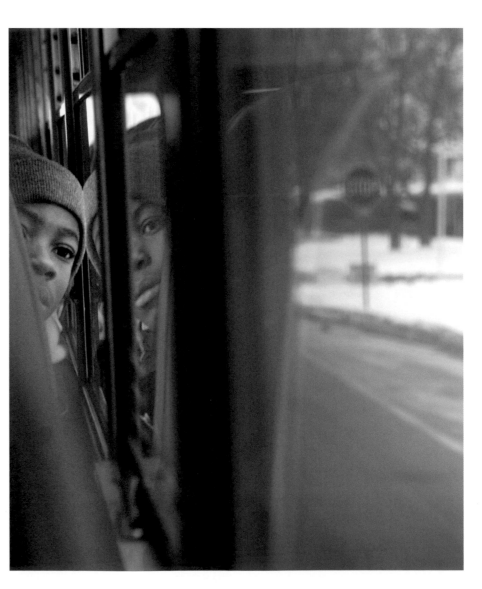

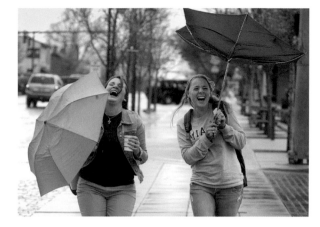

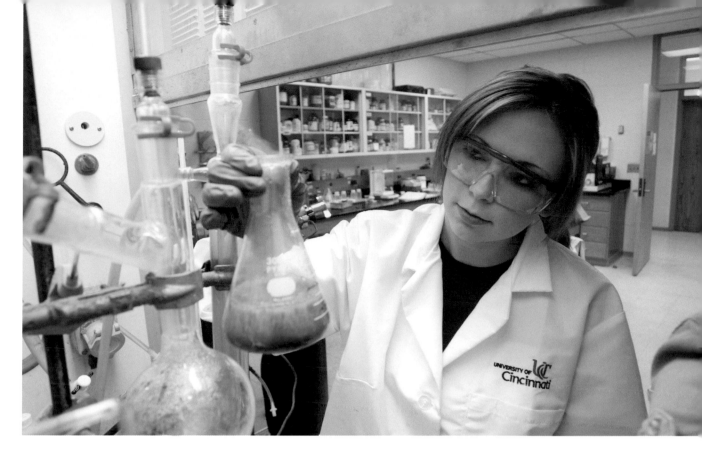

ABOVE ■ Uplifting: Miami University first-year eduction students Rachel Williams, 19, of Loveland, left, and Mary McGovern, 19, of Oradell, N.J., react as a gust of wind blows in while the two were walking along High Street in Oxford in April 2007. "This is the last time I use it," said Mary, of the already unstable umbrella. The two were coming from Kofenya, a coffee house where they were studying.

Photo by Carrie Cochran/The Enquirer

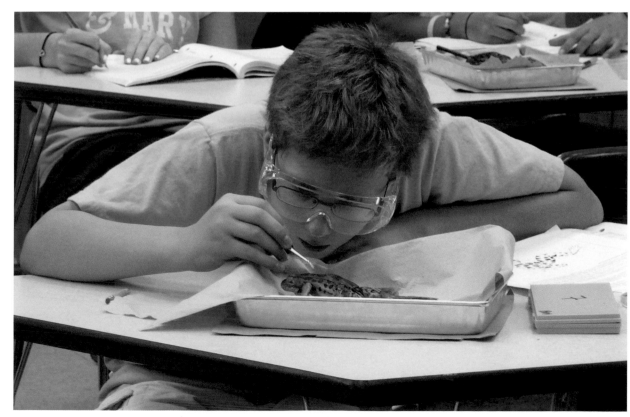

ABOVE ■ University of Cincinnati Lab2: WISE student Christina Smith works on global environmental disturbances associated with the Permo-Triassic Mass at the University of Cincinnati.

Photo by Dottie Stover

LEFT ■ Getting to Know You: Frog dissection day in a Turpin High School honors biology classroom.

Photo by Corey Mullins

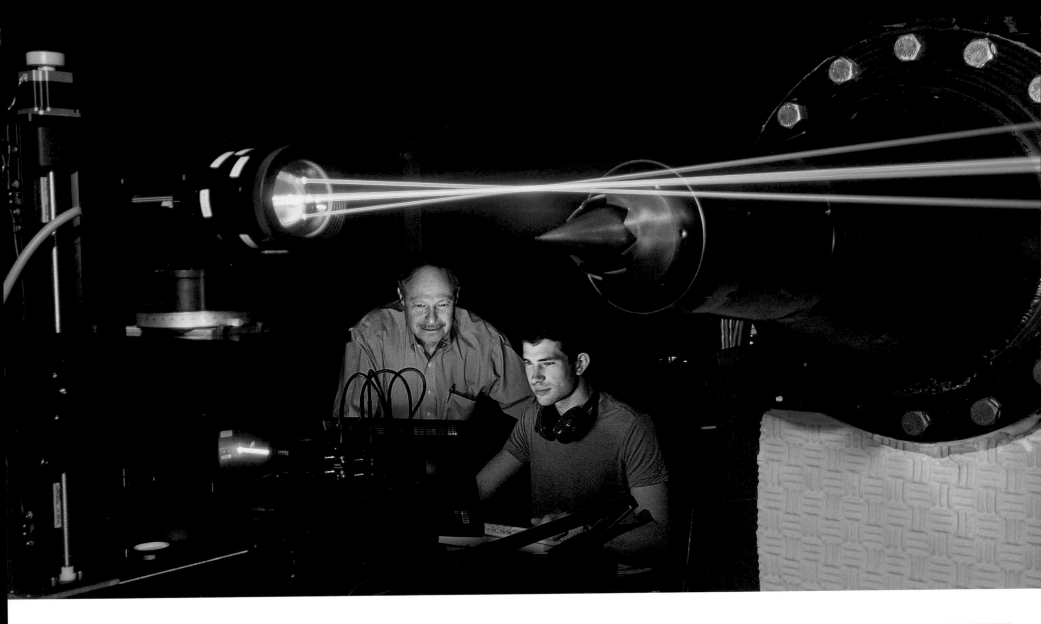

ABOVE ■ University of Cincinnati Research: Effie Gutmark, PhD, and Sid Khosla, MD, are using jet engine noise to learn more about voice production. In this photo, Dr. Gutmark, left, and his graduate student, Chris Harris, use lasers to help with their research. PHOTO BY LISA VENTRE

RIGHT ■ Breds Soccer: Senior Bob Gardner of the Newport Central Catholic High School Thoroughbreds varsity soccer team. Bob has been the team leader in assists the past two years. PHOTO BY JAMES GEYER

FAR RIGHT ■ First-Day Fears: Silver Grove Schools kindergarten teacher Shannon Gubser, left, reassures Haley Lambert as she arrives for her first day of school. PHOTO BY PATRICK REDDY/THE ENQUIRER

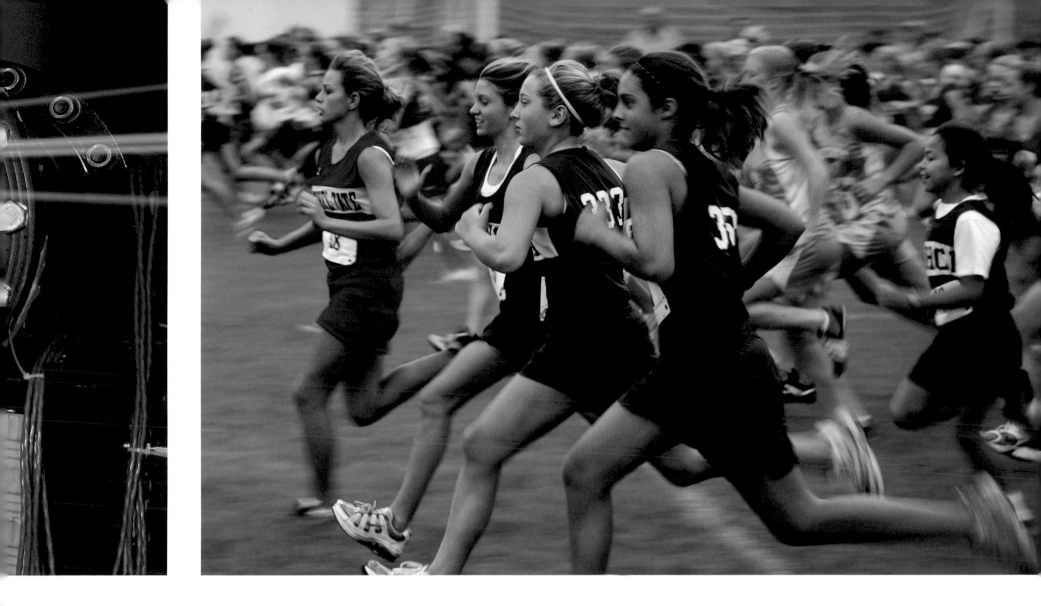

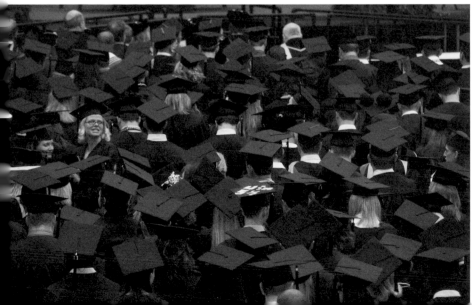

ABOVE ■ Blazing Fast: Sal Mangels, Sam Candee, Nicole Vice and Marissa Shoji, four student-athletes from Cincinnati Hills Christian Academy, take off at the start of the Blanchester Invitational, their first race of the season. PHOTO BY LANCE WEBEL

LEFT ■ Brick facade of Saint Ursula Academy in East Walnut Hills. PHOTO BY DAVID MICHELL

FAR LEFT ■ If These Hats Could Talk: NKU graduation. PHOTO BY CARISSA MCKENZIE

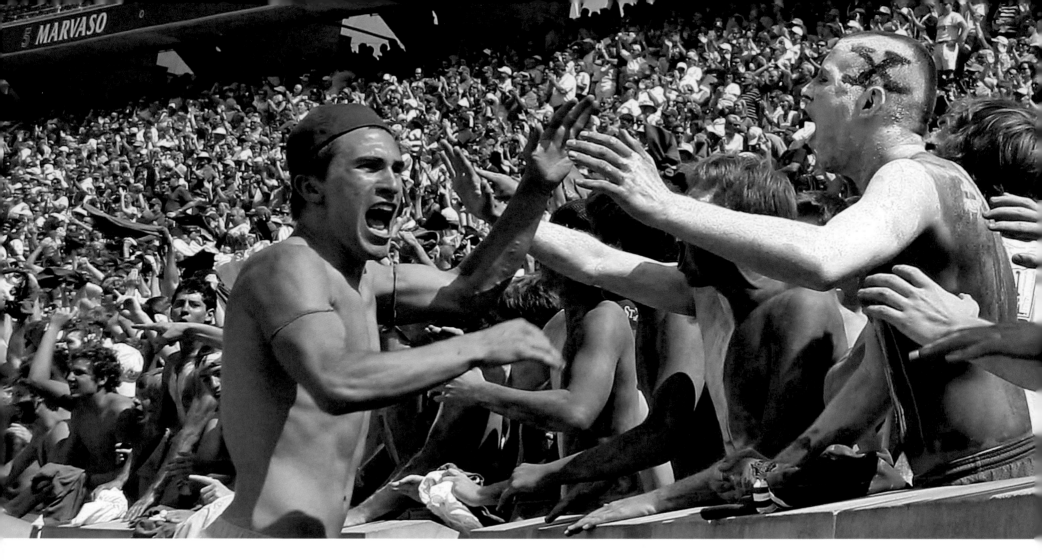

ABOVE: ■ Go Bombers: St. Xavier High School fans are wild about their nationally ranked football team as thousands packed Nippert Stadium to see the Bombers easily defeat powerhouse DeMatha of Maryland. PHOTO BY TERRENCE HUGE

RIGHT ■ Cage Match: The protective gear not only shields the catcher, but sometimes serves to focus energy as well. Reading catcher Lauren Cupp looks down the first-base line between pitches in a spring softball game at Koenig Park. PHOTO BY RICK ELLIOTT

FAR RIGHT ■ Exclamation Point: Freshman Jake Meyer has become a weekly fixture in the student cheering section at the football games in Veterans' Memorial Stadium. Dressing in Blue Crew attire for the football and basketball games has become a Reading tradition. PHOTO BY RICK ELLIOTT

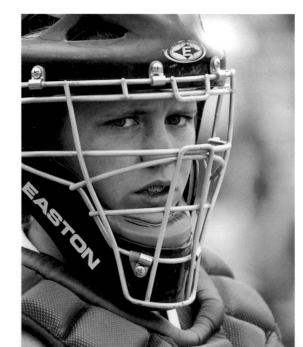

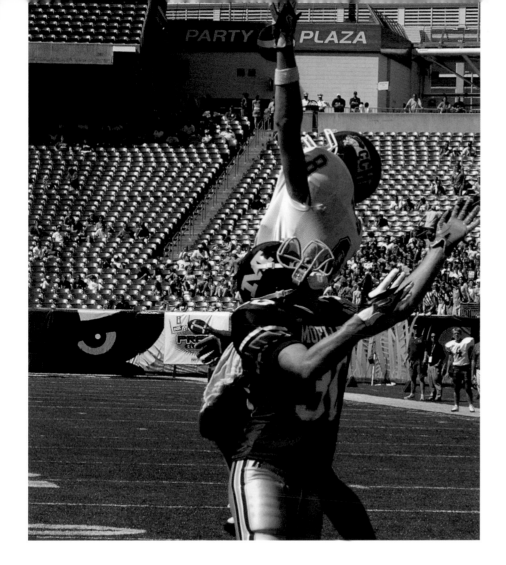

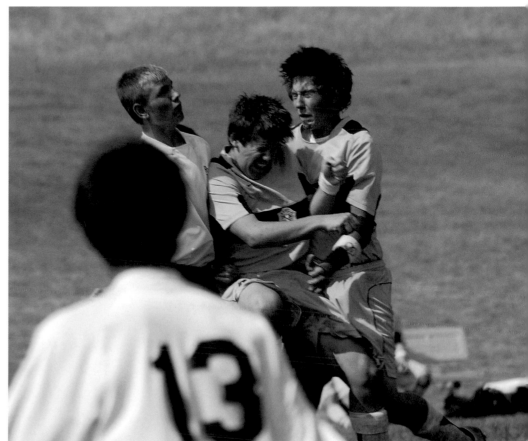

LEFT ■ In Your Dreams: High school football in the Jungle, Covington Catholic vs. Moeller. Does it get better than that? PHOTO BY LINDY BLANKENBUEHLER

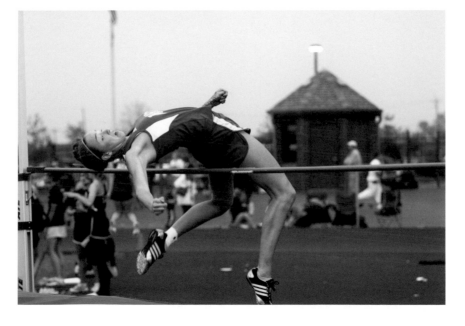

ABOVE ■ Taylor soccer players fight for a header. PHOTO BY BOB SCHLAKE

LEFT ■ No problem at this height for this Mason athlete. PHOTO BY JOE DEZENZO

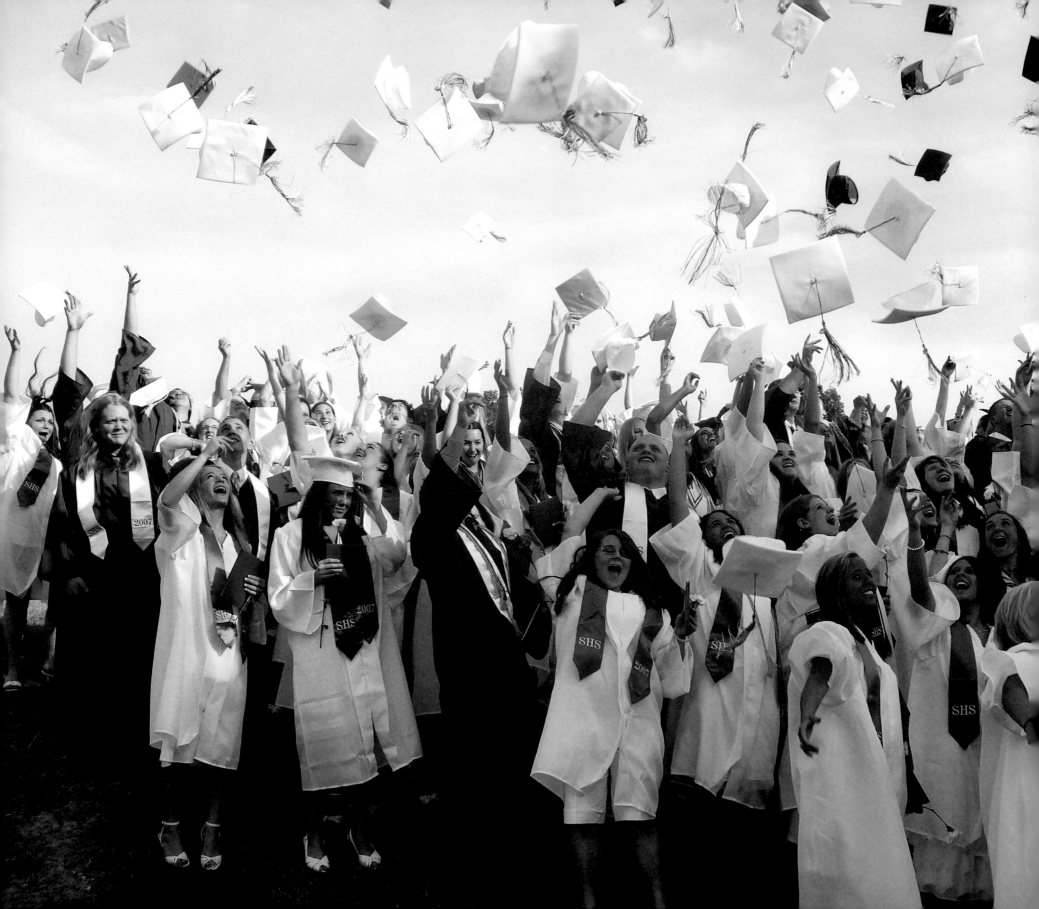

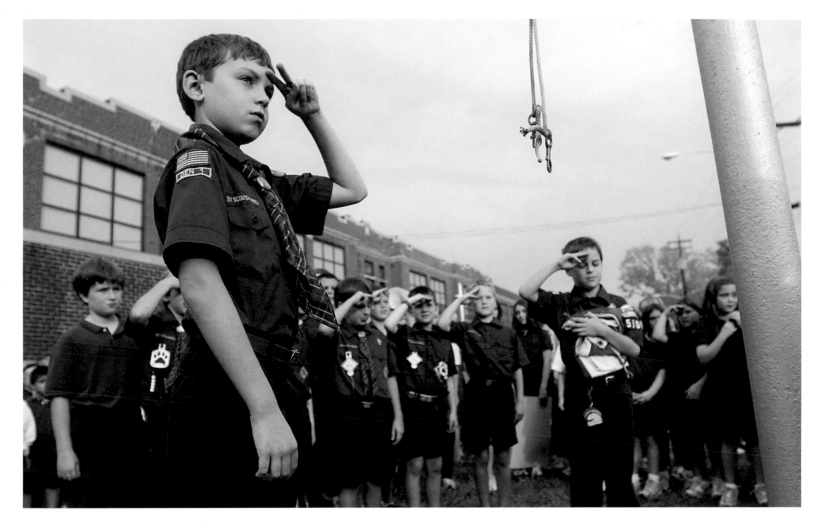

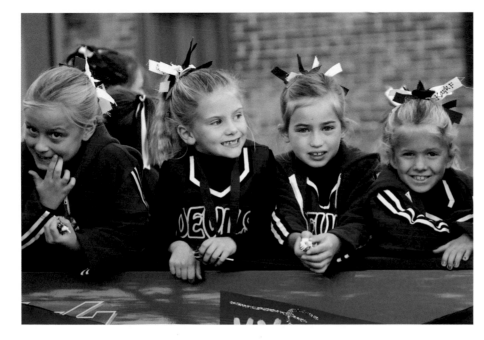

ABOVE ■ Scout's Honor: Tyler Ficker, of Miami Valley Christian School, salutes the flag during the school's "See you at the Pole" event on Sept. 26, 2007. Students watched the flag being raised, had group prayer and sang songs during their outdoor ceremony.

PHOTO BY AMANDA DAVIDSON/THE ENQUIRER

LEFT ■ Little Devils: Little Blue Devils Cierra Toledo, Kayla Schmidtgoessling and Kayla Feld cheer with the high school squad as they travel down Jefferson Avenue during the Reading High School football homecoming parade. PHOTO BY RICK ELLIOTT

FAR LEFT ■ We Did It: Cap toss of the graduating seniors of 2007 from Scott High School in Taylor Mill, Ky. PHOTO BY SHARON THACKSTON

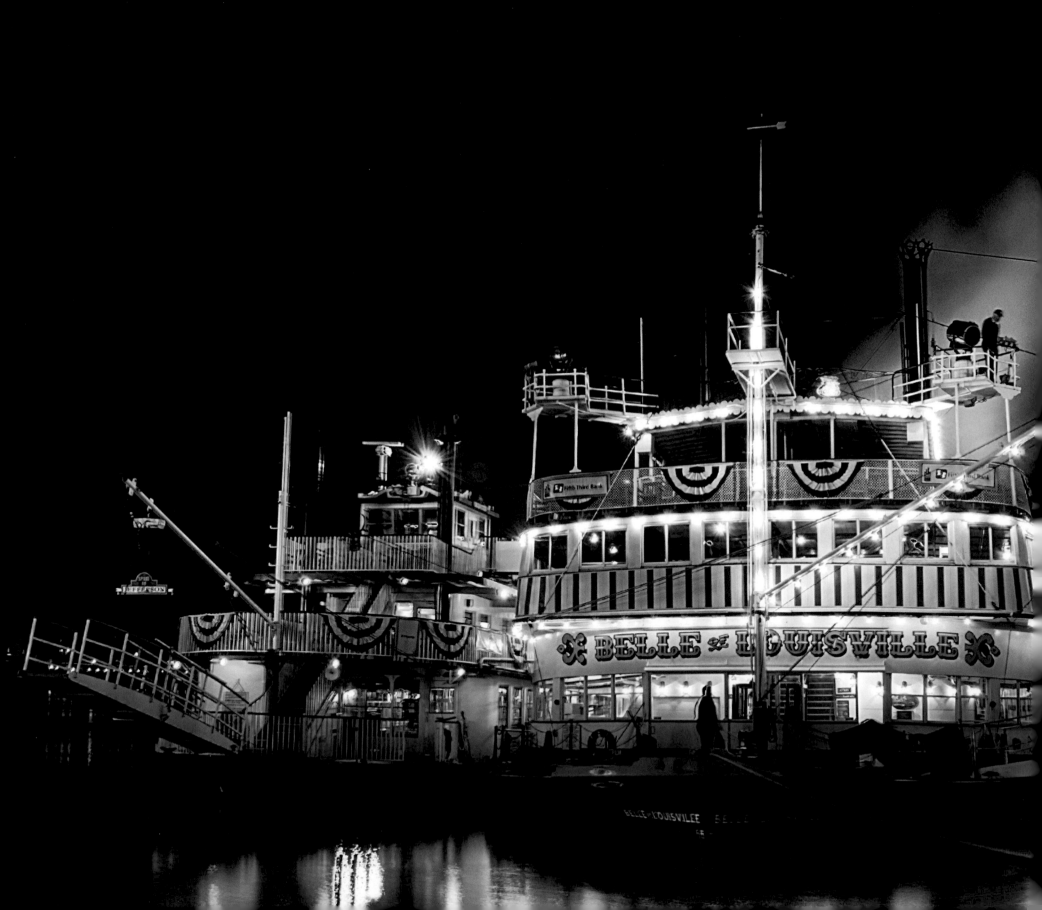

SIMPLY CINCINNATI

The title of this chapter says it all. This is where you'll find some of the more traditional Cincinnati landmarks and events: The many bridges that connect Ohio and Northern Kentucky, the Cincinnati Museum Center, Findlay Market, Tall Stacks and the Tyler Davidson Fountain, to name a few.

But the photos are anything but typical. Local photographers submitted pictures using inviting lighting and creative angles. And, oh, how they used the wonders of Mother Nature – clouds, moonlight and fog – to show off

unique perspectives. Just check out the way Union Terminal and Fountain Square are represented.

A variety of photographers captured the faces, energy and spirit of Oktoberfest, one of many popular annual events in the Greater Cincinnati area. And what would a Simply Cincinnati chapter be without one of the staples of our town – a cheese coney?

One quick tip as you begin to peruse this section: Take a deep breath before turning to the photo on pages 58-59. It's a sight to behold.

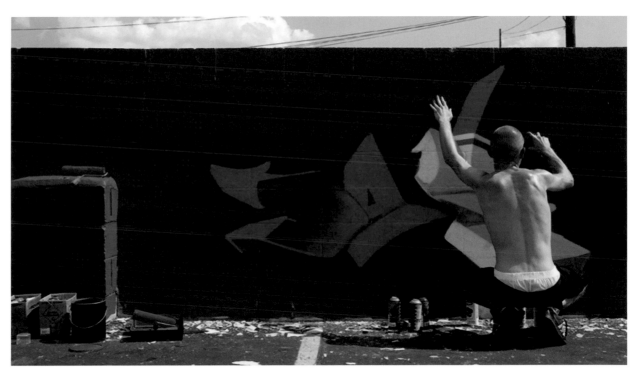

ABOVE ■ Scribble Jam 2007: This is Daystar, from Cincinnati, painting at Scribble Jam, one of the biggest hip-hop festivals in the country. PHOTO BY WES BATTOCLETTE

LEFT The Belle of Louisville: Early morning, freeze-your-butt-off-photo fun at Tall Stacks. PHOTO BY CHRIS THOMPSON

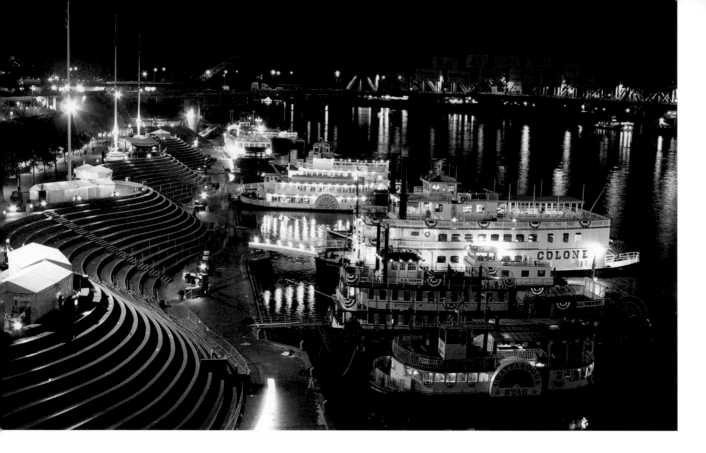

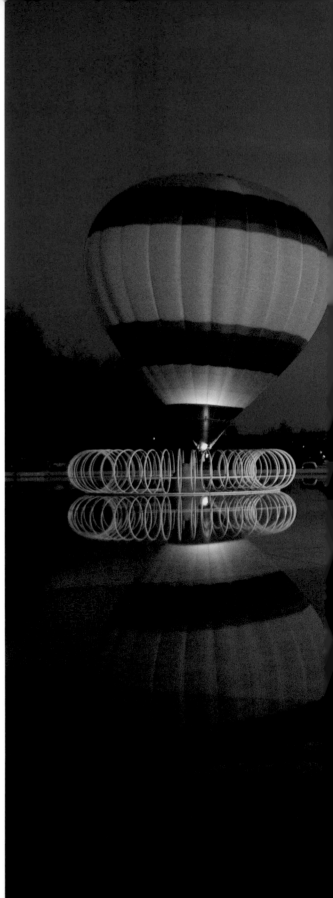

ABOVE ■ Late one evening during Tall Stacks 2003. Taken from the Taylor-Southgate bridge. PHOTO BY BRENT MILES

RIGHT ■ Balluminaria at the Reflecting Pool of Eden Park. Balluminaria usually takes place on the last Saturday in November, and is a fun event for people of all ages. PHOTO BY DAVID WILLIAMS

BELOW ■ Ladies At The River: Ladies at riverside landing during Tall Stacks, 2006. PHOTO BY JOHN MICHELL

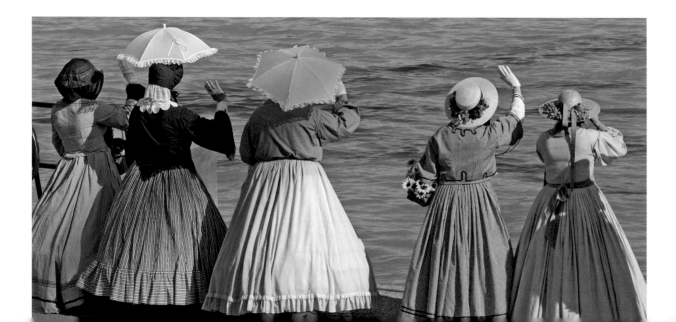

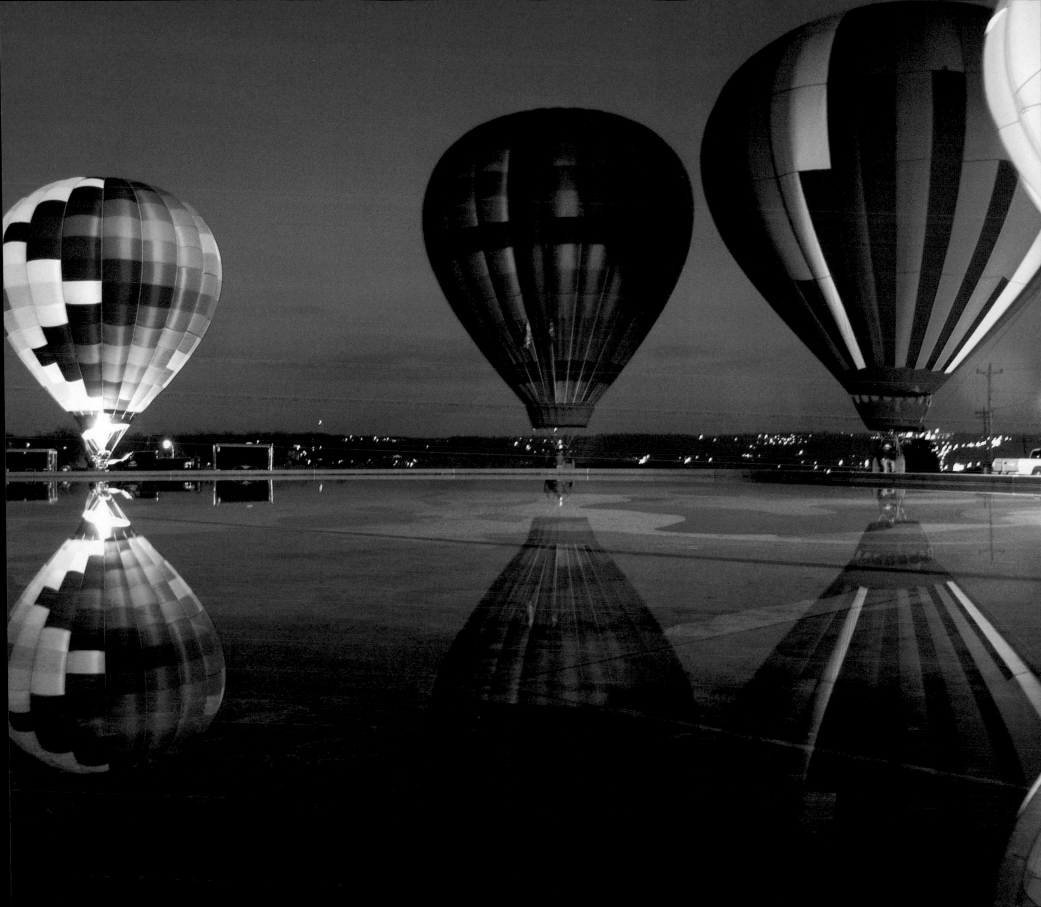

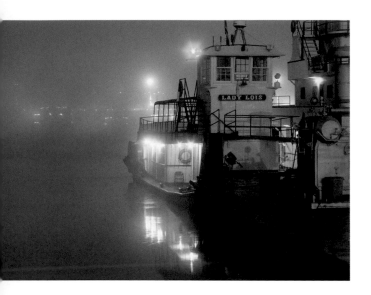

ABOVE ■ Early morning fog during Tall Stacks, 2003. Taken from Newport, Ky. PHOTO BY BRENT MILES

RIGHT ■ Tall Stacks fireworks. PHOTO BY SCOTT DUNGAN

OPPOSITE ■ View from inside the Roebling Bridge. PHOTO BY CHUCK MADDEN

BELOW ■ The Smell is in the Air: One of the many food booths set up for Tall Stacks. PHOTO BY STEVE HORTON

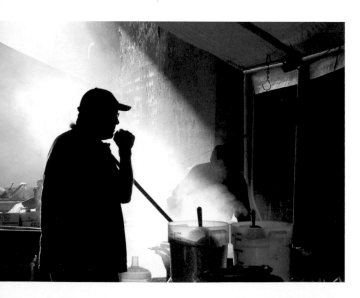

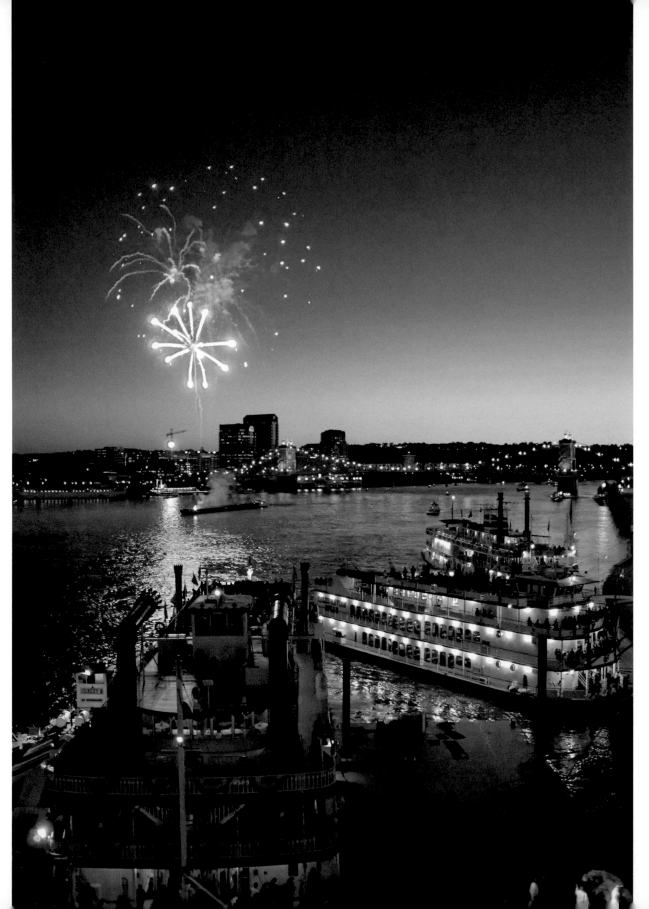

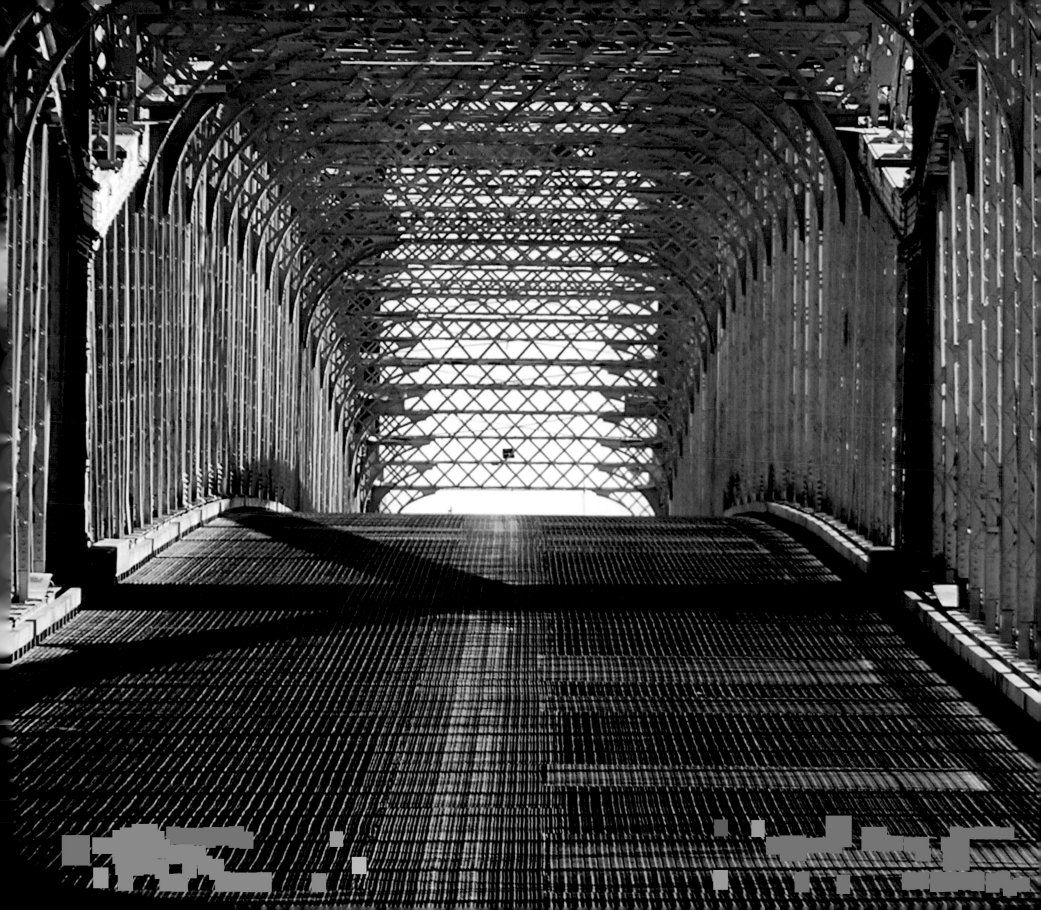

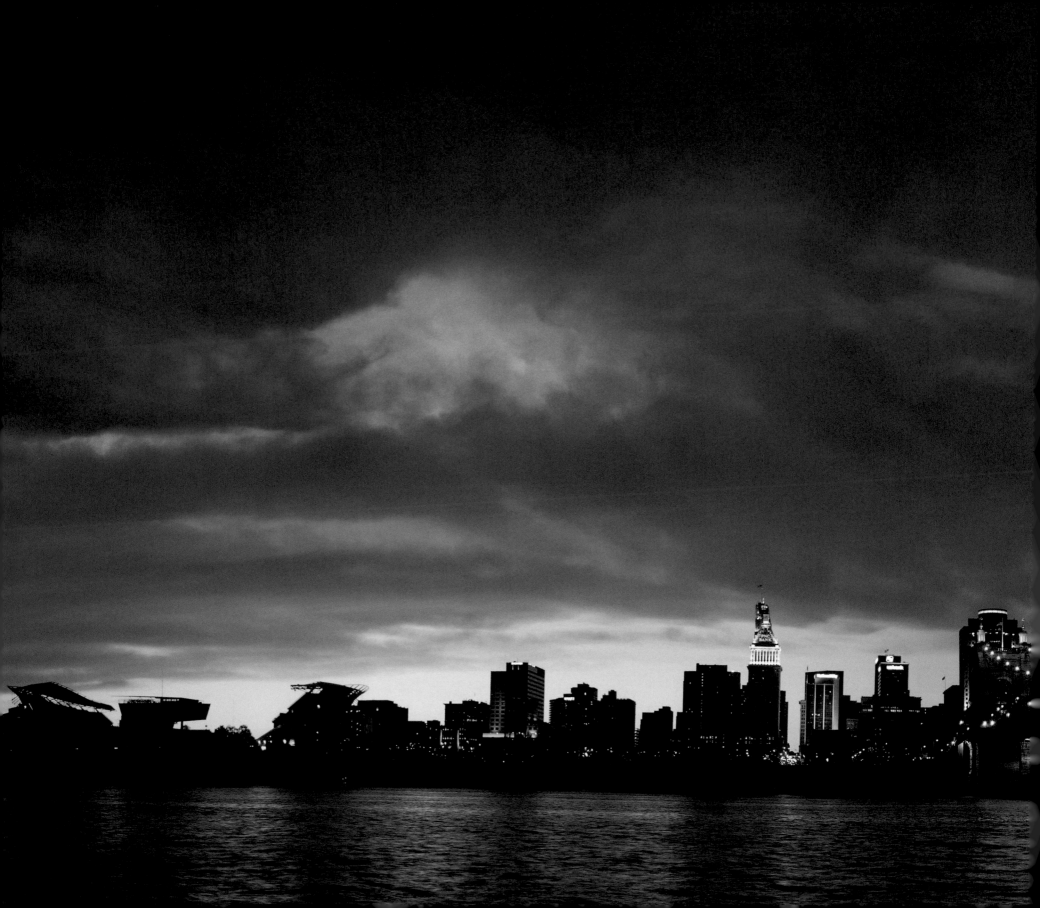

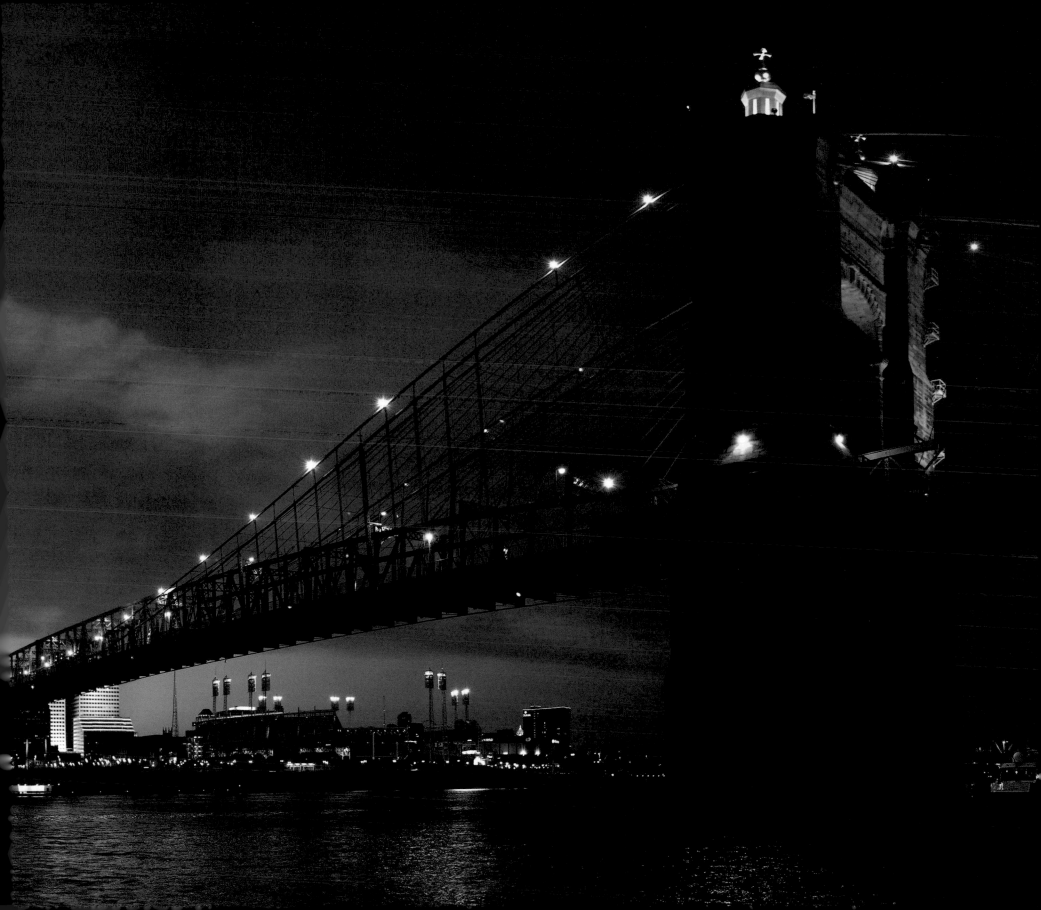

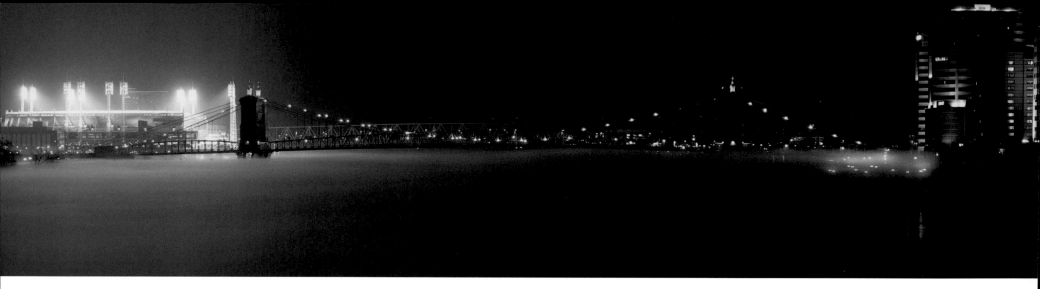

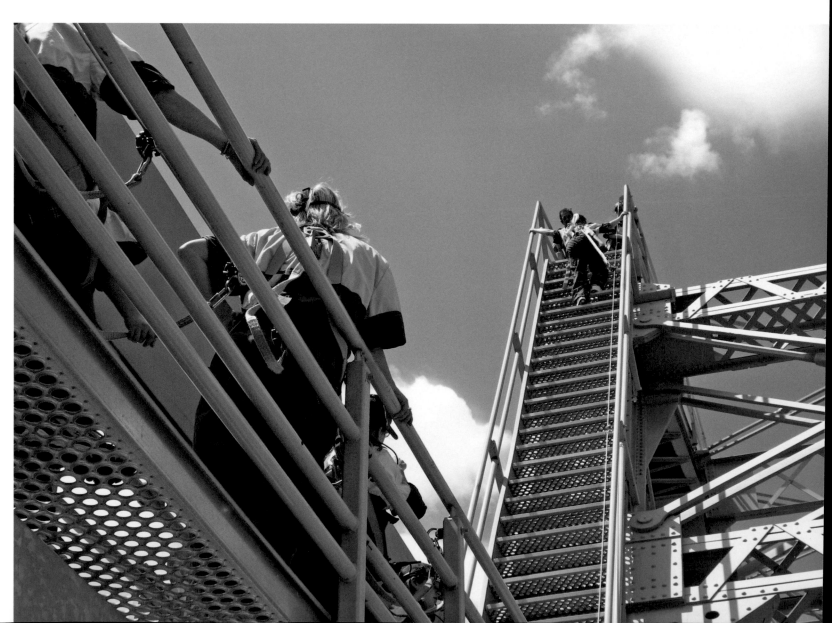

ABOVE ■ Cincinnati Fog: Roebling Bridge surrounded in fog.

Photo by Richard Sunderhaus

RIGHT ■ Rare sight of bridge climbers on Purple People Bridge, linking Cincinnati to Newport, Ky.

Photo by David Bass

PREVIOUS ■ Mr. Roebling's Bridge: The Roebling Suspension Bridge and Cincinnati from Covington, Ky.

Photo by Chris Thompson

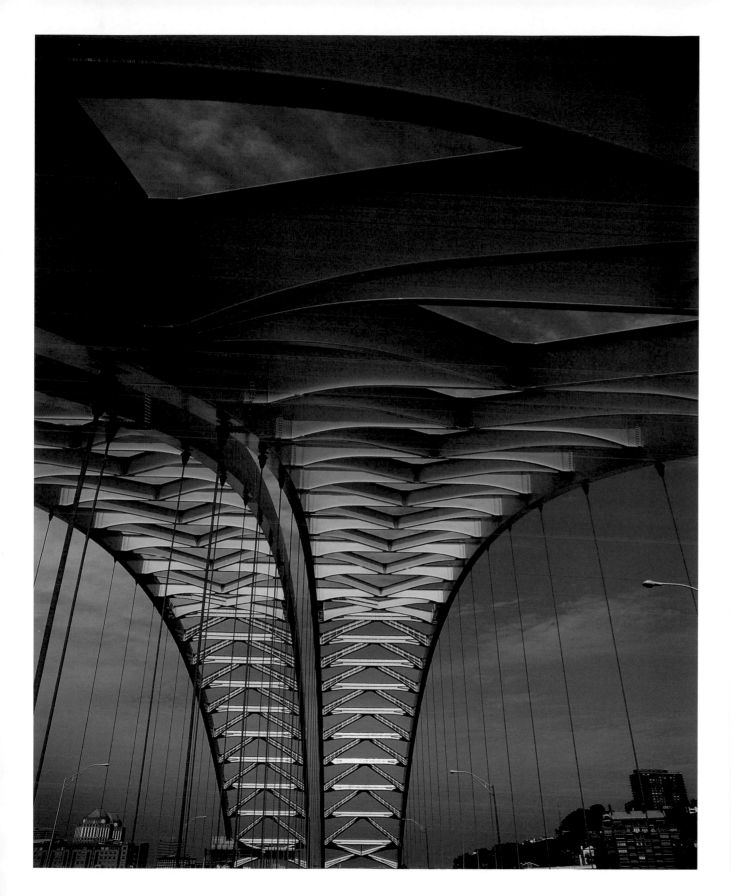

LEFT ■ Heavy Iron: A sunroof, a wide angle lens, and a skewed polarizing filter helped me get this one. PHOTO BY JOHN CREMONS

BELOW ■ Big Mac Tonight: The Daniel Carter Beard (aka the "Big Mac") Bridge at twilight 2007. PHOTO BY BRYAN MULLINS

BOTTOM ■ Beard Bridge in frigid mist.

PHOTO BY BOB BLOOM

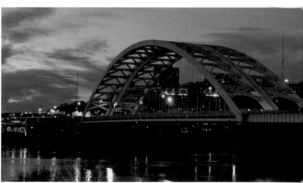

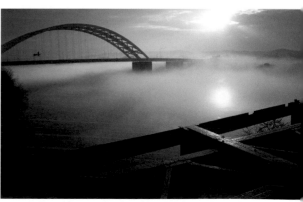

RIGHT ■ Mainline: Main Street, Cincinnati, from a rooftop in Over-the-Rhine, looking toward downtown.

PHOTO BY JULIE HUCKE

BELOW ■ Afternoon Stroll: An elderly couple takes a stroll across the Taylor Southgate Bridge from Kentucky to Ohio. PHOTO BY JIM KRAMER

BOTTOM RIGHT ■ The Historic Findlay Market: Findlay Market, in Cincinnati's historic Over-the-Rhine district, is Ohio's oldest operating public market. It is home to many indoor and outdoor vendors specializing in everything from meat and cheese to flowers and produce.

PHOTO BY WILLIAM FULTZ II

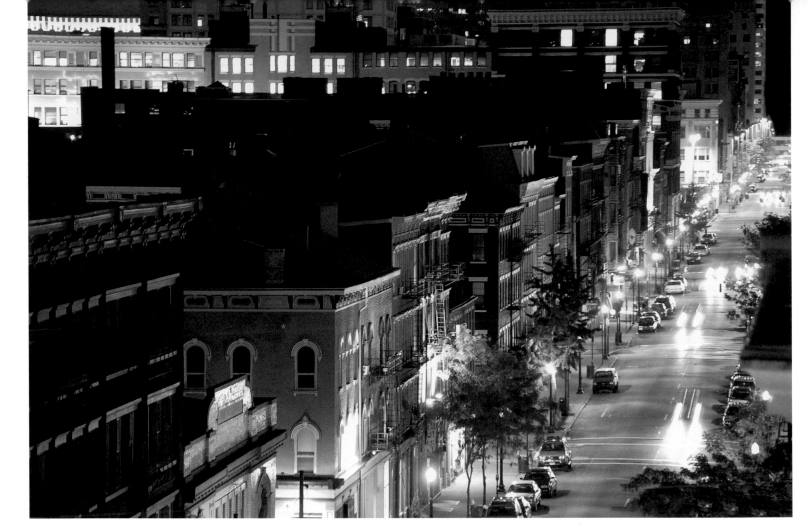

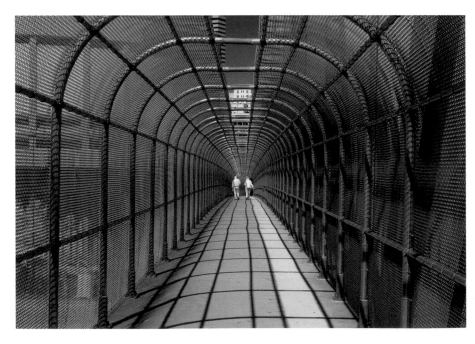

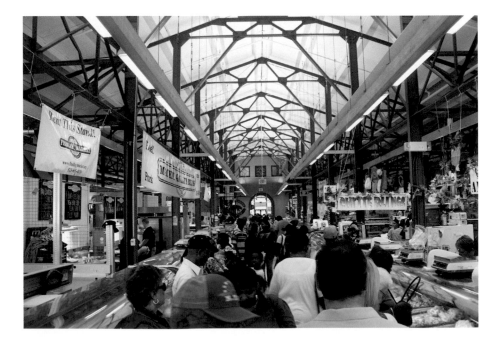

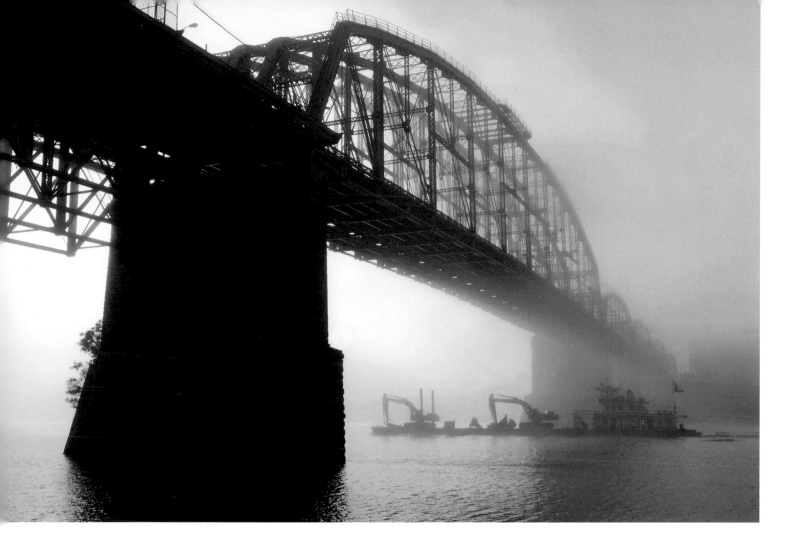

ABOVE ■ Over-the-Rhine glows in fog. Photo by Kevin Monroe

LEFT ■ Time For Work: A barge transporting construction equipment heads up the Ohio River in the early morning fog.
Photo by David Michell

BOTTOM LEFT ■ Over-the-Rhine Gateway. Photo by Keith Neu

BELOW ■ Artists work on a sidewalk drawing at Second Sunday on Main Street in Over-the-Rhine.
Photo by Melanie Wissel

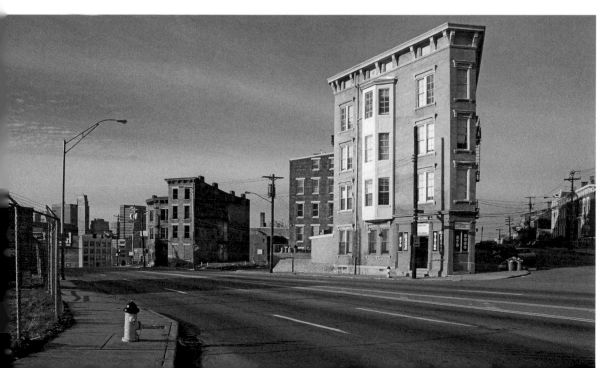

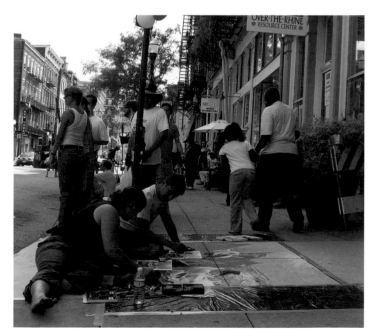

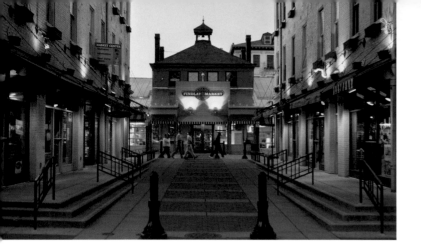

ABOVE ■ Findlay Market: Just a few people were seen at sunrise at Findlay Market in Over-the-Rhine before the start of the annual Findlay Market Parade April 2, 2007.

PHOTO BY GARY LANDERS/THE ENQUIRER

RIGHT ■ Genius of Water: The Tyler Davidson fountain "Genius of Water" at the rejuvenated Fountain Square.

PHOTO BY DAVID MICHELL

BELOW ■ Jazzing It Up at the Market: One of the newer features of Findlay Market, at least as far as I'm concerned, is the wonderful street entertainment that has been added since the 1950s when I was a young girl. In this photo, these jazz musicians in their vivid red shirts capture for me the vibrant, upbeat spirit of the market and its enduring place in the neighborhood where I grew up. PHOTO BY PAT CORNETT

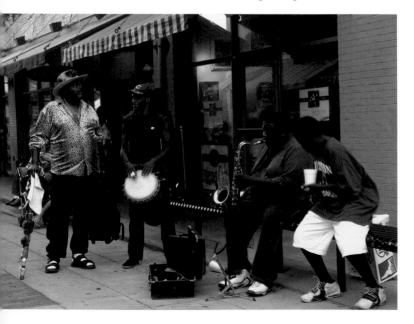

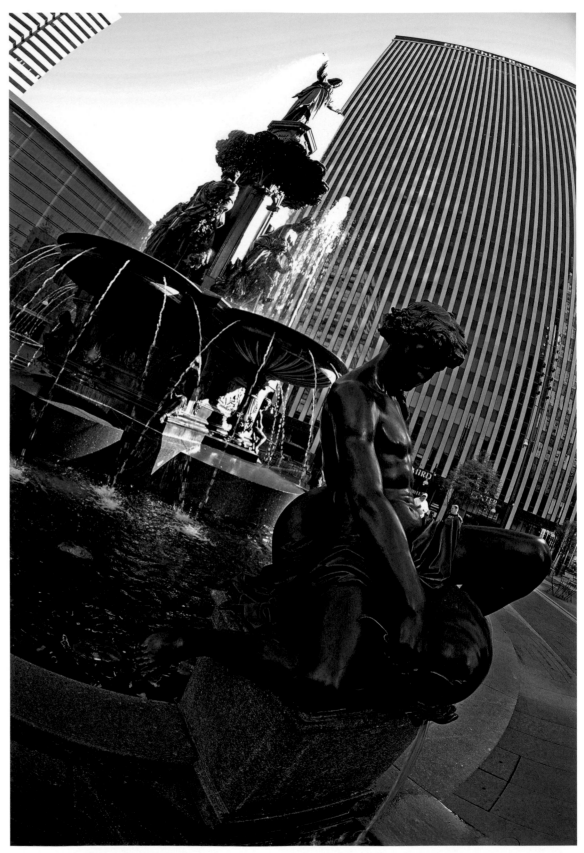

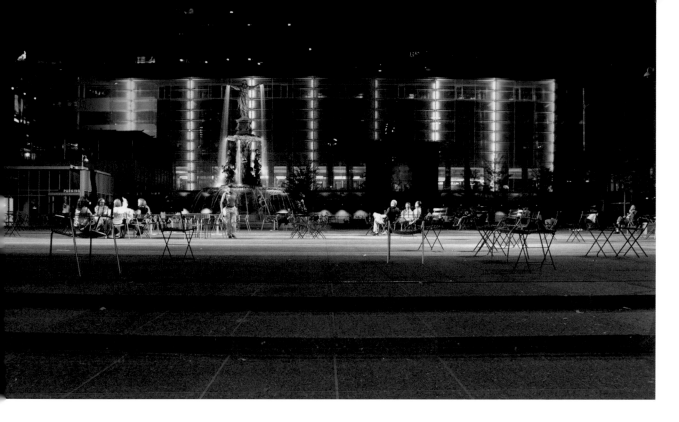

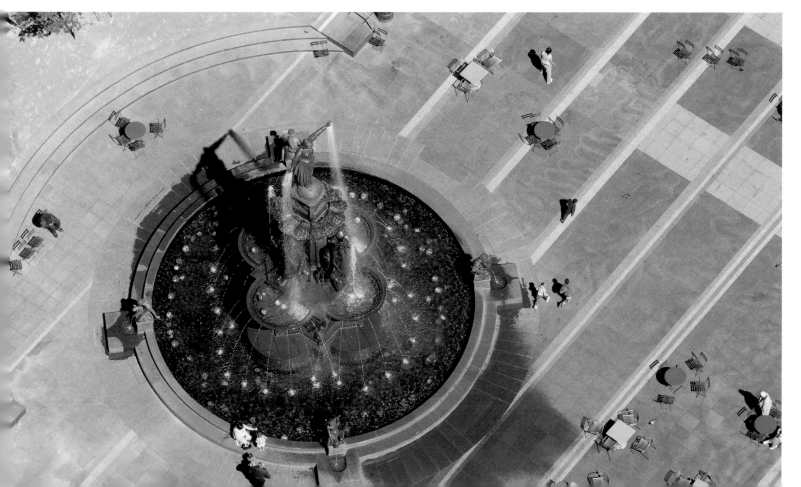

ABOVE ■ Carew Tower: I liked the tree at the top of the image. What a great city this is!
PHOTO BY JEAN WILLIAMS

TOP LEFT ■ Fountain Square Lights: New lights provide a dramatic new backdrop to Fountain Square.
PHOTO BY BLAKE FOX

LEFT ■ The new Fountain Square aerial view from Carew Tower. PHOTO BY JOHN MICHELL

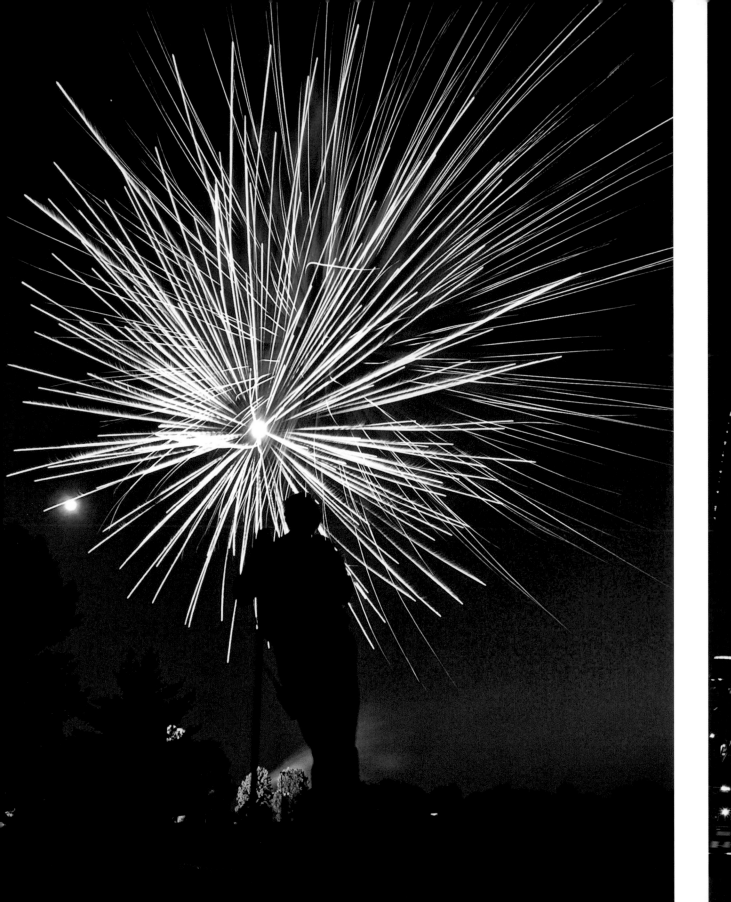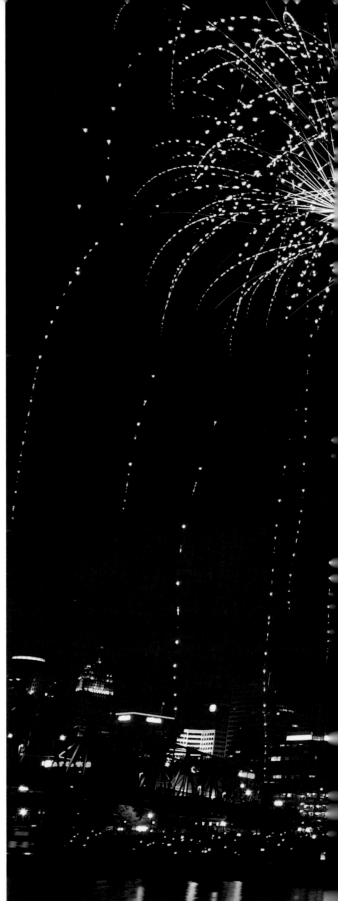

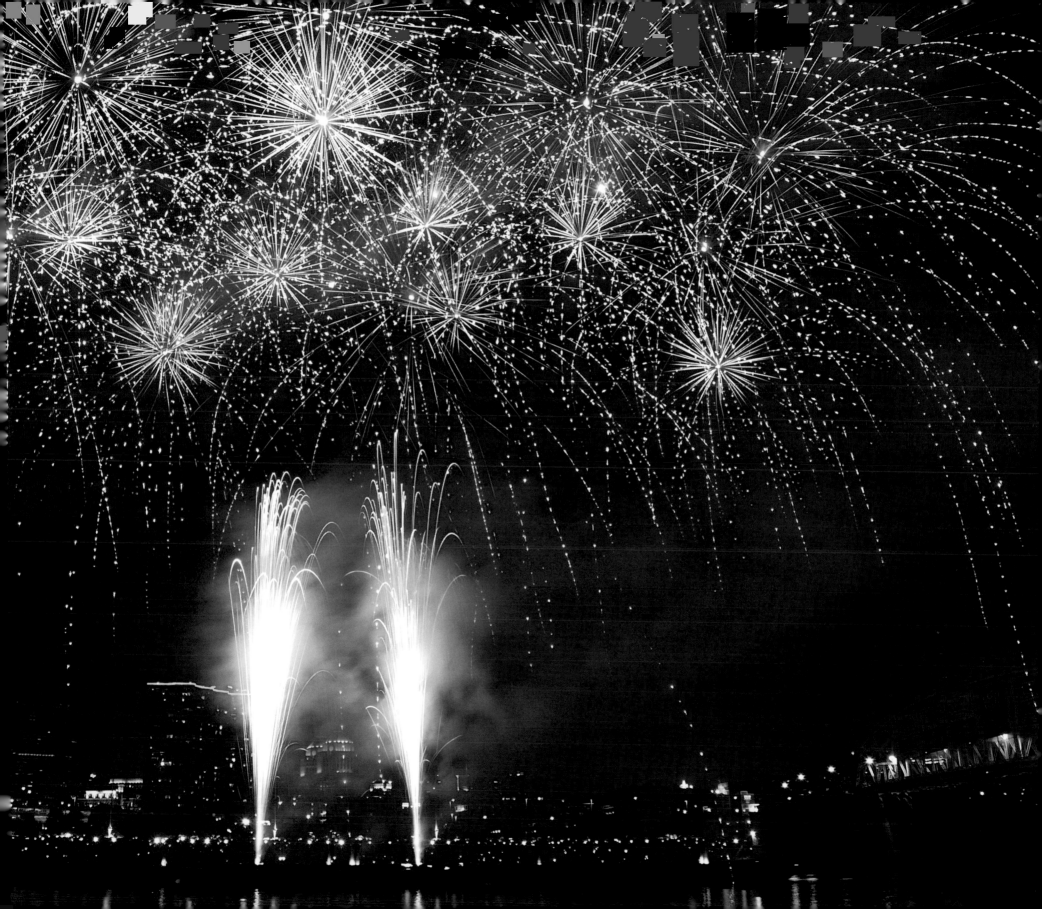

PREVIOUS LEFT ■ Fireworks: Fairfield fire explorer Kyle Lackman is silhouetted as fireworks from Rozzi's Famous Fireworks brighten the night sky over Harbin Park in Fairfield shortly after 10 p.m. during the Red, White & Kaboom, Fairfield Independence Day Celebration. He was standing by along with other explorers and firefighters to beat down any grass fires caused by falling embers and sparks.

PHOTO BY GLENN HARTONG/THE ENQUIRER

PREVIOUS RIGHT ■ Fireworks: View of Riverfest fireworks from Newport. PHOTO BY JAMES STAPLETON

OPPOSITE ■ Cincinnati Museum Center: Beautiful history. PHOTO BY RICK BARGE

RIGHT ■ Dexter Mausoleum at Spring Grove Cemetery. PHOTO BY JIM KRAMER

BELOW ■ Follow the Path: The beautiful Procter and Gamble grounds at night. PHOTO BY LINDSAY GIBSON

BOTTOM ■ The Procter and Gamble Twin Towers. PHOTO BY JASON HUSBAND

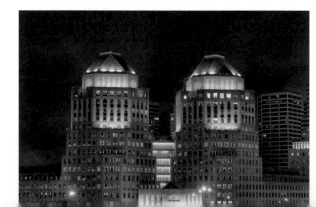

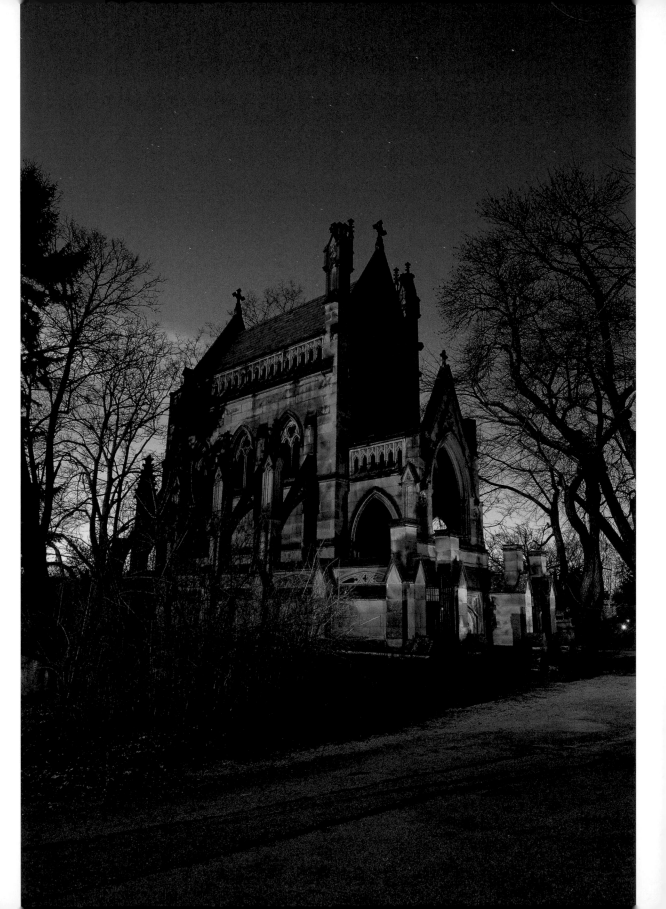

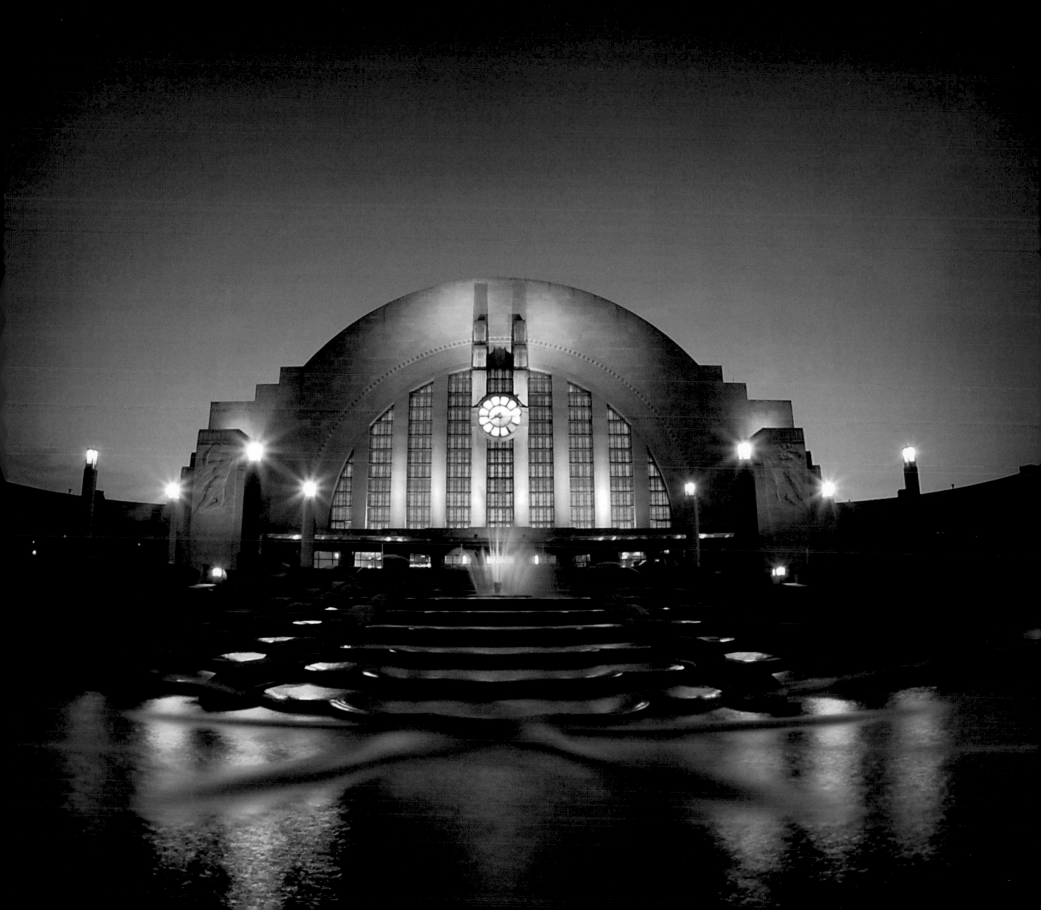

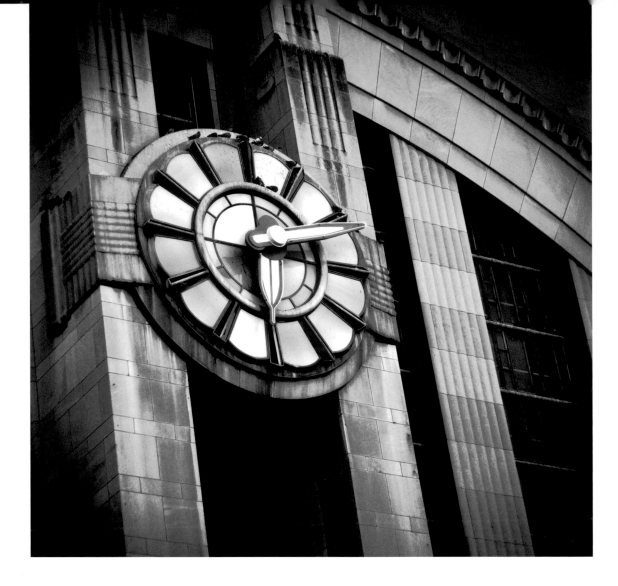
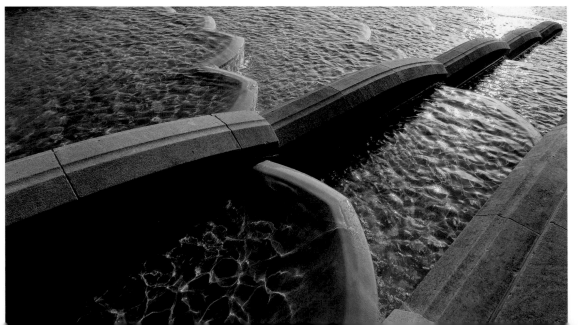

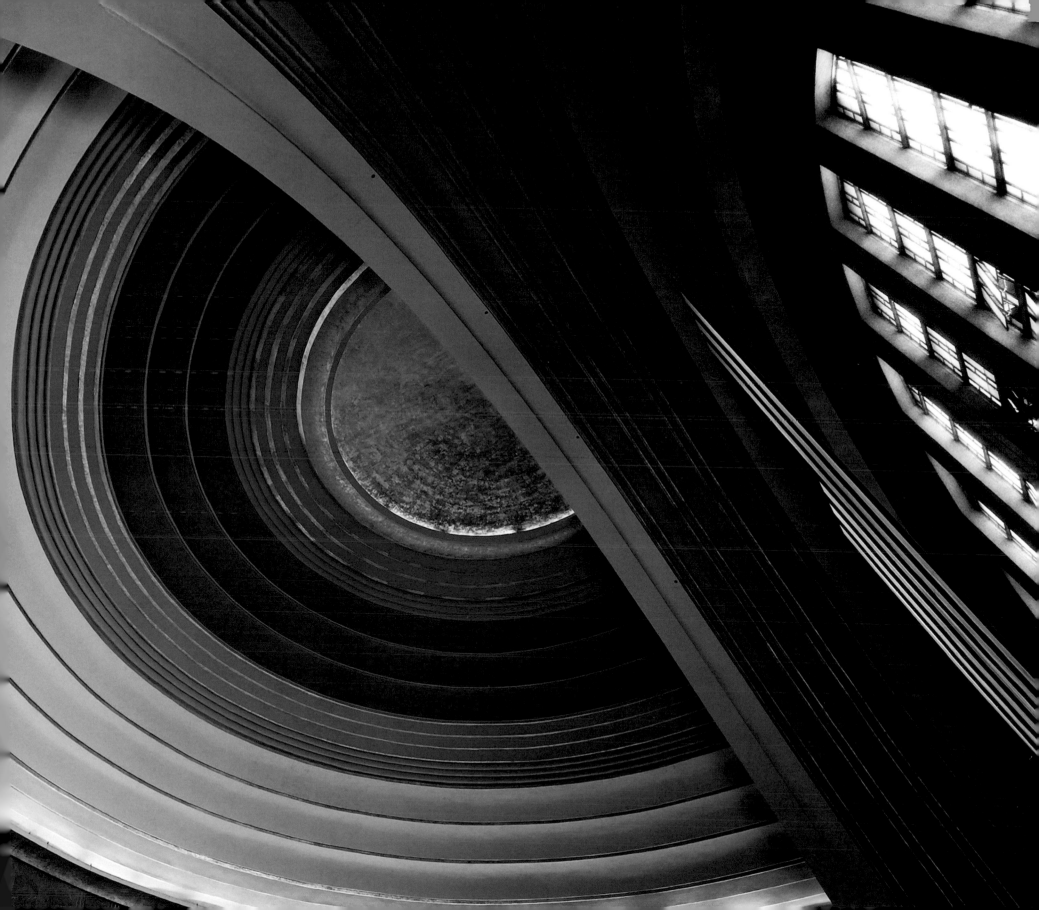

PREVIOUS TOP LEFT ■ Clock at Union Terminal. PHOTO BY MATTHEW ANDERSON

PREVIOUS BOTTOM LEFT ■ On a summer day, the pool in front of the Museum Center has an inviting look. PHOTO BY ROBERT WEBBER

PREVIOUS RIGHT ■ That Ceiling: The ceiling is always an eye catcher when you walk into the rotunda at the Museum Center. There is never just one way to look at it. PHOTO BY ROBERT WEBBER

RIGHT ■ Faces of the City: Like the nation, Cincinnati is a melting pot. People from around the world live here and celebrate Oktoberfest. PHOTO BY YIMING HU

BOTTOM RIGHT ■ Fountain Square overflows with people of all ages coming together to soak in the sights, sounds and tastes of Oktoberfest. PHOTO BY JENNIFER SCHILLER

BELOW ▢ Beer stein race on Fountain Square during the kick-off festivities for Oktoberfest Zinzinnati '07. I loved the expression on her face as she tried hard not to lose any of the precious cargo in those steins as she dashed to the finish line. PHOTO BY DAVID WILLIAMS

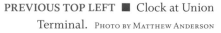

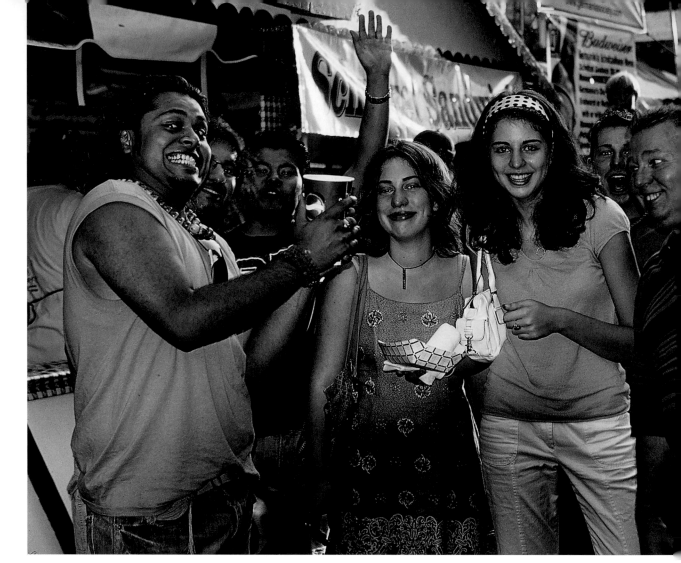

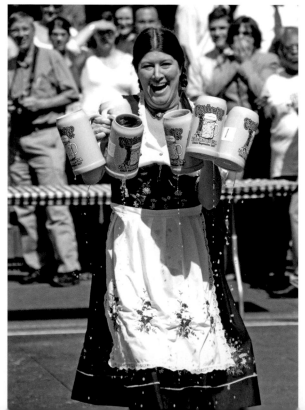

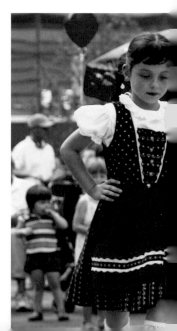

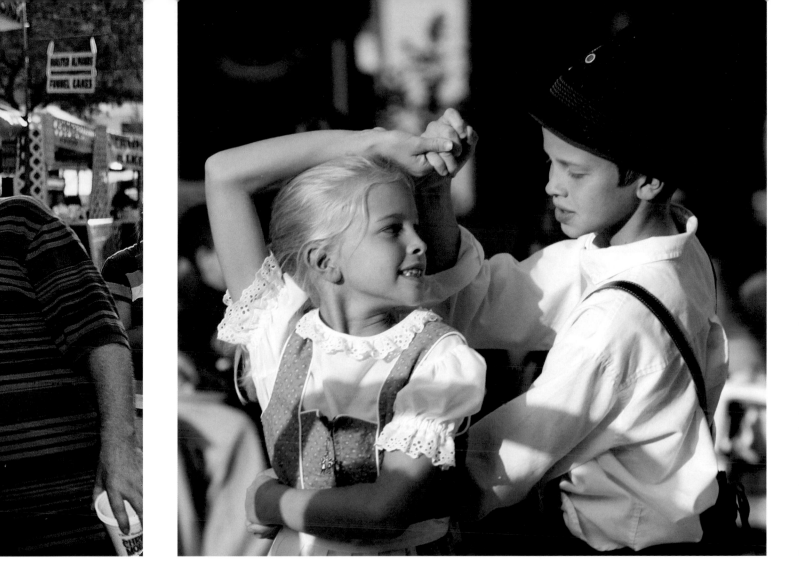

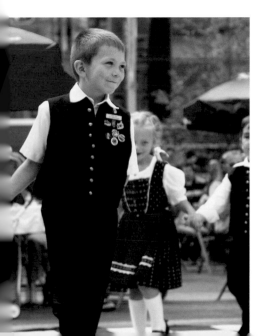

LEFT ■ Enzian Folk Dancers, Rachel and Matthew Ahrnsen (siblings), at Oktoberfest Zinzinnati, 2005. PHOTO BY AMY HARTMAN

BOTTOM LEFT ■ Little Ones, Big Talent: Young Donauschwaben Kleine Kindergruppe Dancers entertain an enthusiastic audience at Oktoberfest, 2007.

PHOTO BY KABIR BAKIE

BOTTOM MIDDLE ■ Chili on a Chilly Day: An icy winter day (check out those icicles!) at the corner of Ludlow and Clifton.

PHOTO BY ELIZABETH METZ

BELOW ■ The Skyliner: I like mine juicy with light onion. PHOTO BY MICHEL KEIDEL

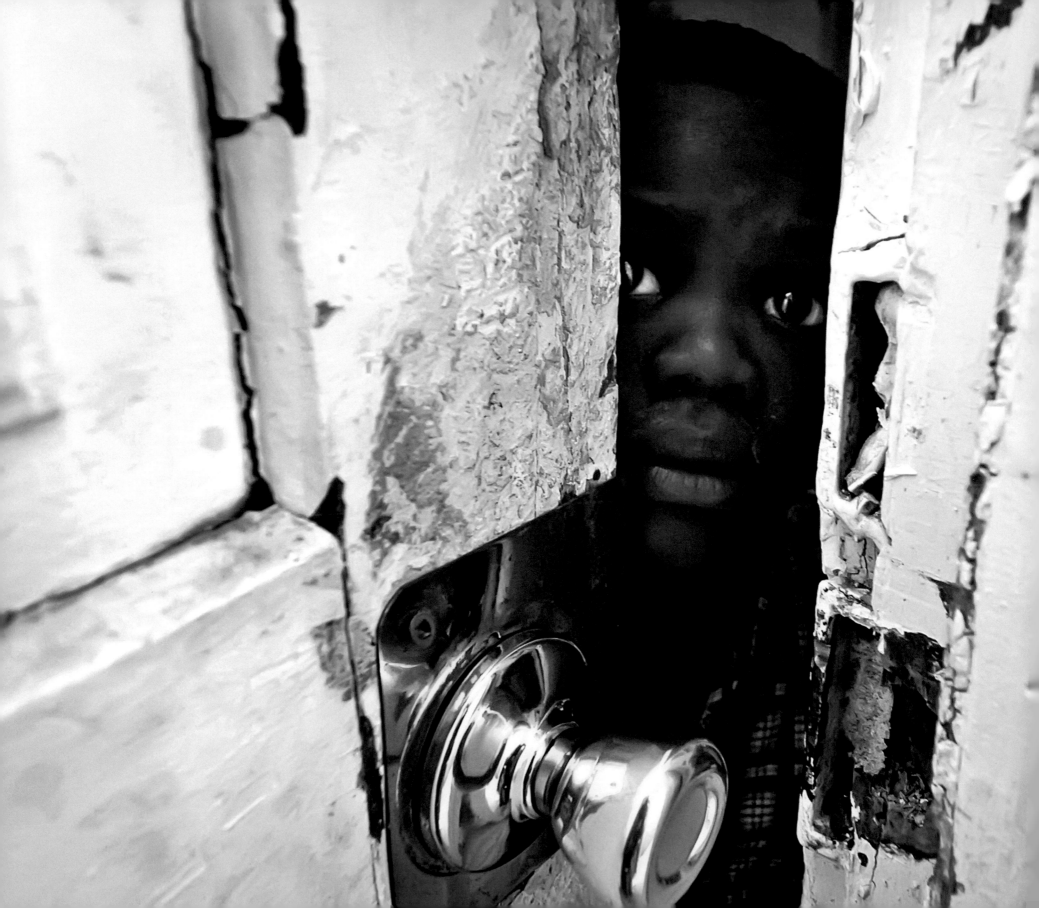

NEWS

News is defined here in many ways. Tragedy, heroism, dramatic weather and offbeat events.

One Enquirer photographer brilliantly captured the boisterous release of Mentos geysers on Fountain Square when Greater Cincinnatians attempted to set a world record in May 2007. A few pages later, you can almost feel the cold when you see steam coming from Cincinnati firefighters at the scene of a house fire in February 2007, captured by another Enquirer photographer.

Some of you showed a knack for documenting severe weather with several spectacular shots of snow and ice scenes. There is a multitude of ways to look at flood-level waters, as three photographers captured in this section.

Gaze into the eyes of the 5-year-old on the opposite page; he is one of several family members to have been exposed to lead in his home. Later you'll see the serious look of a police officer patrolling Vine Street.

That's the reality of news for many – it's all about the people.

ABOVE ■ Getting Old: Oh, how I wish it would rain. On the plus side, I've saved some gas by not having to mow my lawn. Photo by Rick Stegeman

LEFT ■ Lead Poisoning: Five-year-old Marquise Taylor lives with his family on Dreman Avenue in South Cumminsville. He, his brother, and two sisters all have elevated levels of lead in their bodies. Here, he peers through the front door, which tested positive for lead paint. Photo by Glenn Hartong/The Enquirer

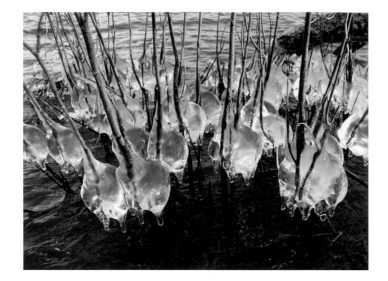

LEFT ■ Ice Globes: The water level on the Ohio River went down a bit that week, leaving frozen globes of ice on the base of this riverside bush. PHOTO BY STEVE GROH

MIDDLE LEFT ■ Kenwood On Ice: I-71 Kenwood Cut In The Hill after an ice storm. PHOTO BY SCOTT STANLEY

BOTTOM LEFT ■ Snow and Ice: Ornamental grass covered with ice in the snow. PHOTO BY STEVE HORTON

RIGHT ■ Ice Formation: The ice storm of 2007 coats local vegetation with a layer of ice. PHOTO BY COURT FURBER

BELOW ■ Blue Ice: After the ice storm had cleared in February of 2007. PHOTO BY MARK FERGUSON

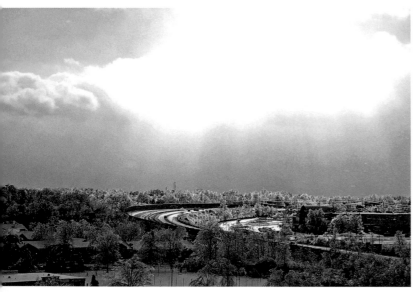

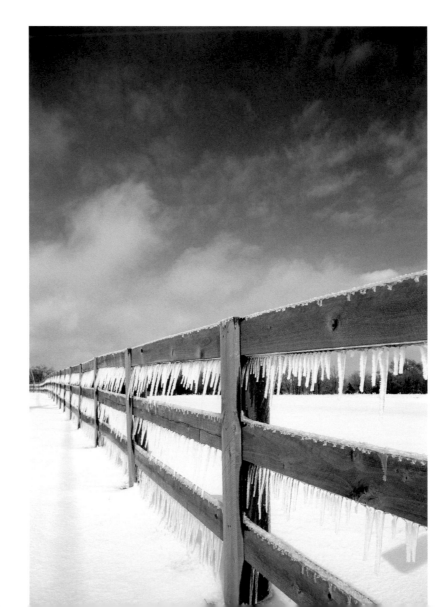

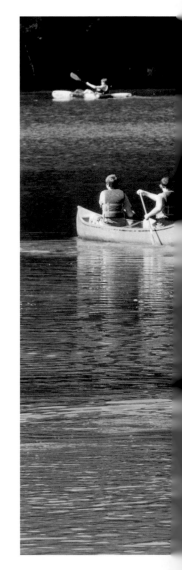

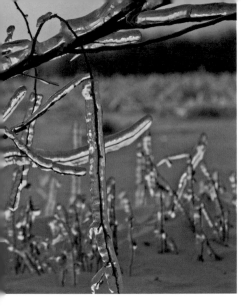

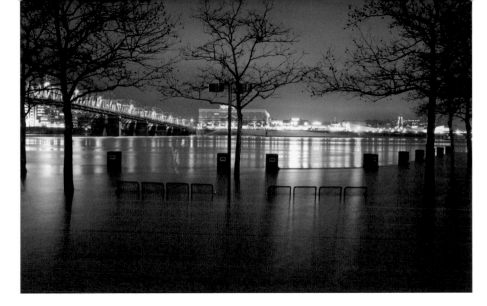

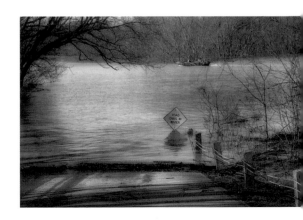

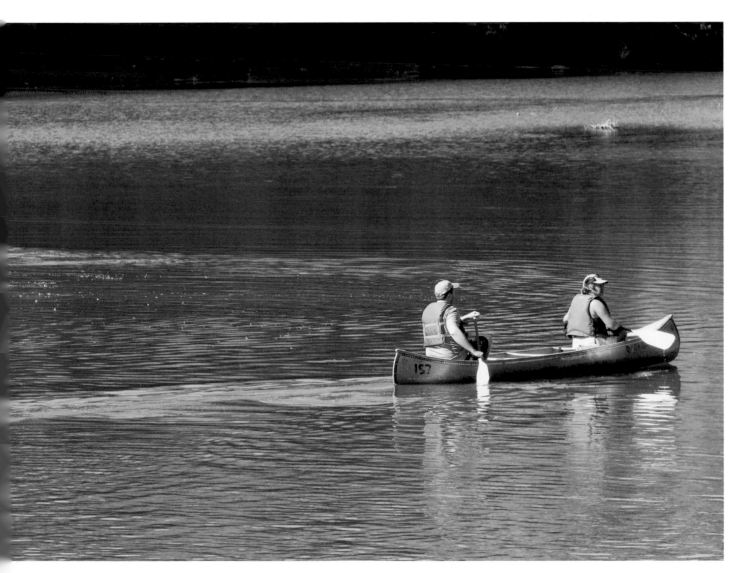

ABOVE ■ Too Little, Too Late: The boat ramp at Shawnee-Lookout park.

PHOTO BY BOB SCHLAKE

TOP LEFT ■ The Flood: In January of 2005, about midnight, I took this shot of the river from Serpentine Wall. The reflections made a pretty shot.

PHOTO BY MICHAEL SMITH

LEFT ■ River Cleanup: Volunteers head out in canoes to clean up the Little Miami River. Thanks to the efforts of volunteers like these, they will find less than 100 tires this day, whereas when efforts first began 40 years ago, there were some 400 tires, some with a car attatched. They worked on 11 miles of the river on this Saturday and planned to send high schoolers out to cover another 10 miles the next day.

PHOTO BY MALINDA HARTONG/THE ENQUIRER

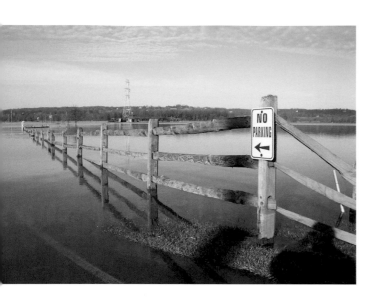

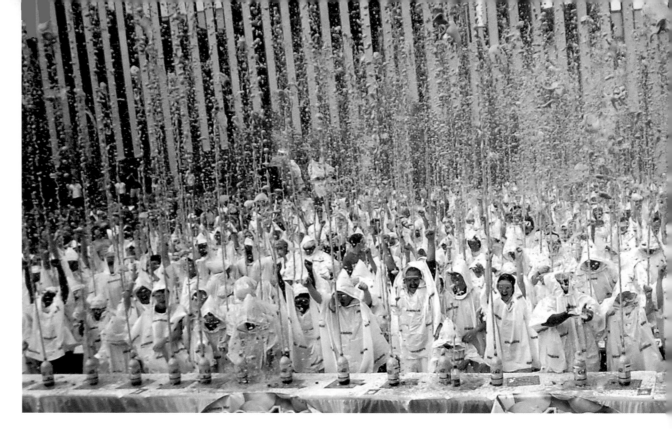

ABOVE ■ No Parking Batavia Road North of Beechmont Levee: Sign probably not needed during the January 2005 flooding of the Little Miami, being fed by the backflow from the Ohio River. PHOTO BY KIRK ROHLING

TOP RIGHT ■ Mentos Geyser: People cheer as they set off their Mentos geysers on Fountain Square as part of the largest Mentos geyser ever, May 25, 2007. Mentos sponsored the event in which 500 people all set off their Mentos geysers at the same time to set a world record. PHOTO BY LEIGH TAYLOR/THE ENQUIRER

BOTTOM RIGHT ■ Bike & Flags: Local Fort Thomas children show their support for U.S. troops with small flags attached to their handlebars. PHOTO BY JENNIFER SCHILLER

OPPOSITE LEFT ■ On the Job: Even with a camera in his face, a nameless officer is undetered patrolling Vine Street. PHOTO BY DANA SMITH

OPPOSITE TOP ■ Firefighter Memorial: Firefighters hang an American Flag at a memorial service. PHOTO BY KEITH CARL

OPPOSITE BOTTOM ■ Firemen Supporting the Bengals: Thank you to all of our city's firemen and firewomen. PHOTO BY LINDSAY GIBSON

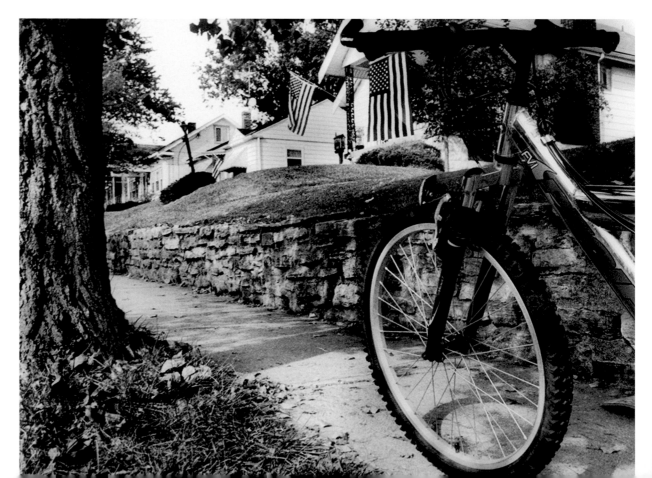

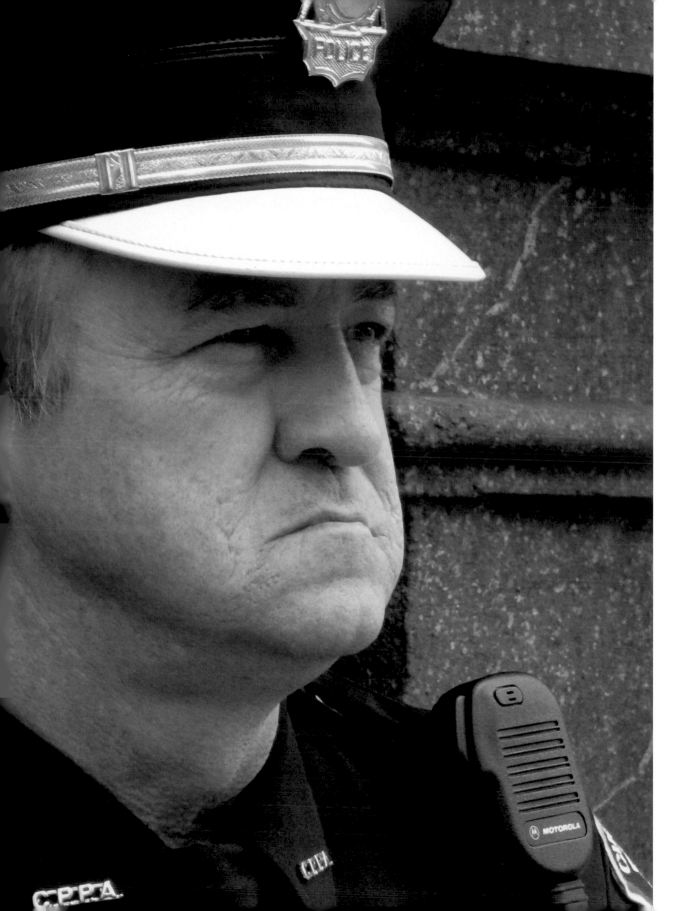

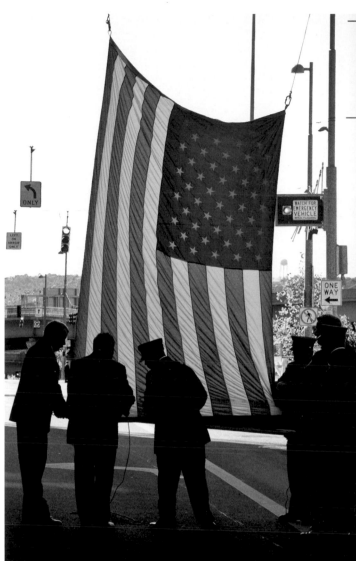

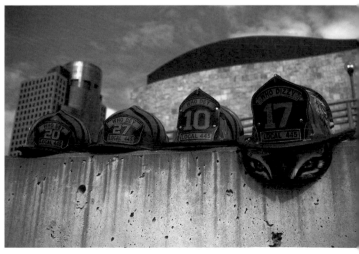

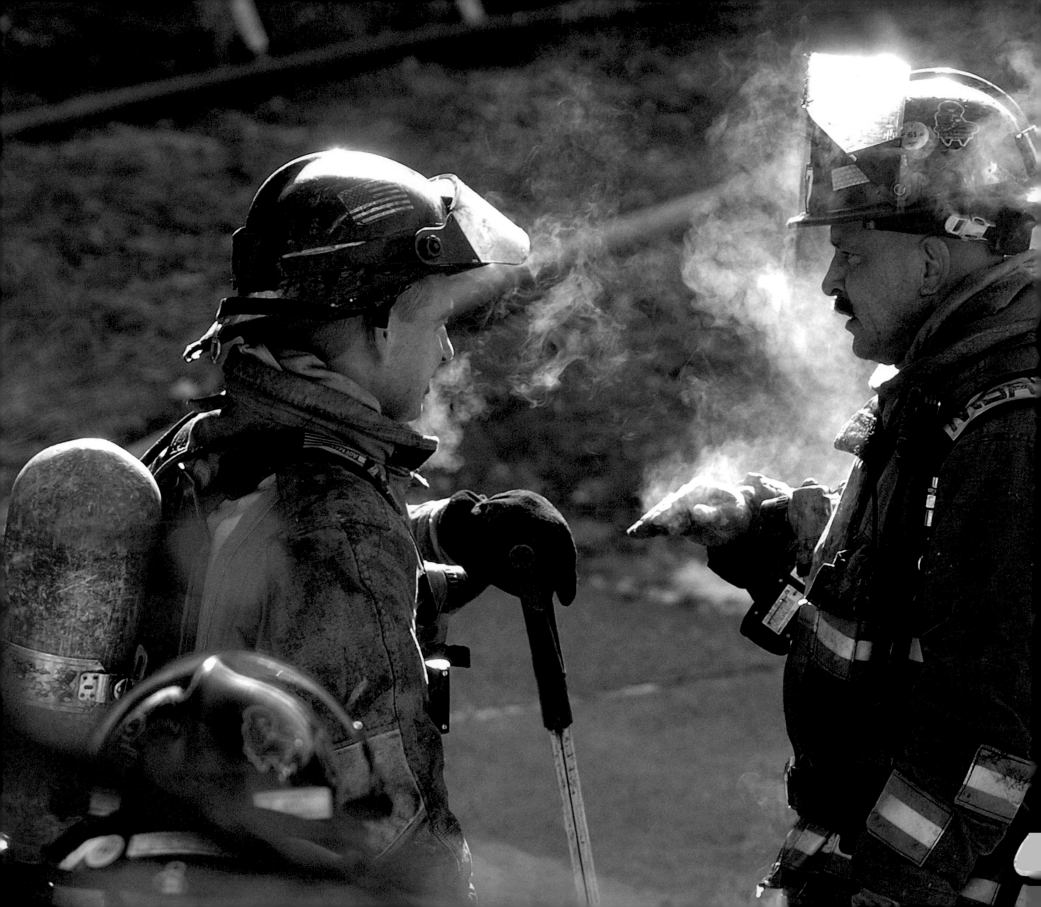

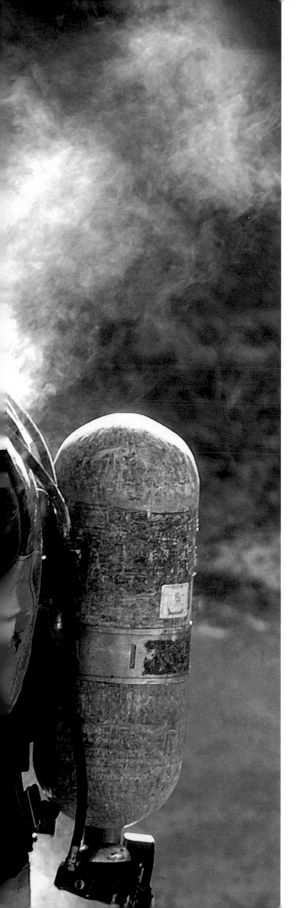

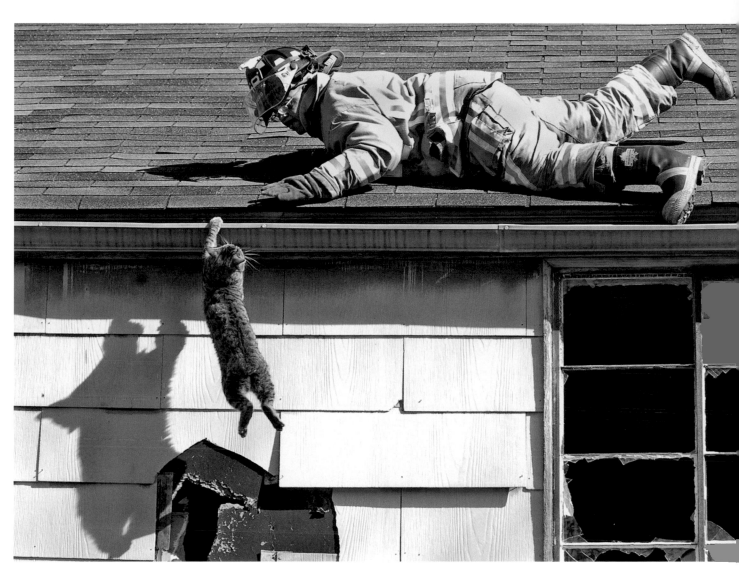

ABOVE ■ Cat Rescue: Lincoln Heights firefighter Marvin Spears slowly reaches toward a cat as it hangs off of the gutter of a two-story apartment building at the Valley Homes Apartment on North Leggett Court in Lincoln Heights. Residents called the fire department to rescue the cat that had been up on the roof for several days. The cat chose to drop from the gutter rather than be rescued, landed on its feet and ran off. Photo by Glenn Hartong/The Enquirer

LEFT ■ Cold Firefighters: Steam billows from Cincinnati firefighters at a house fire in the 1200 block of Quebec in East Price Hill, February 2007. A Metro bus was brought to the scene to allow the firefighters to warm up. Photo by Cara Owsley/The Enquirer

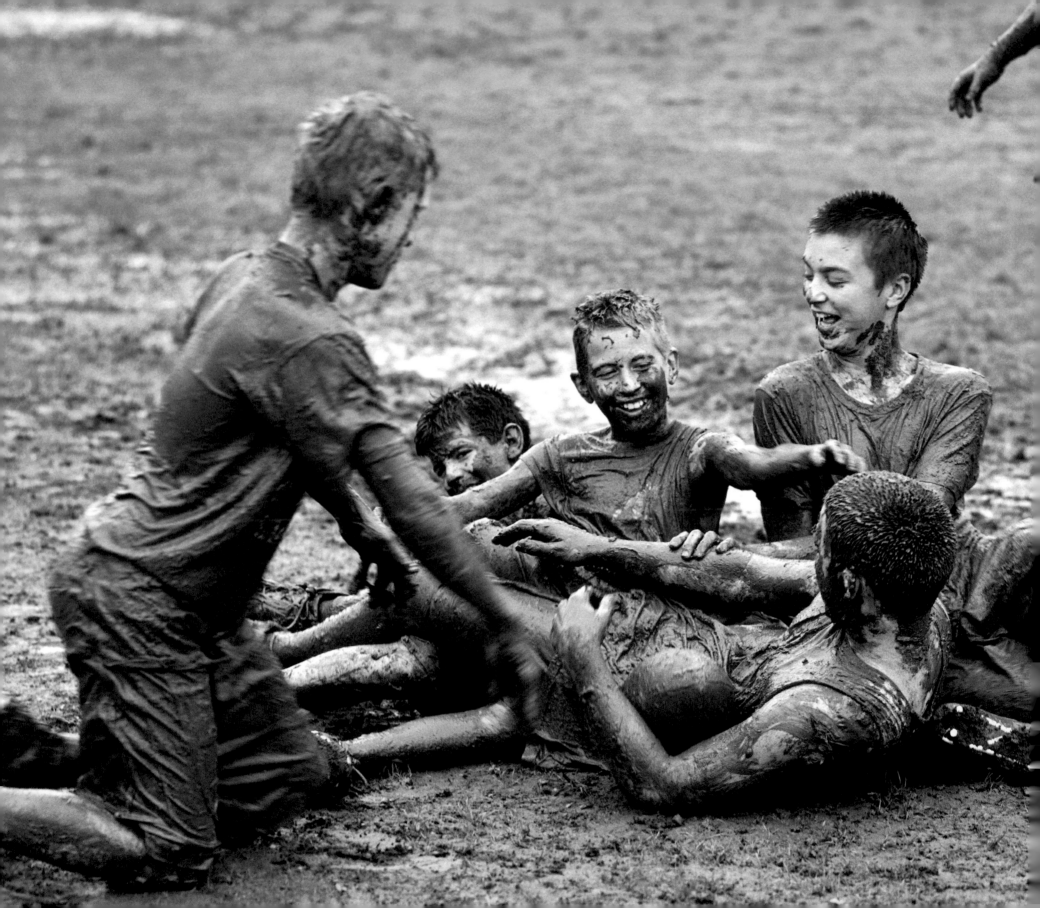

SPORTS & RECREATION

The broad interpretation of this category proved one thing: The sports and recreation scene in this region is about way more than the Reds and Bengals, our local college teams and high school athletics.

There were photos submitted from horse shows and air shows, lumberjack competitions and weiner dog races. There were photos of rugby, rock climbing, cycling, fishing, sledding, canoeing, running, softball, and even demolition derbies.

Youth sports are big in this area; we know that. There were photos from soccer, baseball and T-ball. You submitted pictures of local hot air balloon events, Kings Island rides and high school sports, not to mention Great American Ball Park, Paul Brown Stadium and Bengals training camp in Georgetown, Ky.

Photos captured everyone from the pros to kids to everyday athletes; from band members to cheerleaders and mascots. We tried to capture some of the fun in a variety of ways. We even managed to get Dick Vitale in the book. Now *that's* awesome, baby!

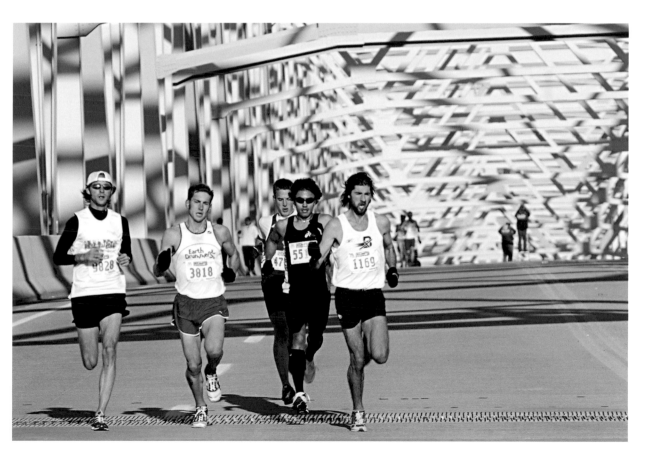

ABOVE ■ The Leaders of the Pack: Leaders crossing the bridge, Thanksgiving Day Race, 2006 PHOTO BY LARRY BRESKO

LEFT ■ Football Fun: Fort Thomas boys play a game of football on a Sunday morning after a night of heavy rain.
PHOTO BY JENNIFER SCHILLER

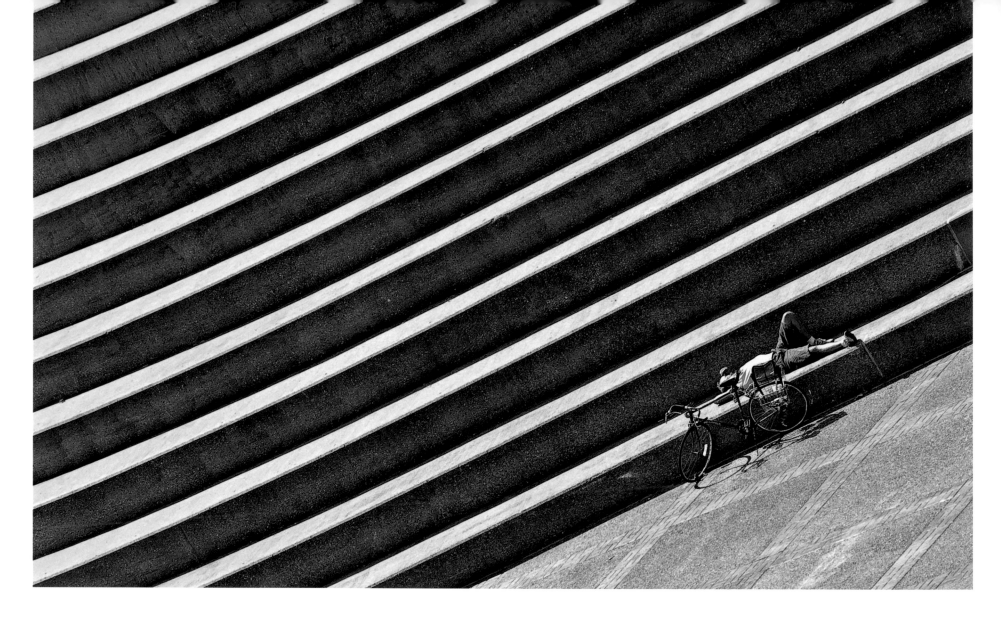

ABOVE ■ Bike riding is fast becoming popular with the many trails available in Cincinnati. This rider rests at Serpentine Wall. Photo by Linda Erhart

RIGHT ■ The Klotz family, of Mt. Auburn, enjoys a quiet afternoon hour on Winton Woods Lake.

Photo by Kevin Moser

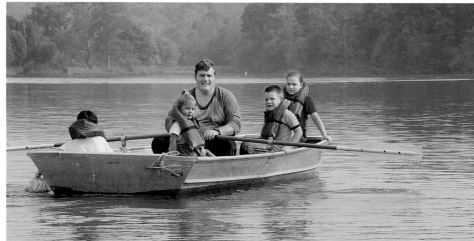

OPPOSITE TOP ■ Cyclists round the bend of Hyde Park Square during the Hyde Park Blast. Photo by Christine Lefever

OPPOSITE LEFT ■ Demolition Derby, Hamilton County Fair. Photo by Bryn Lewis

OPPOSITE MIDDLE ■ Playing Hard: This little guy played one heck of game, St. Vincent Ferrer, Kenwood. Photo by Melissa Speelman

OPPOSITE RIGHT ■ Excitement of tubing on the lake. Photo by Brenda A. Meister

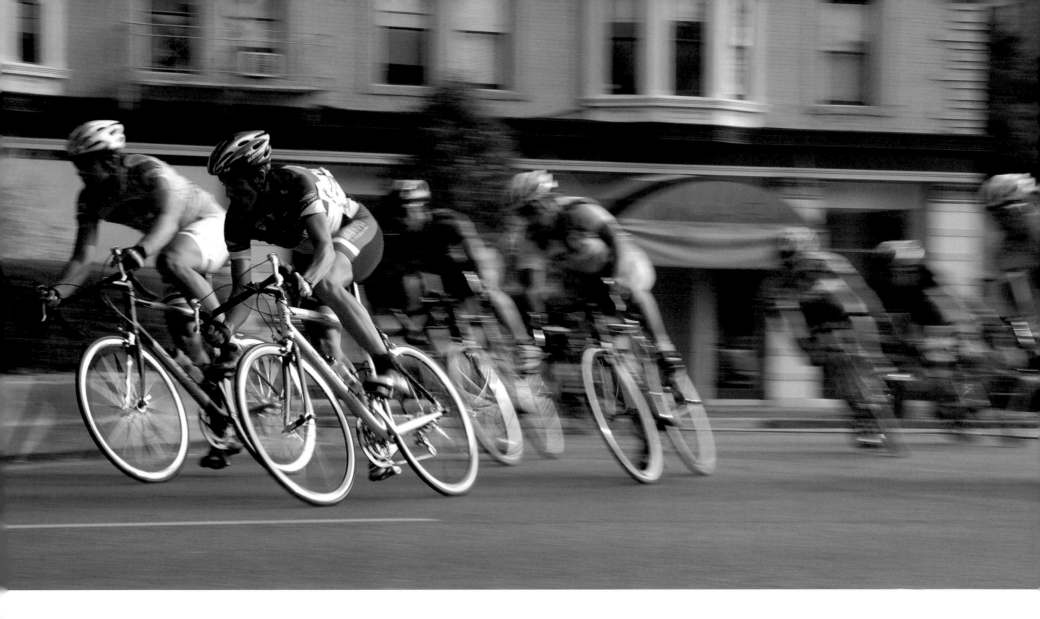

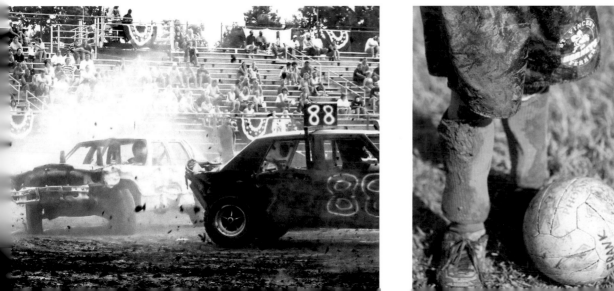

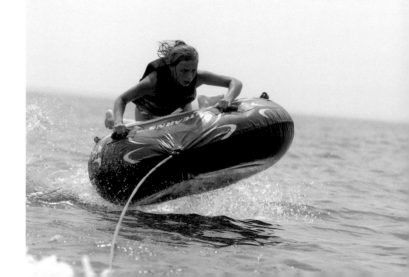

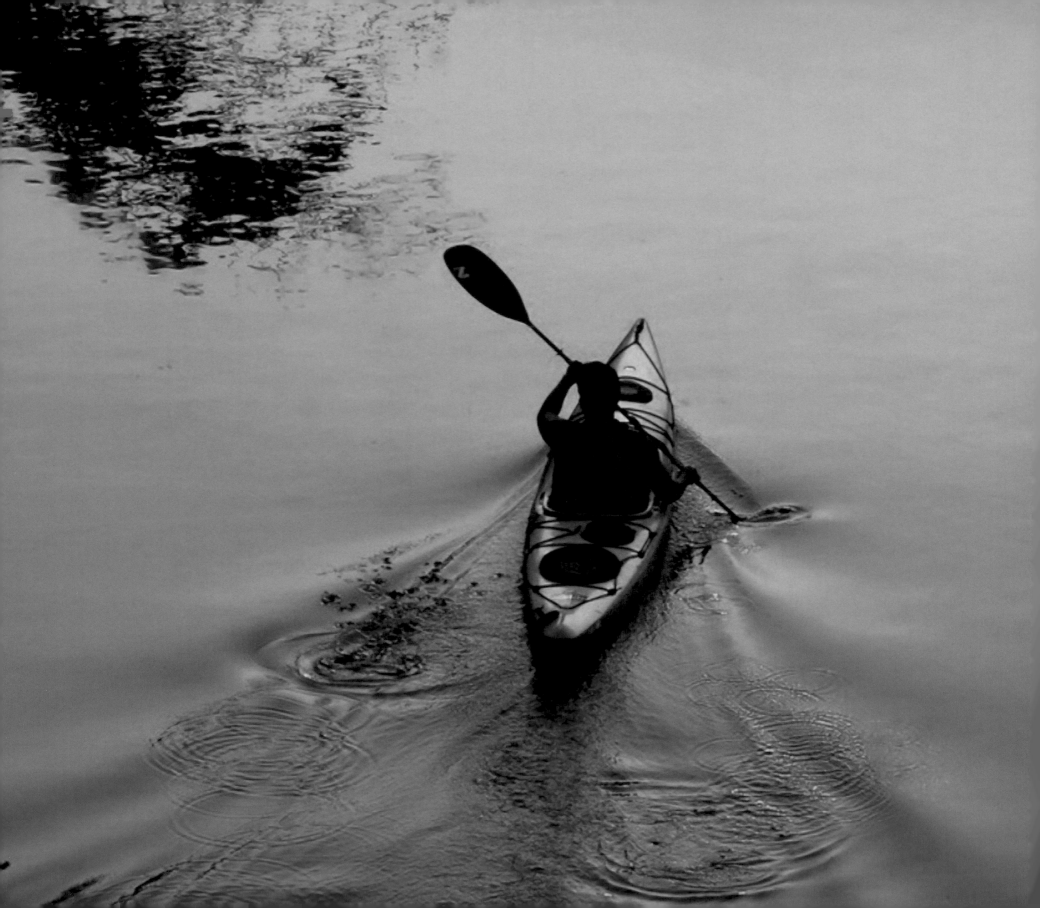

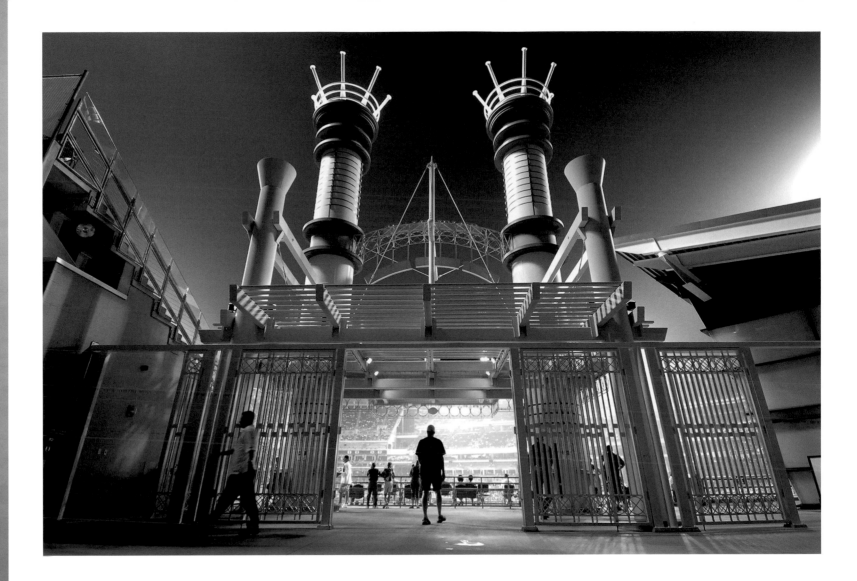

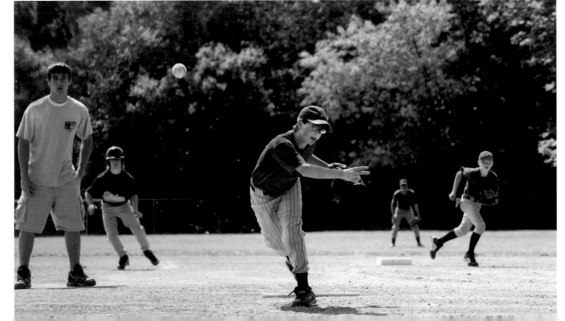

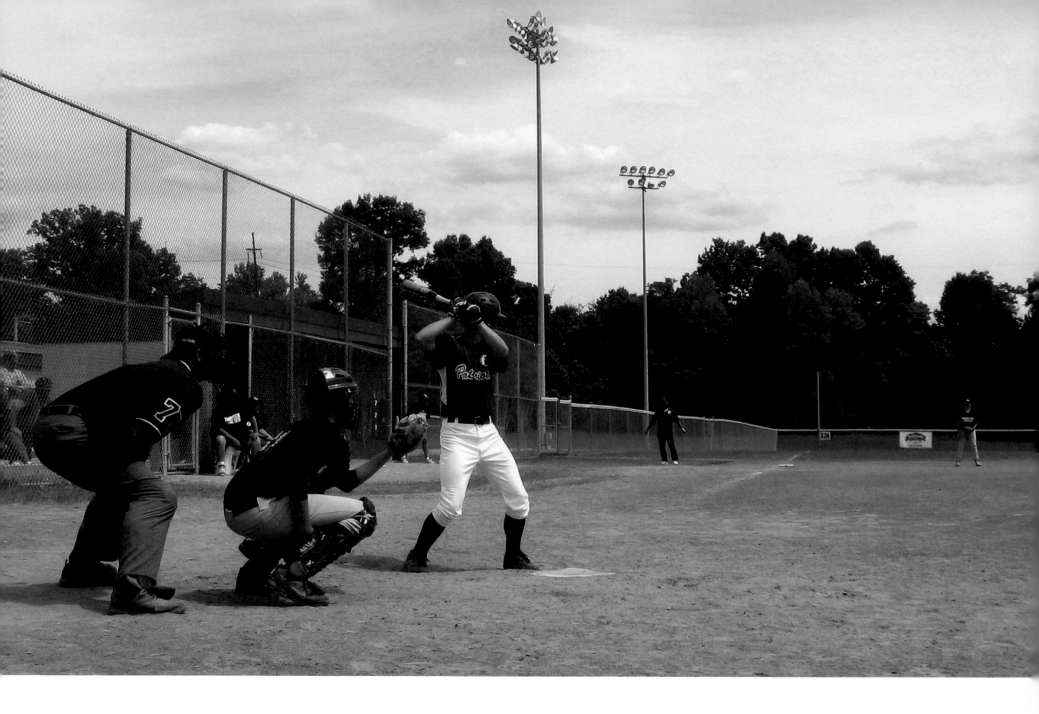

PREVIOUS LEFT ■ Colors: Sunset canoe ride at Winton Woods. Photo by Larry Fosse

PREVIOUS TOP ■ Ball Park Entrance: A somewhat mystical entrance into the home of the Cincinnati Reds. Photo by Daniel Davenport

PREVIOUS BOTTOM MIDDLE ■ Skate. Photo by Larry Fosse

PREVIOUS BOTTOM RIGHT ■ Eric the Red: Eric Brown of the CNE Raiders pitching another win. Photo by Dennis Camp

ABOVE ■ Baseball Pride: My brother playing baseball. Photo by Evan H.

OPPOSITE ■ Self Portrait: That's me in a self-portrait, taken at the Fairfield Freshman Building. After skating around I saw an unobstructed view of the sun setting and thought it would be perfect for a silhouette. With no one else around, I had to settle with the timed self-portrait. Photo by John McNamee

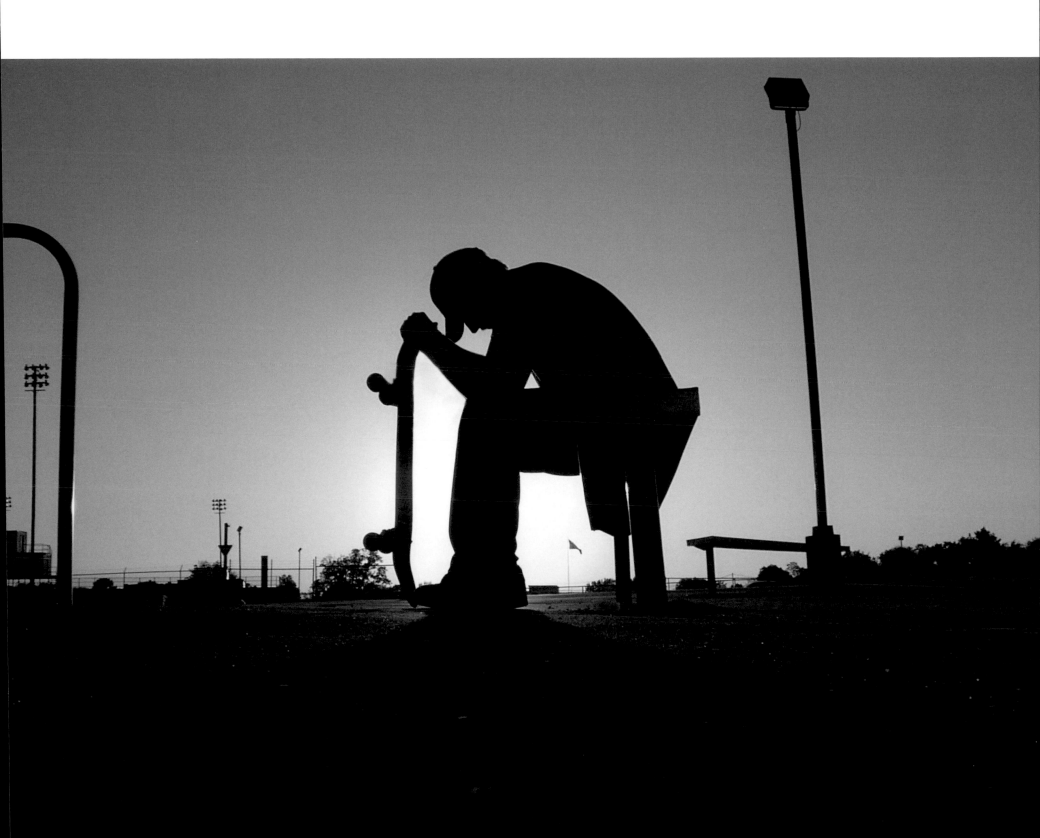

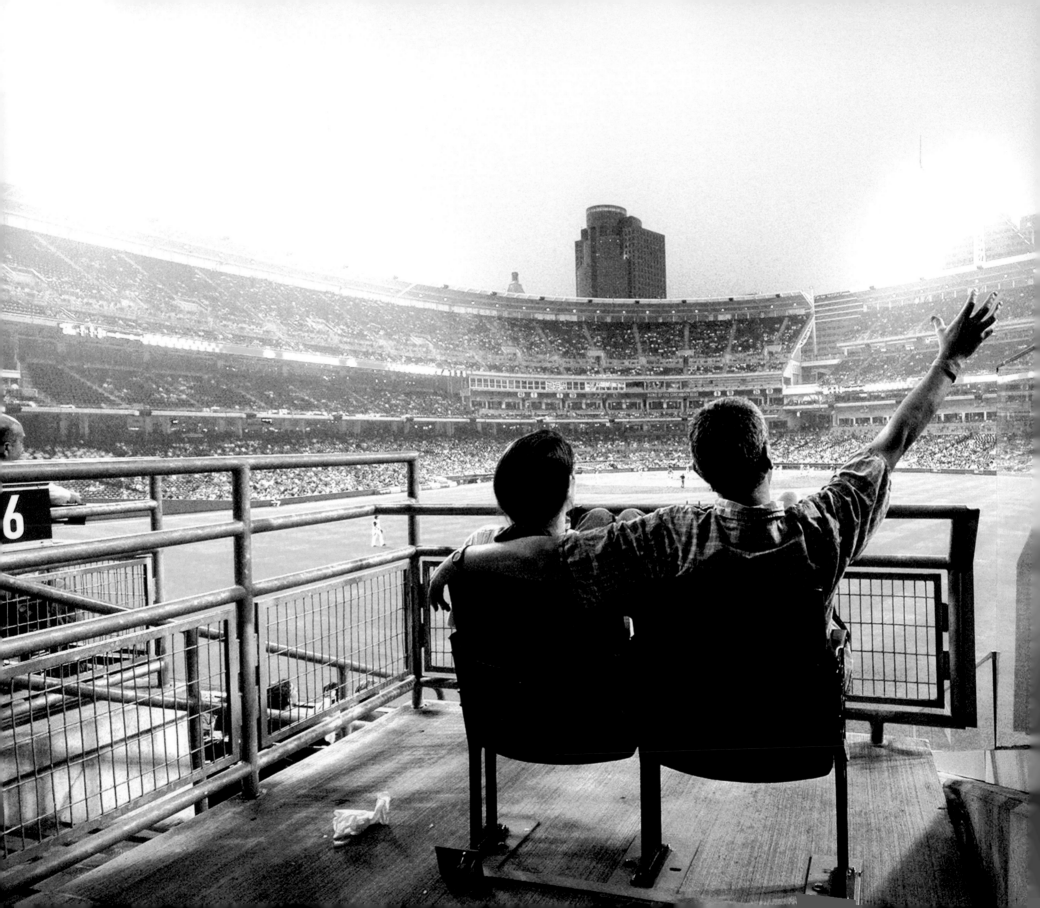

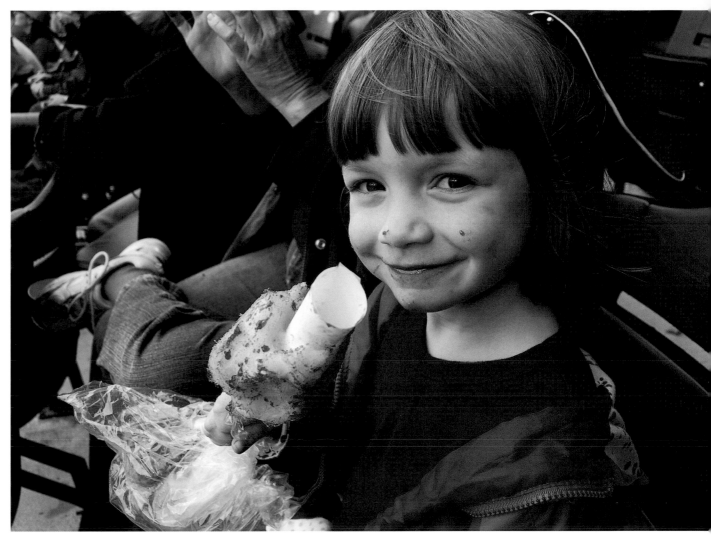

ABOVE ■ An Afternoon at the Ballpark: My little sister, Emerald Clifton, eating cotton candy (and making a mess in the mean time) at a Reds game at Great American Ball Park. Photo by Bradley Clifton

LEFT ■ Opening Day, Great American Ball Park, 2007.

Photo by Kevin Lush

FAR LEFT ■ Fly Ball Center Field: A fan's half-hearted attempt to catch a fly ball to center field.

Photo by Daniel Davenport

ABOVE ■ Pete Rose on Opening Day: Pete Rose celebrates Opening Day with Bill Cunningham.
PHOTO BY SCOTT STANLEY

RIGHT ■ Knothole Tournament: Boone County Lions get fired up between innings during the Knothole tournament. PHOTO BY MEGGAN BOOKER/THE ENQUIRER

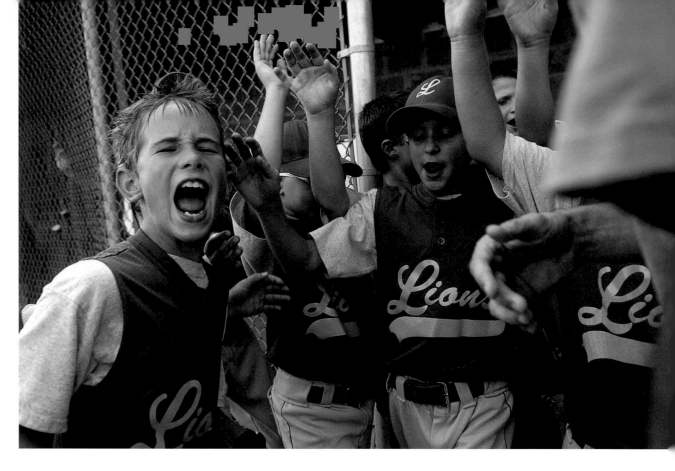

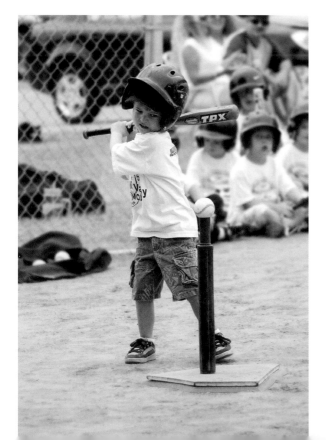

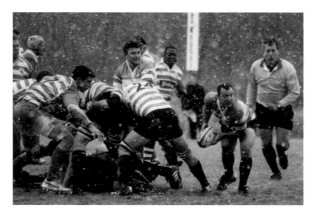

ABOVE ■ Scrumhalf Bobby Deck of the Cincinnati Wolfhounds Rugby Football Club passes the ball out from a ruck through giant snowflakes during a spring snowstorm on March 3, 2007. PHOTO BY LISA FRENTZEL

LEFT ■ T-Ball game in a Fairfield park. PHOTO BY KERRI HALEY

RIGHT ■ An extreme BMX rider gets serious air at the Extreme Sports Games in Sawyer Point. PHOTO BY J.P. PFISTER

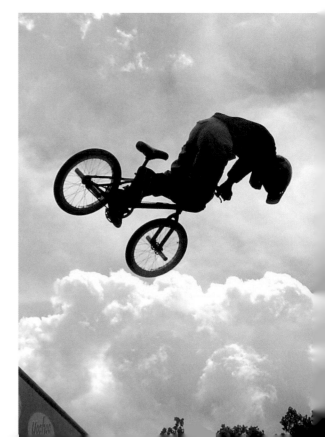

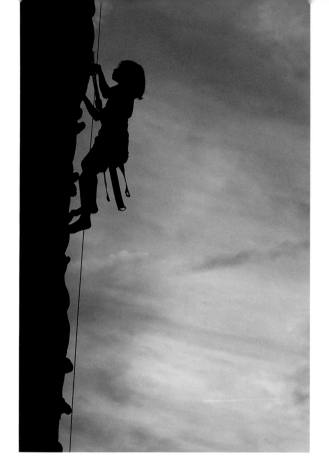

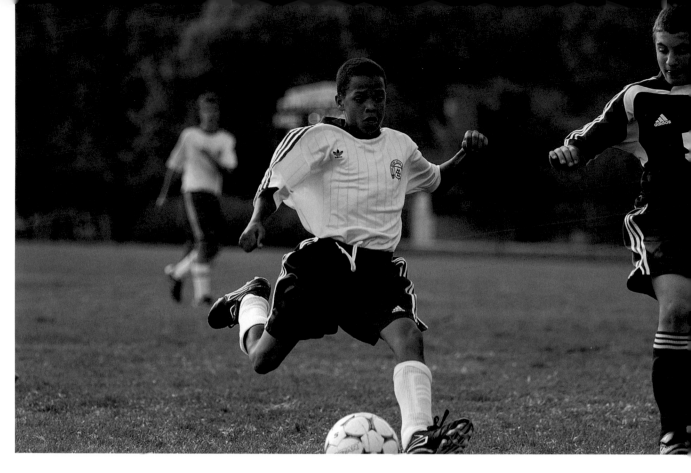

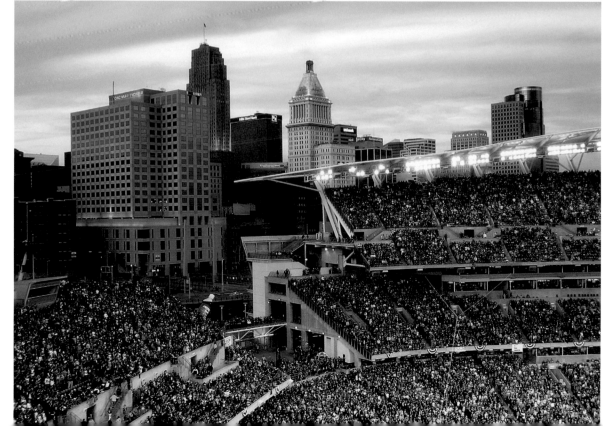

ABOVE ■ Shot on goal. PHOTO BY KEITH NEU

LEFT ■ Cincinnati Bengals vs. Pittsburgh Steelers, NFL playoffs 2006.

PHOTO BY SANDRA FREYLER

TOP LEFT ■ Summer Blast: Libby Moore, 9, of Springfield Township, ascends to the top of the rock tower at sunset, nearing the end of another Summer Blast celebration.

PHOTO BY MALINDA HARTONG/

THE ENQUIRER

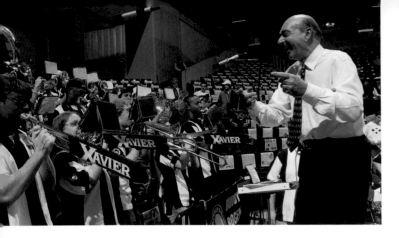

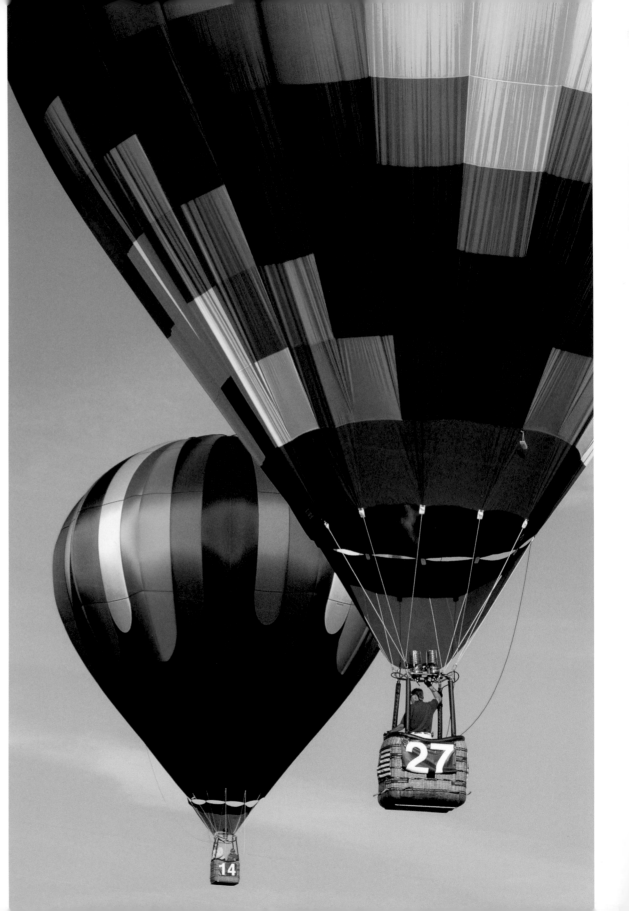

ABOVE ■ Dick Vitale warms up the Xavier University band prior to a men's basketball game on ESPN. PHOTO BY GREG RUST

RIGHT ■ An early morning and a short summer drive to Middletown on a beautiful, San Diego-like morning rewarded us with this stunning vista of a 'flock' of balloons floating over the horizon. PHOTO BY PETE FOLEY

BELOW ■ Derrick Brown dunks on Temple. PHOTO BY GREG RUST

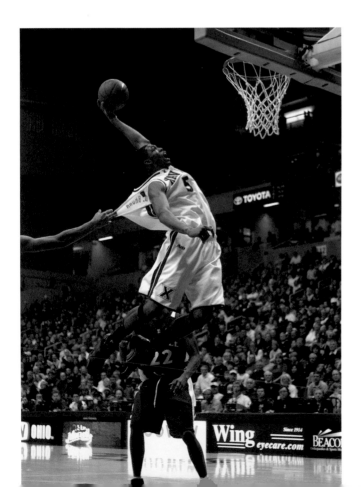

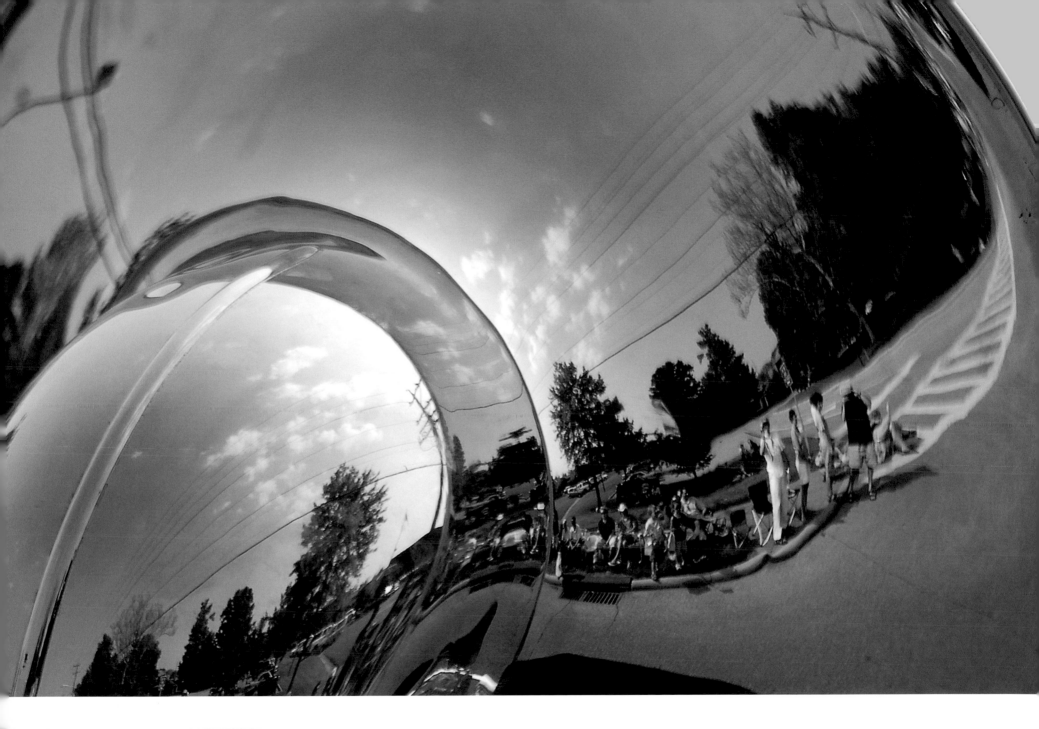

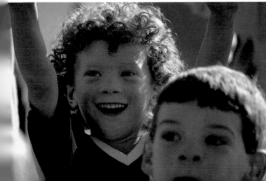

ABOVE ■ Fourth of July parade in Blue Ash reflected in a tuba. Photo by Samuel Birkan

LEFT ■ The Victory Tunnel: An excited member of the "Black Panthers" U6 SAY Soccer Team in Milford expresses the thrill of victory as he runs through the tunnel made by parents and family at a fall game. Photo by Meg Fite

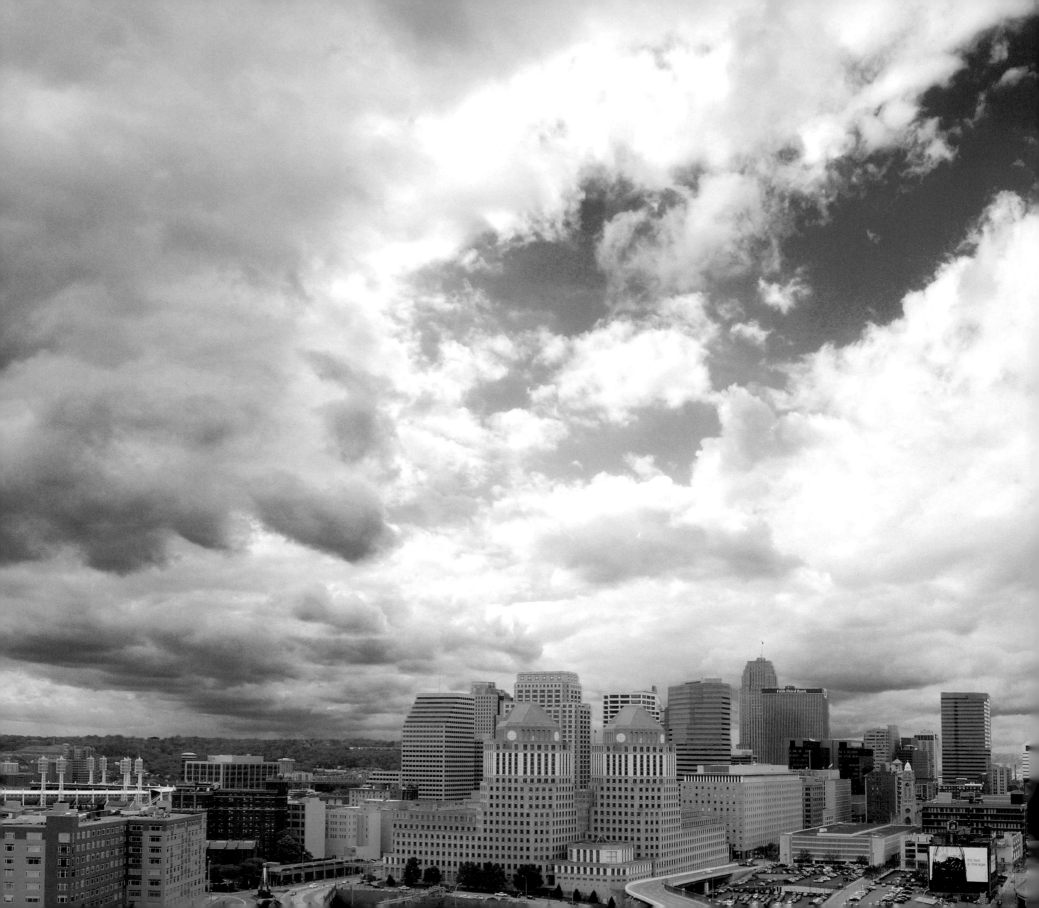

PLACES & SPACES

When residents were asked to "capture" Greater Cincinnati and Northern Kentucky, it would have been hard to imagine the variety of ways that people would approach that challenge.

This chapter represents some of the more spectacular submissions for the online photo contest that turned into this book. The pictures here are often colorful and creative, but most of all breathtaking.

There are talented photographers who took simple scenes – a fire escape, a waterfall, raindrops on a flower,

trash in the Ohio River – and turned them

There is nothing like a photo that places moment. A glorious September morning in In A father and son working together on a Kentuc arm. A couple watching the sun set from the Loveland Bike Trail.

In the following pages, you're going to discover buildings and bridges, tunnels and walkways, people and outdoor scenery on display in ways that are new and exciting.

You may never look at our fine city the same way again.

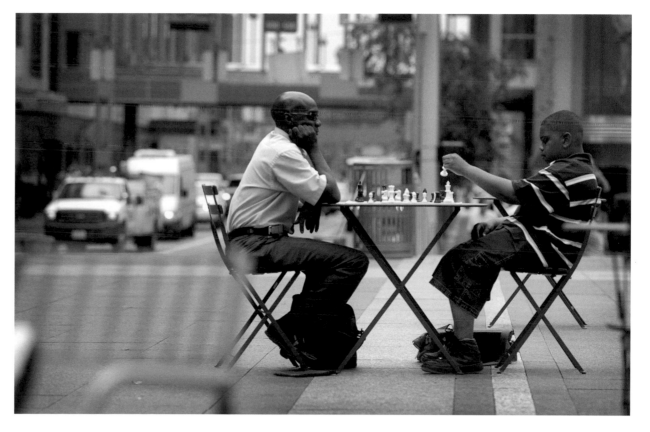

ABOVE ■ Chess on the Square: After making a donation, Freddy Rembert of North College Hill plays chess with Burton Elementary School incoming 7th-grader Clayton Cunningham, 12, during lunchtime at Fountain Square. Cincinnati Public School students were raising funds to restore full-time status to Fairview Language School art, music and gifted teachers, after CPS budget cuts. PHOTO BY CARRIE COCHRAN/THE ENQUIRER

LEFT ■ The Sky is the Limit: This photo was taken on the final day that Capture Cincinnati was accepting entries into this book. It was a gorgeous fall day. PHOTO BY DON DENNEY

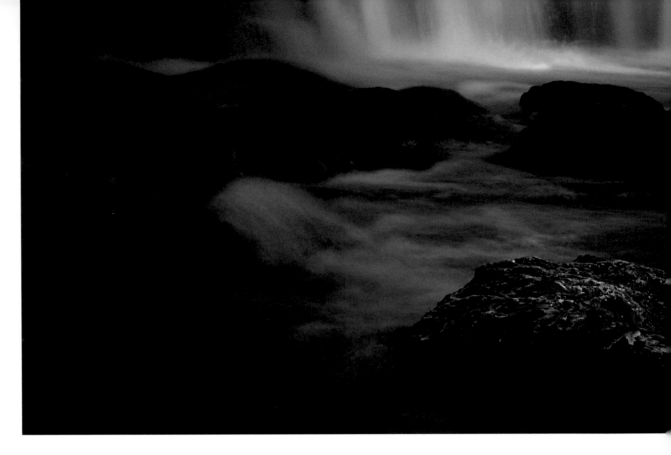

RIGHT ■ Fall Colors: The waterfalls and the late evening sun made for a nice shot with the leaves adding a nice touch. PHOTO BY MICHAEL SMITH

BOTTOM RIGHT ■ JT's on Main Street. PHOTO BY JULIE BROWN

BELOW ■ Through the Alley: Fire escapes climb between buildings in an off street alleyway. PHOTO BY STEVE HORTON

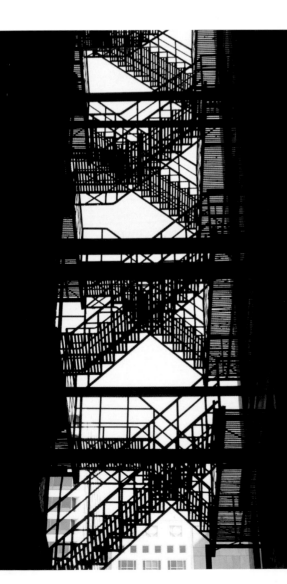

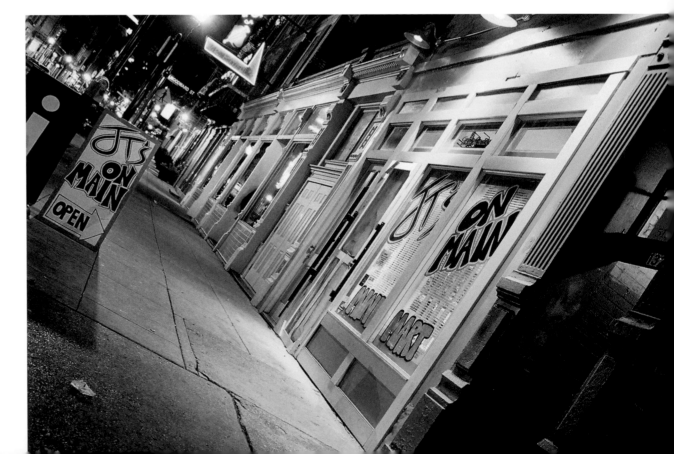

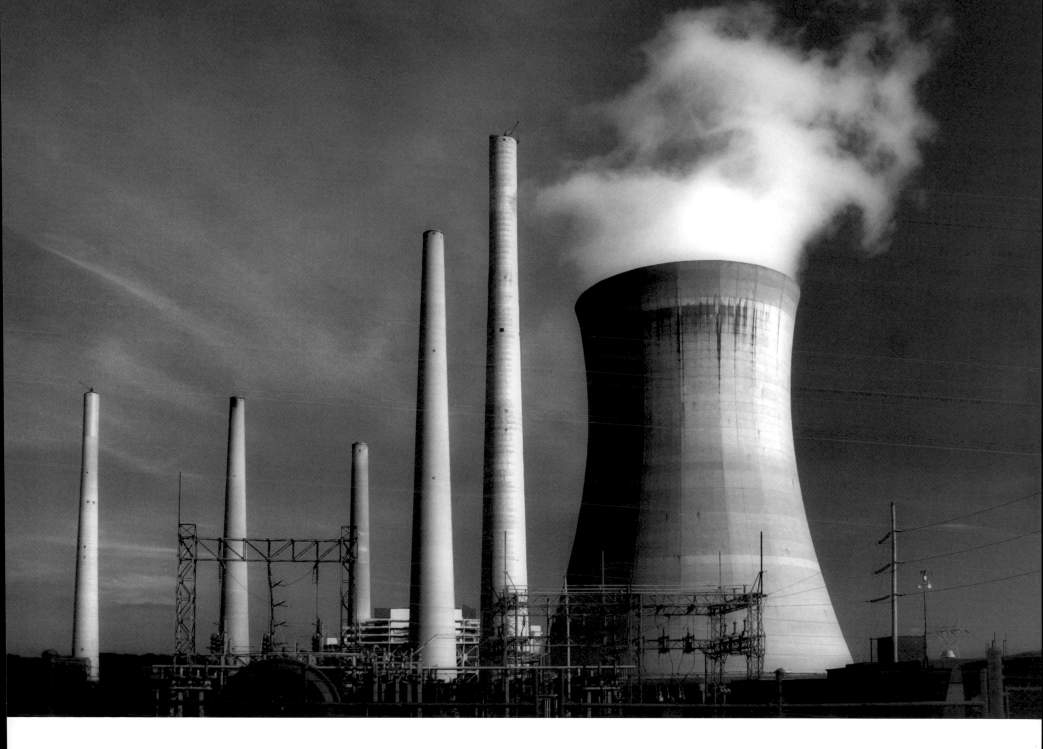

ABOVE ■ Tall Stacks: The powerplant that can be seen from 275 near Lawrenceburg. PHOTO BY RICK STEGEMAN

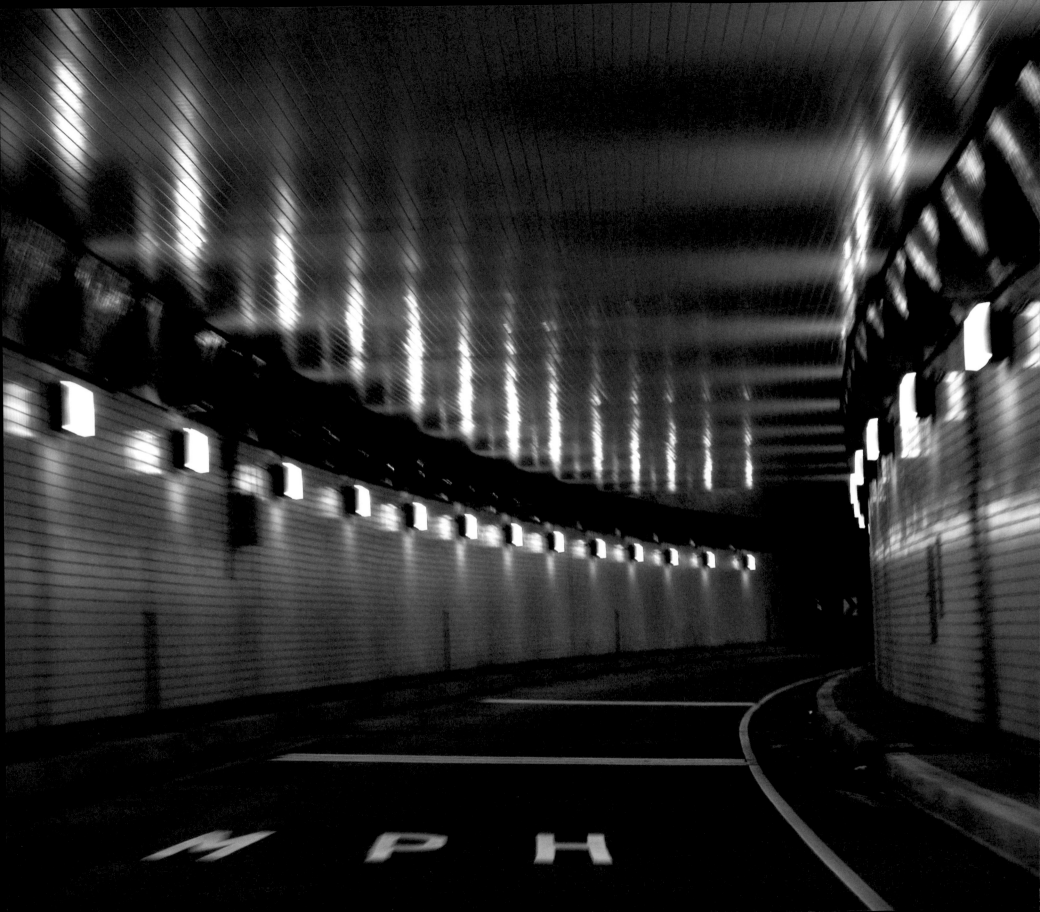

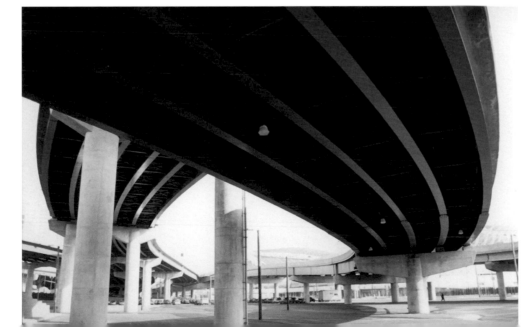

ABOVE ◼ Reflection of the PNC Bank building PHOTO BY DAVID MICHELL

LEFT ◼ Highways Above: Under the highways going through the city. PHOTO BY SCOTT HERRMANN

FAR LEFT ◼ MPH: Just wanted to capture what it's like to drive through this tunnel at night. PHOTO BY LINDSAY GIBSON

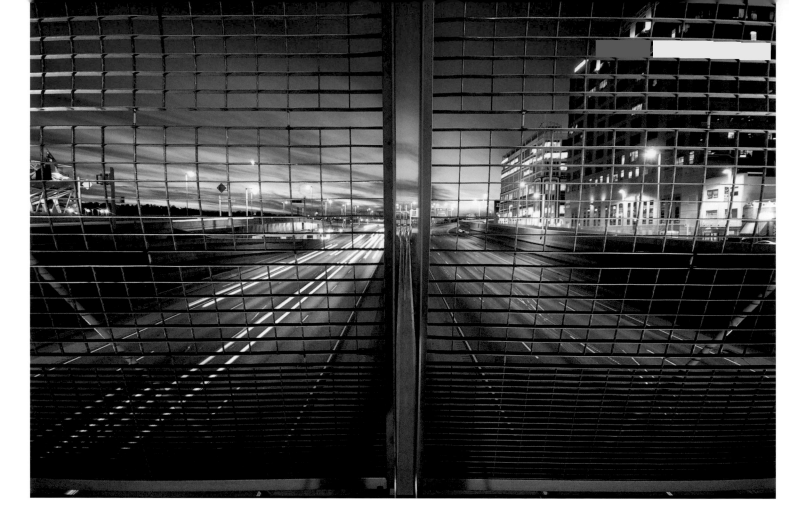

RIGHT ■ Saturated City: Fort Washington Way at sunset in the spring.

Photo by Julie Hucke

BOTTOM RIGHT ■ Trash on the Ohio: This was one of those late, late nights shooting, September of 2006.

Photo by Jeremy Stump

BELOW ■ Eden Park: Zakyia Stuckey, 8, from Roselawn, stands holding her little sister Sirus Stuckey in the shade of the tree in Eden Park, watching the ducks.

Photo by Ernest Coleman/ The Enquirer

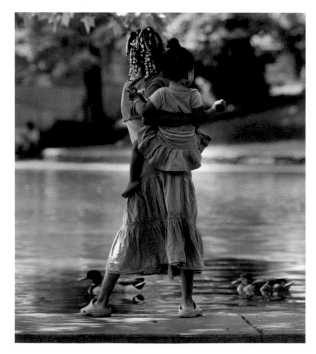

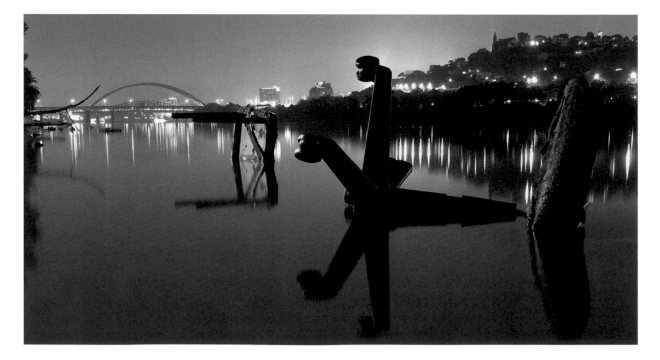

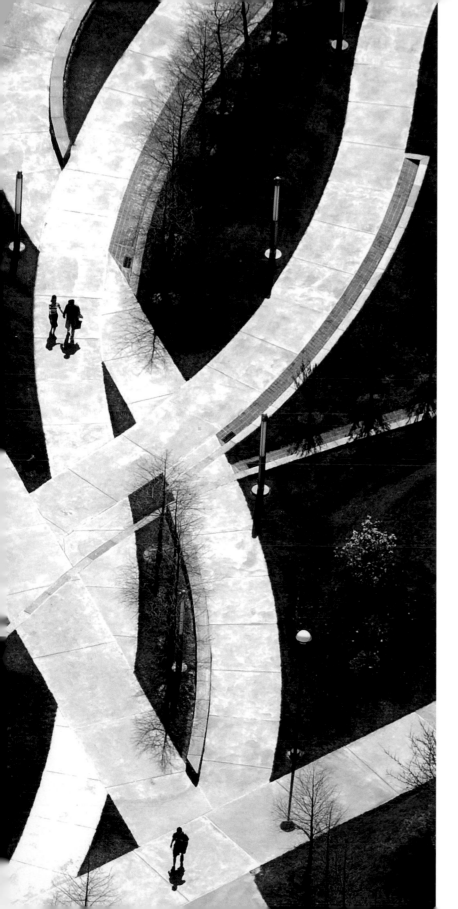

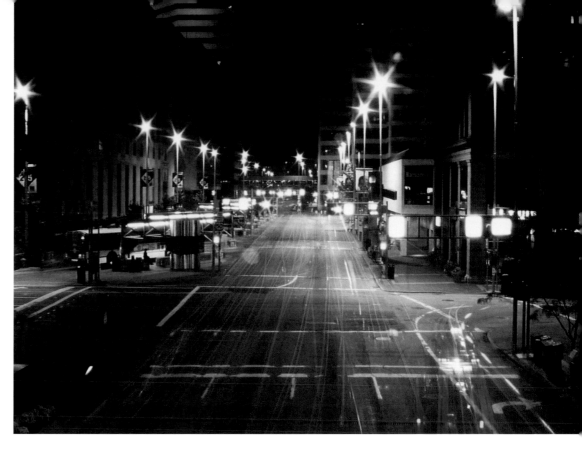

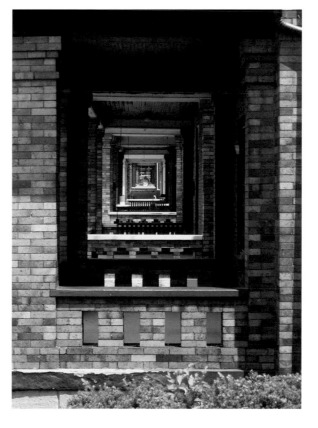

ABOVE ■ Old downtown Cincinnati–taken in 1997 before the renovation of Fountain Square and the bus area. The walkway this was taken from is now non-existent! PHOTO BY KIM COCHRANE

LEFT ■ Perfect Framing: Northside, Cincinnati.

PHOTO BY JAN HERBERT

FAR LEFT ■ Curves: A trio of pedestrians cast dark shadows as they walk along the serpentine sidewalks on Campus Green at the University of Cincinnati on a warm and sunny afternoon. This photo was shot from a helcopter at 1,200 feet above Martin Luther King Drive.

PHOTO BY GLENN HARTONG/THE ENQUIRER

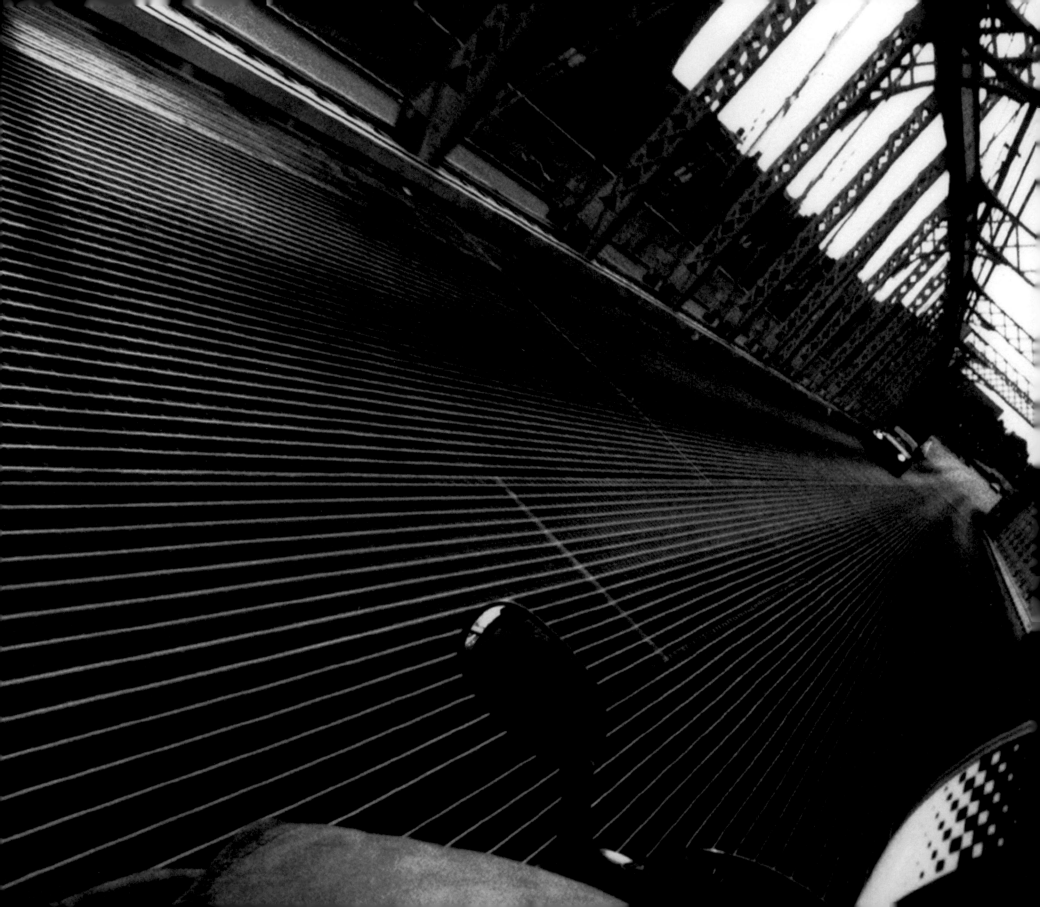

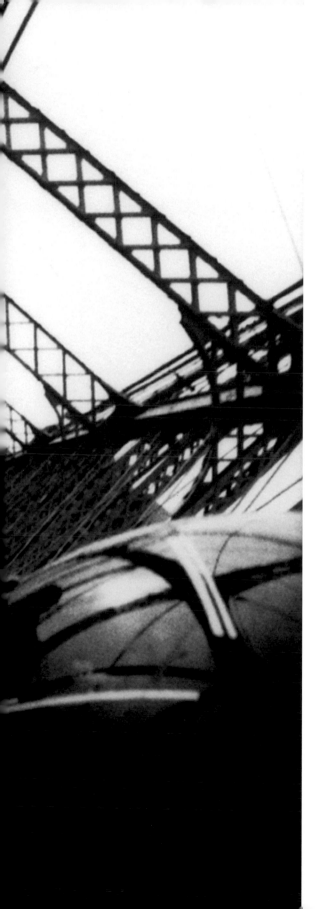

TOP ■ Spring Time: After a spring shower witness nature's beauty first hand. Photo by Eric Schira

ABOVE ■ Inwood Village: An abandoned community in the shadows of Christ Hospital. Photo by Wes Battoclette

LEFT ■ Crossing the John Roebling Bridge, as seen from the back of a motorcycle on a crisp Sunday morning. Photo by Jennifer Schiller

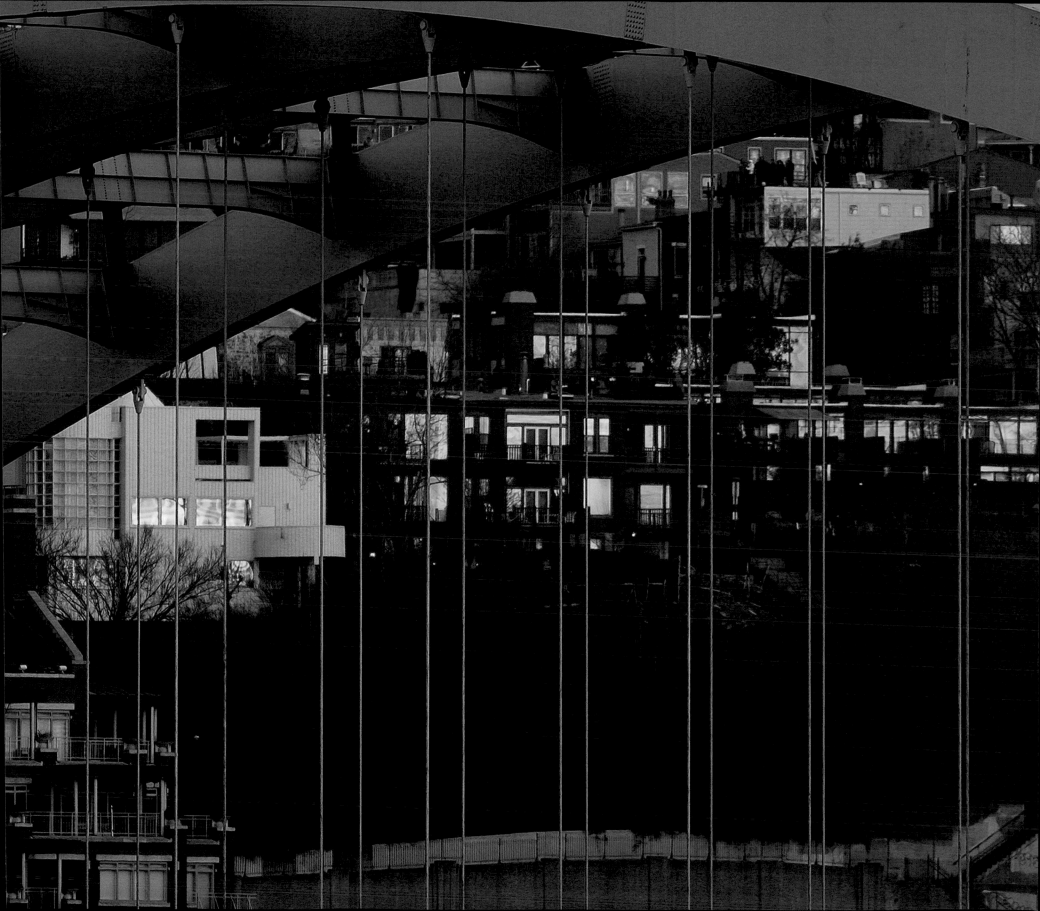

PREVIOUS LEFT ■ Drops of morning dew.

<div align="right">Photo by Leslie Na</div>

PREVIOUS RIGHT ■ Mount Adams Sunrise: Sunrise thru the 471 bridge. Photo by Mike Wehrman

RIGHT ■ Wonderful Majesty: The main aisle in the Basilica in Covington. What a magnificent place.

<div align="right">Photo by Rick Stegeman</div>

BELOW ■ Light Inside the Shadows: Inside the Athenaeum of Ohio in Anderson Township; if you haven't been, it's worth the drive to check it out.

<div align="right">Photo by Julie Hucke</div>

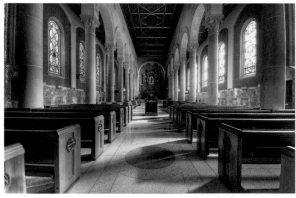

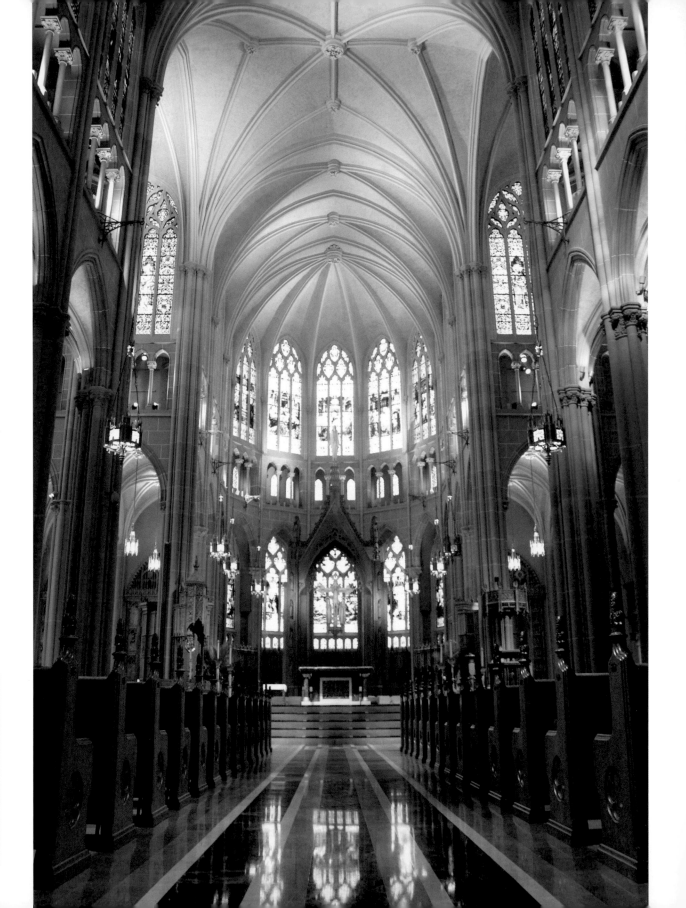

LEFT ■ Two Tables: Immediate seating available. PHOTO BY RICKY CARTER

BOTTOM LEFT ■ Standing in a Dream: The Church of St. Francis and St. George is an amazing treasure–a near surreal blend of faith, art and craftsmanship.
PHOTO BY JOHN CREMONS

BOTTOM MIDDLE ■ Verdin Bells on the old Verdin Building. PHOTO BY TIMOTHY CANNON

BELOW ■ Majestic Cypress Tree: A lake in Spring Grove Cemetery with a large cypress tree and its cypress "knees" protruding from the ground as part of the root system near the edge of the lake.
PHOTO BY BOB STOTHFANG

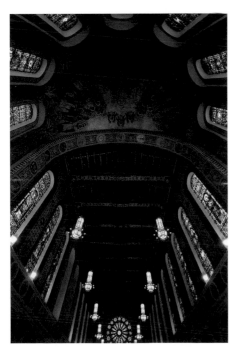

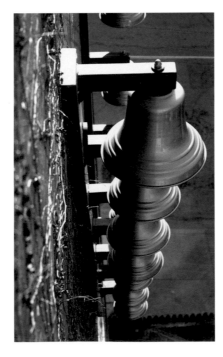

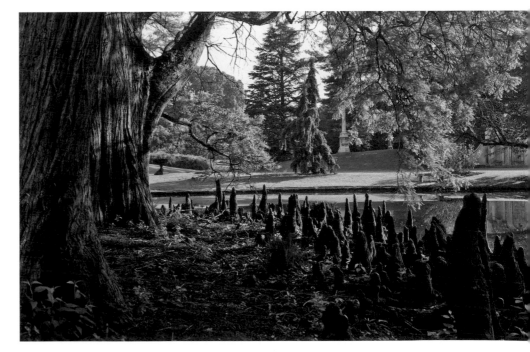

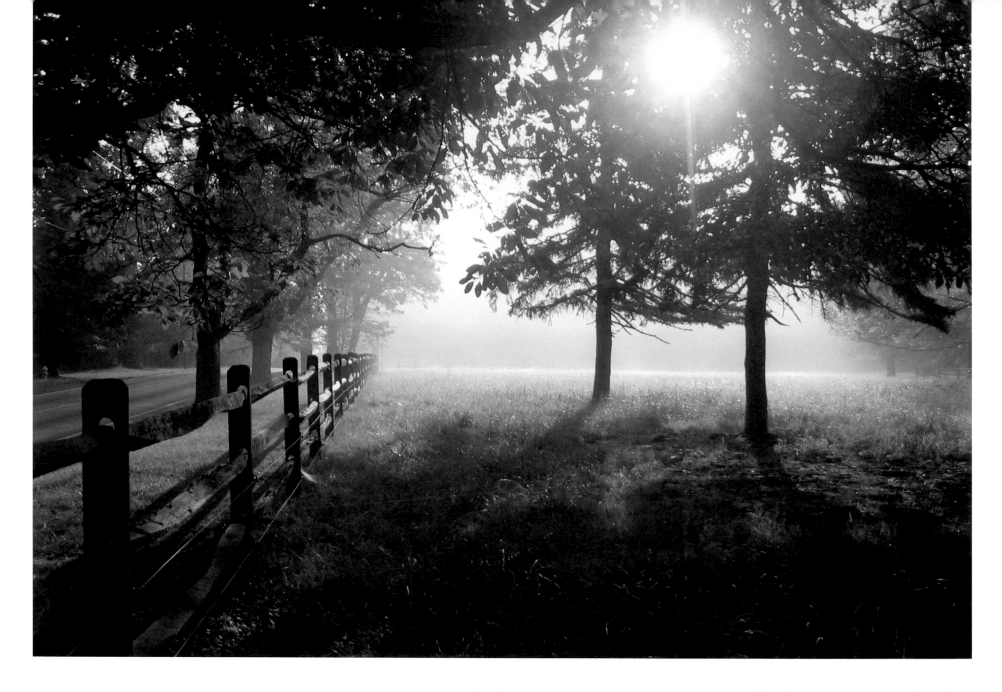

ABOVE ■ September morning in Indian Hill. Photo by Graham Wolstenholme

RIGHT ■ Kids in Woods: Looking for the brave new world in Colerain Township. There's always something to discover. Photo by Linda Erhart

OPPOSITE TOP ■ Stairs leading up the pedestrian walkway to Mt. Adams. Photo by Ryan Thomas

OPPOSITE BOTTOM ■ Cincinnati during the Light Up Cincinnati event, May 1, 2006. Photo by Chris Thompson

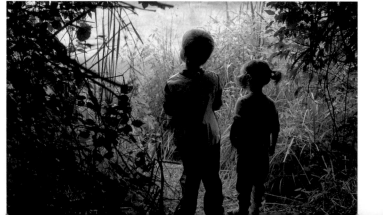

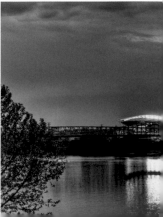

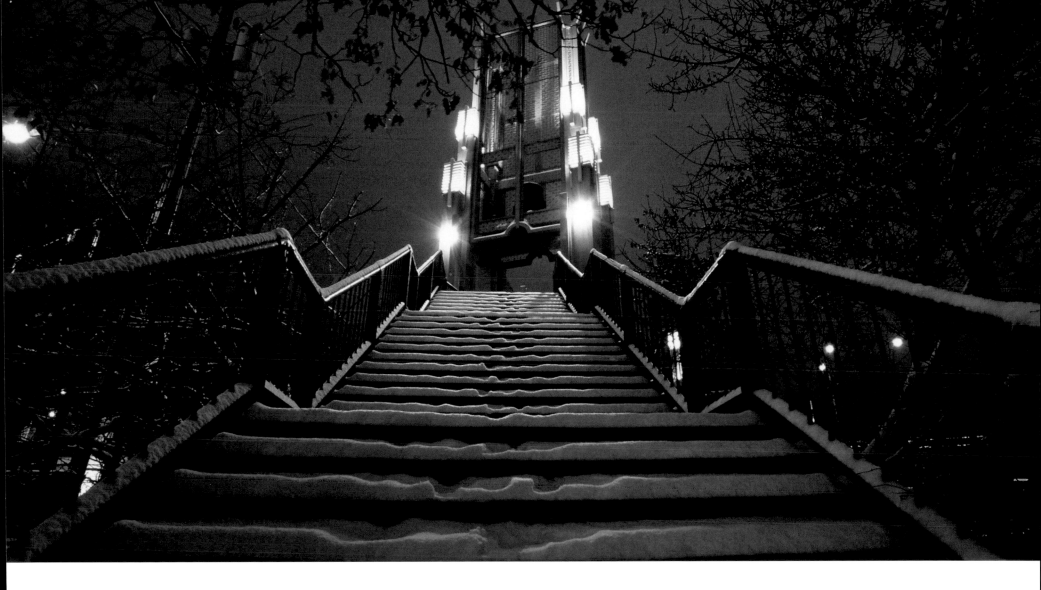
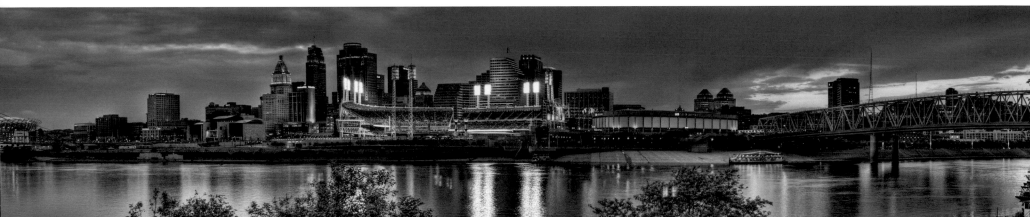

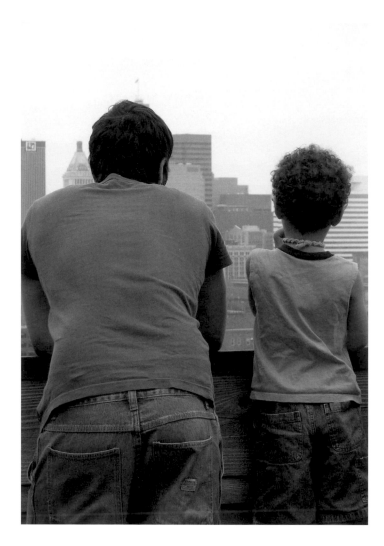

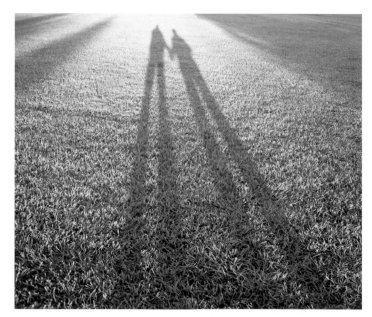

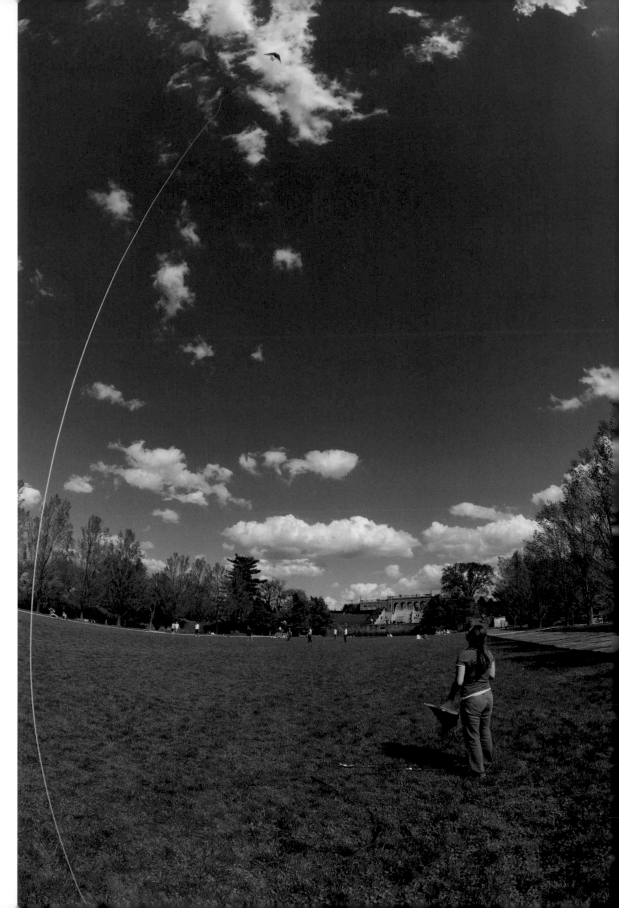

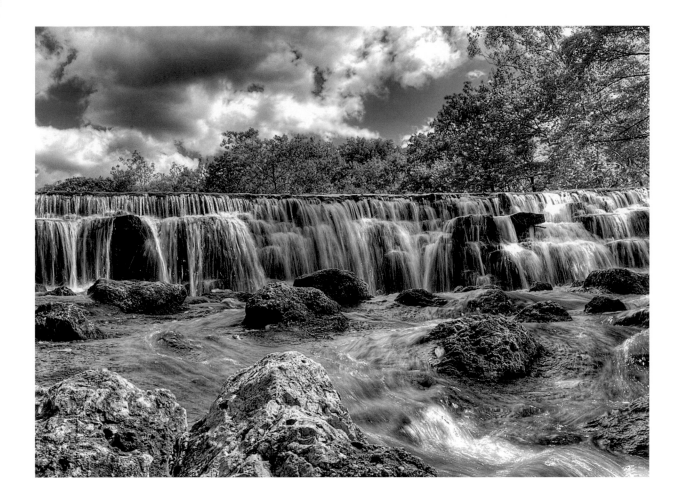

ABOVE ■ Taking some time to watch the sunset from the Loveland bike trail. Photo by Mark Jones

OPPOSITE TOP LEFT ■ And This Shall Be Yours: Father and son take in the sites of downtown Cincinnati. Photo by RoAhnna Cobb Figgs

OPPOSITE BOTTOM LEFT ■ Me and My Shadow: Taken at park in Camp Dennison. Photo by Brandon kinman

OPPOSITE RIGHT ■ Kite Flying at Ault Park.
Photo by Wes Battoclette

TOP LEFT ■ Buckeye Falls: I fell in love with the clouds and decided to head over to Sharon Woods since I've seen a lot of great shots from there.
Photo by Chris Thompson

BOTTOM LEFT ■ Helping Dad: Kevin Neltner and his son, Brendan Neltner, 7, pick zucchini and yellow squash at their farm in Melbourne, Ky.
Photo by Carrie Cochran/The Enquirer

BELOW ■ Browsers: In the Main Library Atrium from the second floor looking down. Photo by Rob Ireton

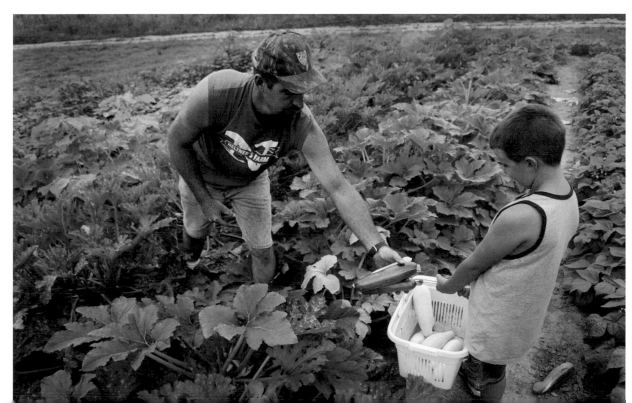

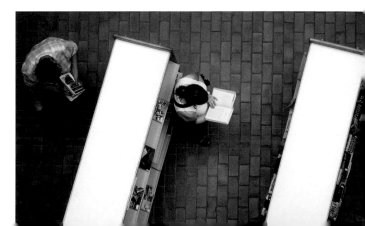

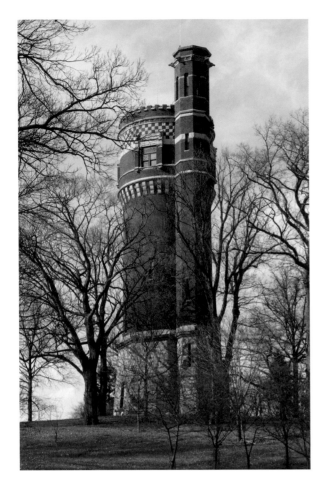

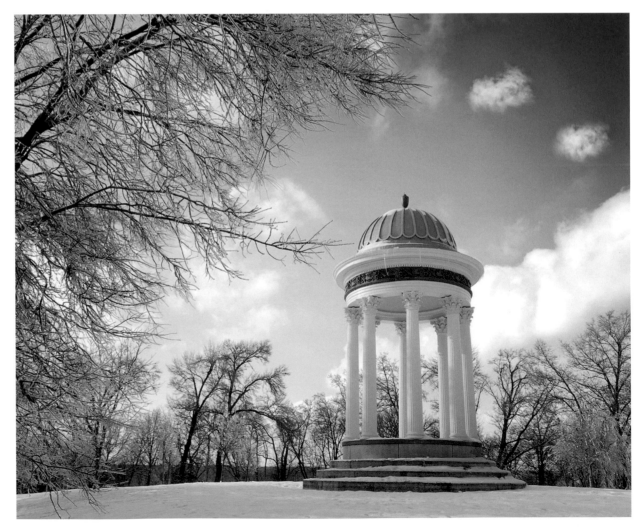

ABOVE ■ Water tower in Eden Park. What a wonderful brick structure. PHOTO BY STEVE HORTON

TOP RIGHT ■ Mount Storm Park.
PHOTO BY TUDOR REBENGIUC

RIGHT ■ Icy Mount Storm Park. PHOTO BY RICK BARGE

OPPOSITE LEFT ■ Foggy Elms near the Mariemont Concourse. PHOTO BY JOE STONER

OPPOSITE TOP RIGHT ■ Fifth and Main streets, downtown Metro Bus stop. PHOTO BY MARK BYRON

OPPOSITE BOTTOM RIGHT ■ Janitor Door: Photo taken of the Old Ford Factory, off of I-71 at Taft, before it was renovated. PHOTO BY RYAN THOMAS

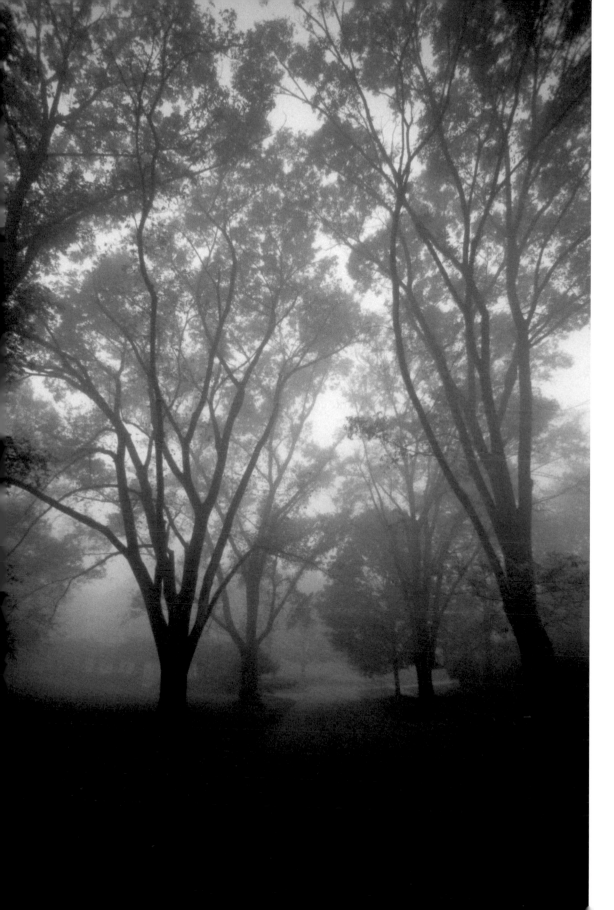

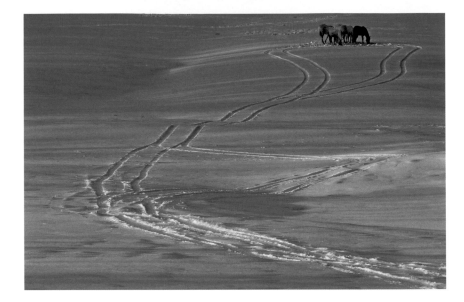

OPPOSITE ■ Summer Splash: I had to wait about 10 minutes before this boy finally hit that patch of light. I was afraid that he would give up before I got the shot. Photo by Robert Webber

RIGHT ■ Winter Wonderland: Horses and tracks on snow. It it hard to believe that you can find a scene like this with a short drive from busy downtown Cincinnati. Photo by Yiming Hu

BELOW ■ The Loveland Bike Trail in Newton.
Photo by Rich Brilli

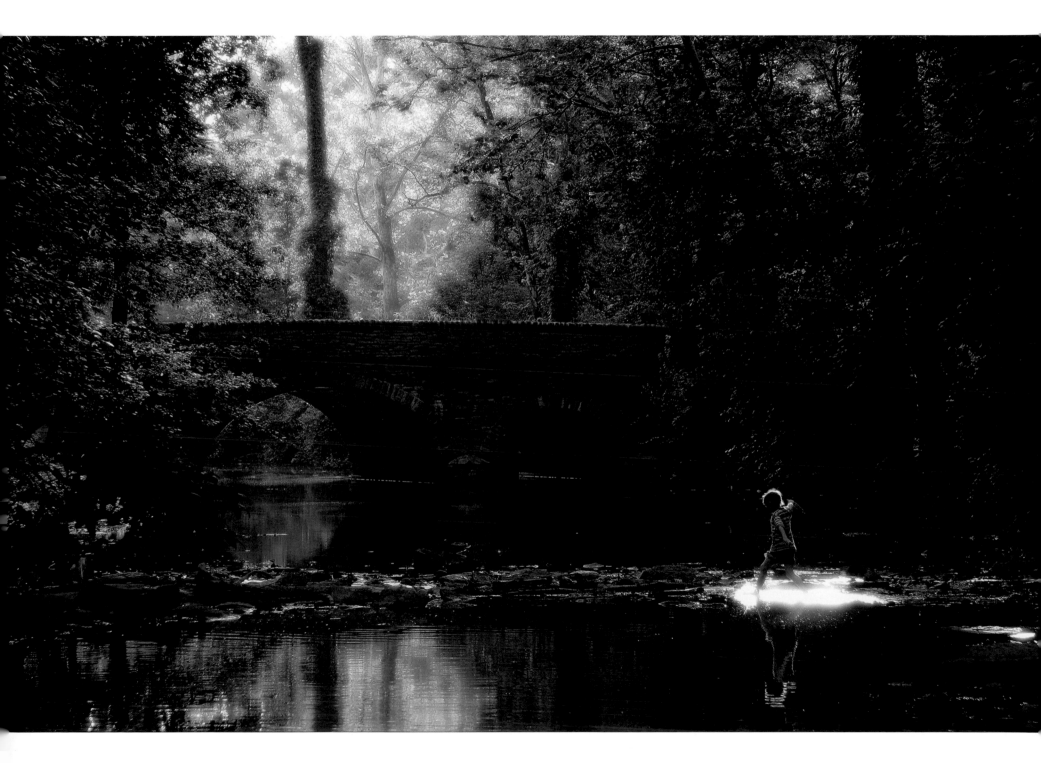

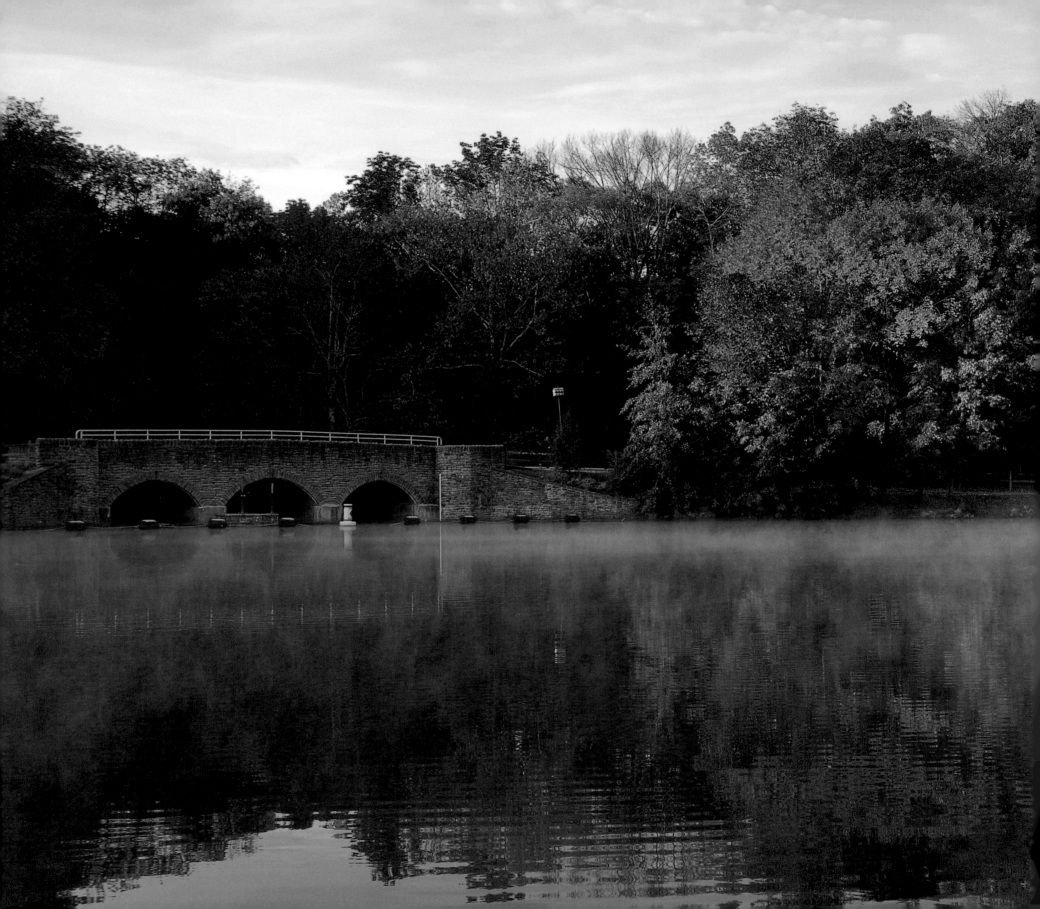

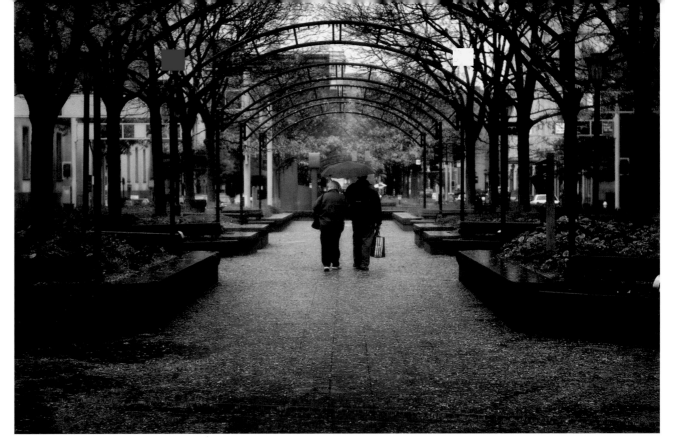

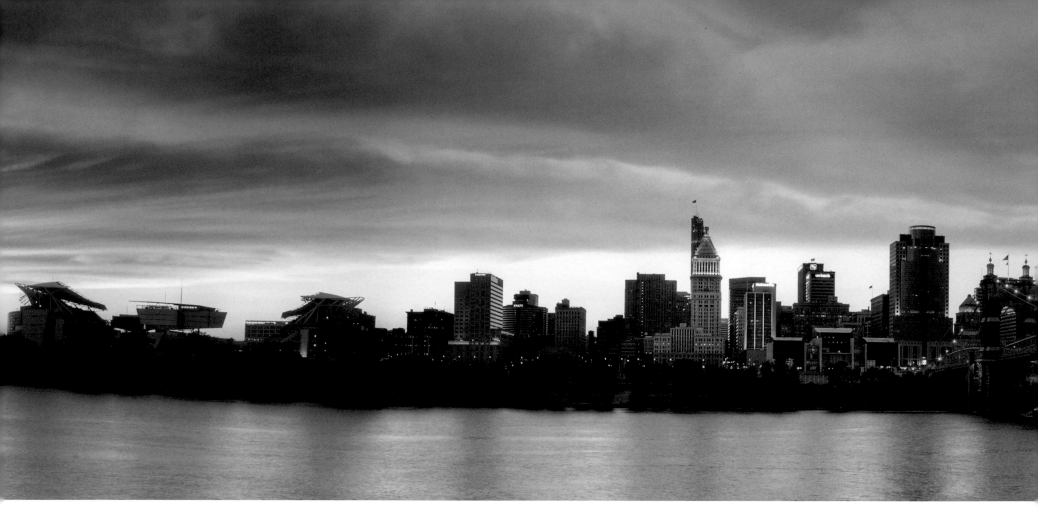

ABOVE ■ Cincinnati at Sunset. Photo by Chris Thompson

RIGHT ■ A March morning at Miami-Whitewater Wetlands. Photo by Bob Schlake

FAR RIGHT ■ Kites flying over Devou Park with a view of Cincinnati in the distance. Photo by Chris Thompson

PREVIOUS LEFT ■ Frosty Fall Morning at Sharon Woods. Photo by Larry Bresko

PREVIOUS TOP RIGHT ■ Urban Autumn: Appreciate those ash trees while you can. Photo by Julie Hucke

PREVIOUS BOTTOM RIGHT ■ City Hall in Fall. Photo by Douglas Owen

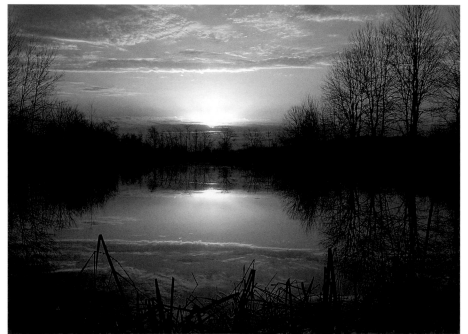

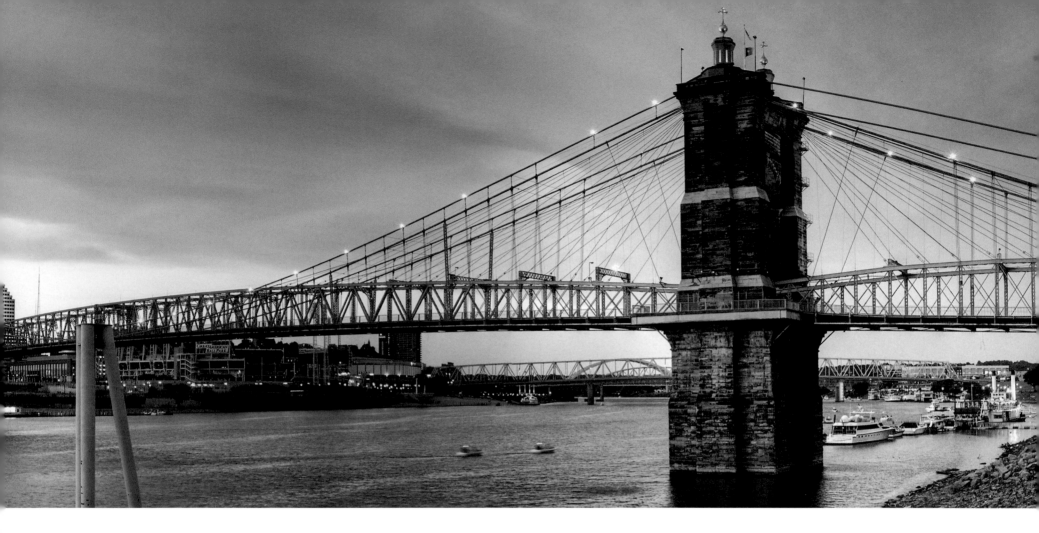

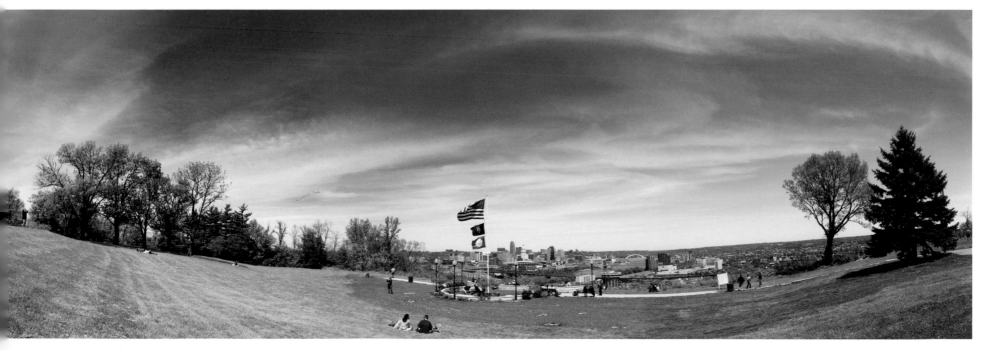

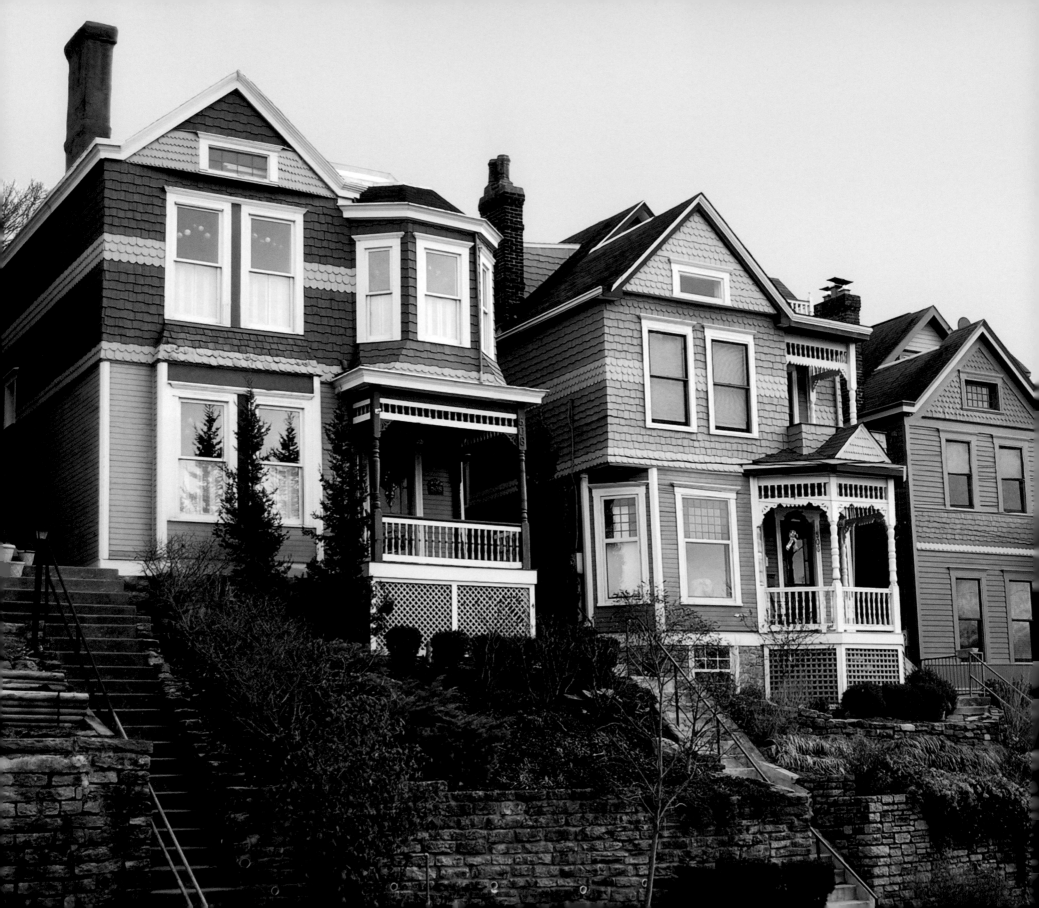

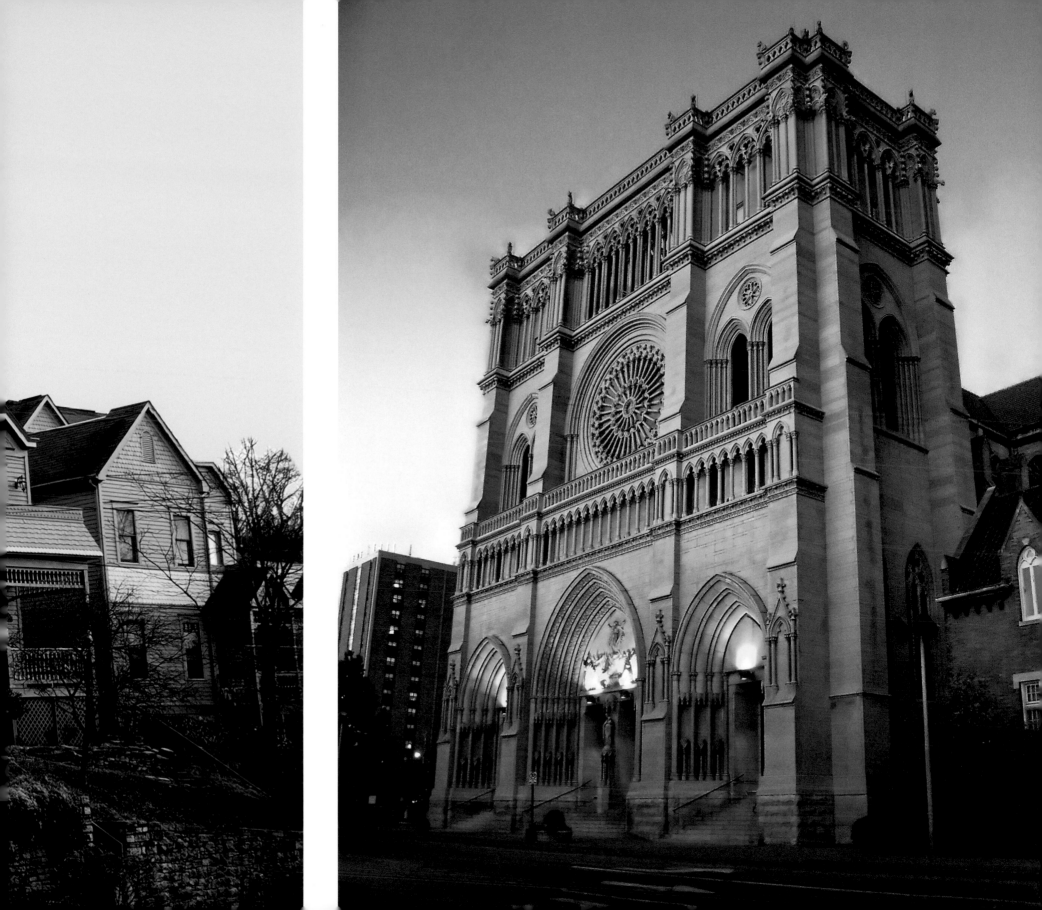

ABOVE ■ Ice Scape: Morning sunset over the ice-covered fields of Blanchester. PHOTO BY COURT FURBER

RIGHT ■ Cold Shelter: Mount Airy Forest. PHOTO BY PAUL KAUCHER

PREVIOUS LEFT ■ Line of Painted Ladies: Painted ladies are a great tradition among the houses along Tusculum Avenue in Cincinnati. PHOTO BY JOHN MICHELL

PREVIOUS RIGHT ■ Gothic Grandeur: The Cathedral Basilica houses the largest stained glass window in the world. PHOTO BY CHUCK EILERMAN

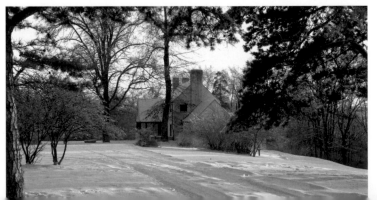

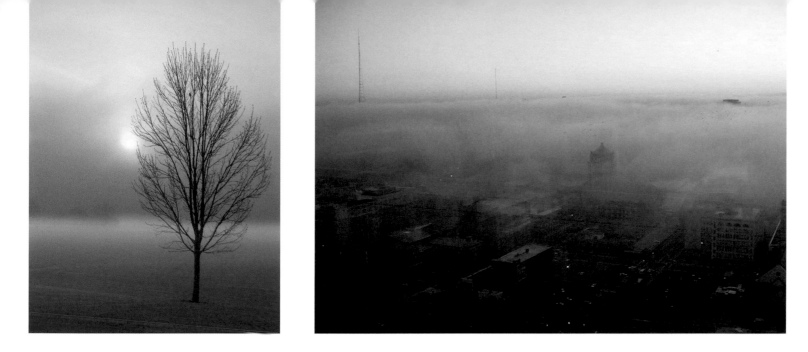

TOP LEFT ■ Tree in Fog: Along State Route 128 and the Great Miami River, there are many soccer fields owned by the Hamilton County Park District. This wide open space was filled with fog from the river one spring day as the sun arose. Photo by Linda Erhart

TOP RIGHT ■ Disappearing city. Photo by Barbara Easter

LEFT ■ Fog Bank at Sunrise: I was at the Museum Center at sunrise one early summer morning and caught this shot of the old Sister's of Mercy steeple (now the Job Corps Center), with a low bank of fog in the distance.

Photo by Robert Webber

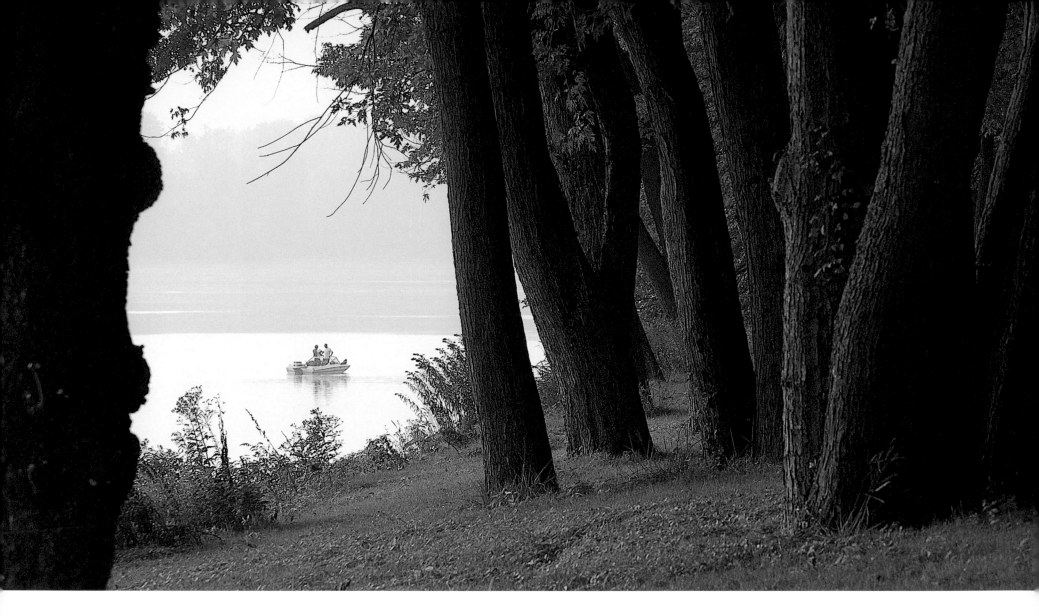

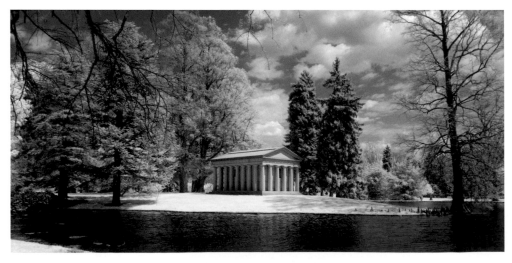

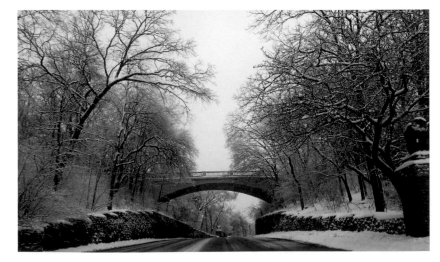

OPPOSITE TOP ■ Early morning fishermen on the Ohio River across from Coney Island. Photo by Samuel Birkan

OPPOSITE LEFT ■ Amazing Grace: An infrared photo of Fleischmann Monument at Spring Grove Cemetery. Photo by Jim Kramer

OPPOSITE RIGHT ■ A wintry drive through Eden Park. Photo by Rachel Ferree

BELOW ■ St. George in Clifton. Photo by Kylie J. Wilkerson

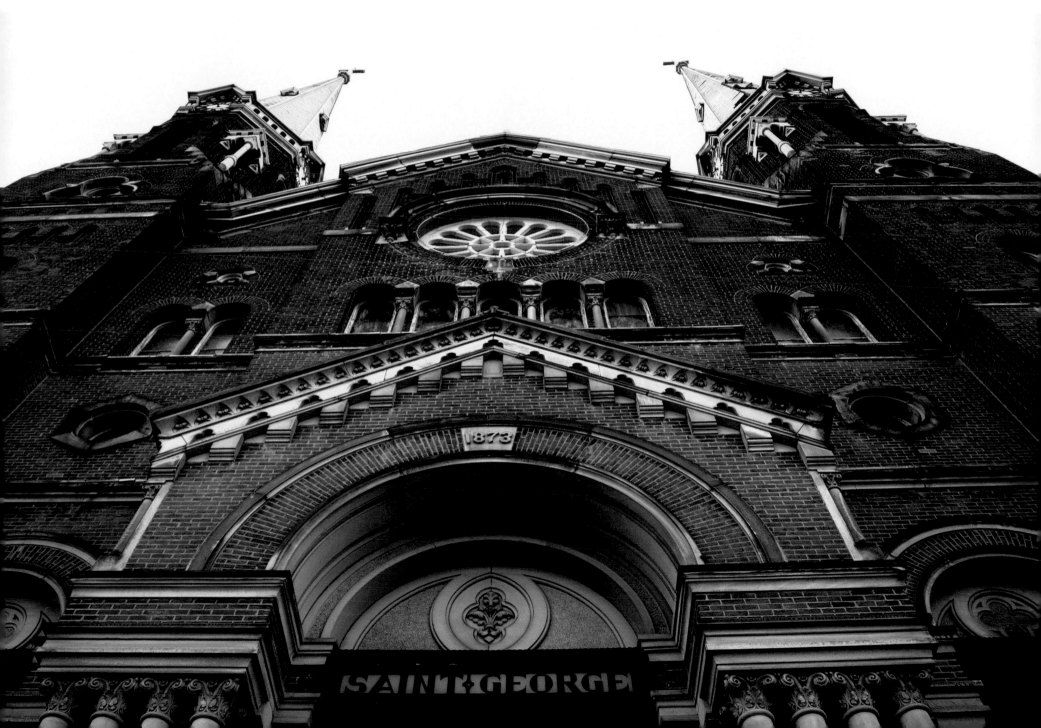

RIGHT ■ Taking a stroll in Hyde Park Square. Photo by Rebekah Johnson

MIDDLE RIGHT ■ Steeple on top of a church in downtown Cincinnati at the corner of Eighth and Plum streets. Photo by Thadd Fiala

FAR RIGHT ■ Early morning on the Ohio River: Riley and Henry Groh of Bridgetown watch the fog lift off the Ohio River on an early October morning at Fernbank Park. Photo by Steve Groh

BELOW ■ The Front Porch: No waiting to be seated. Photo by Ricky Carter

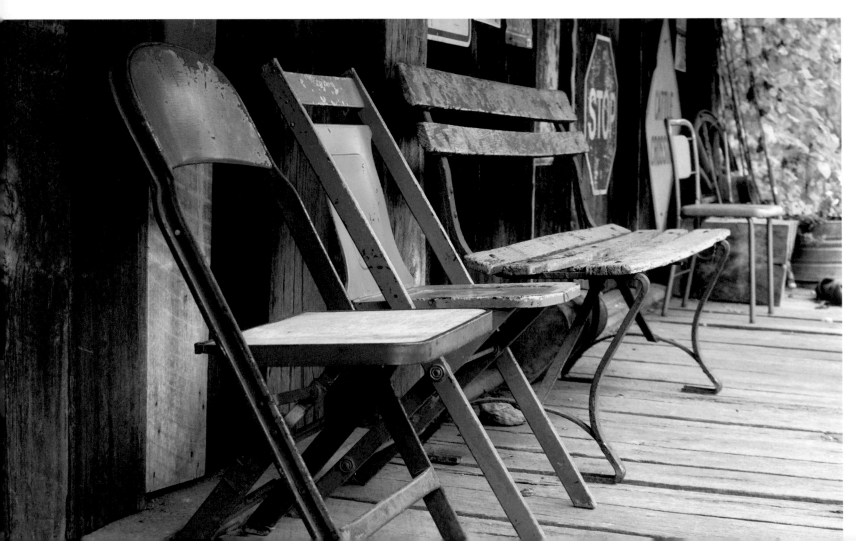

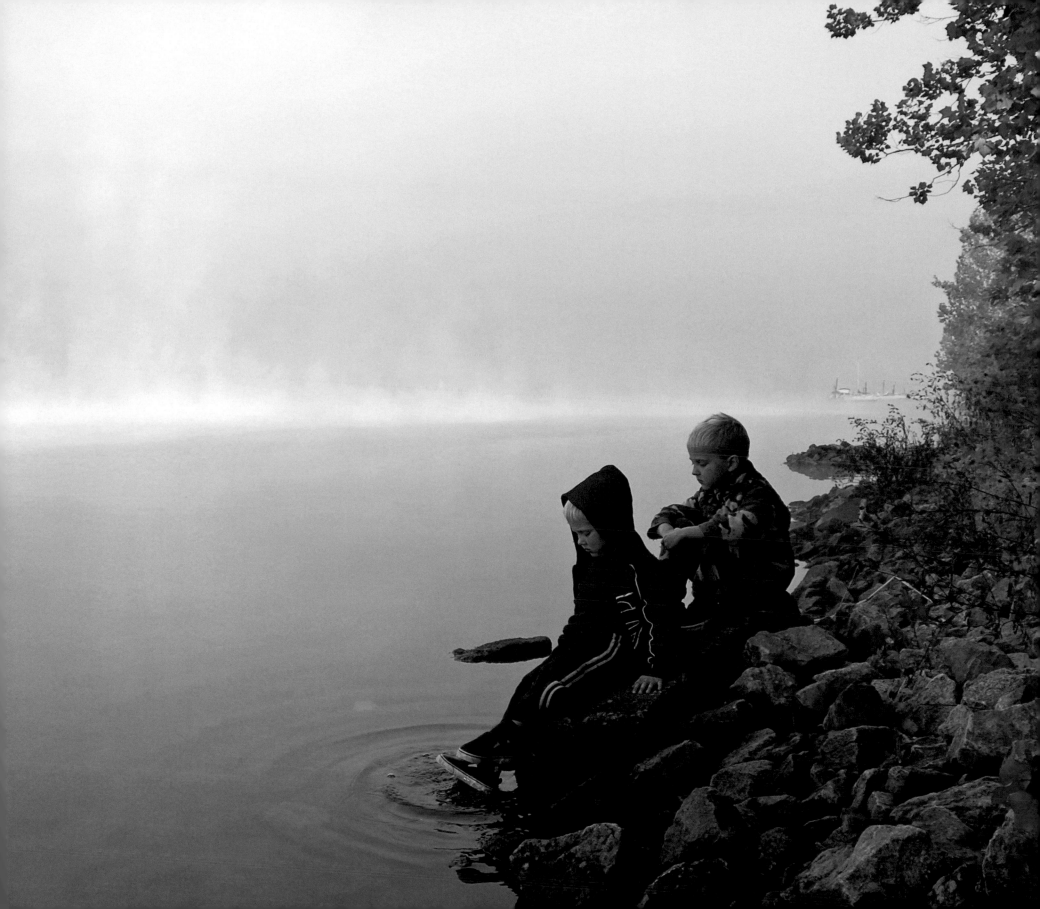

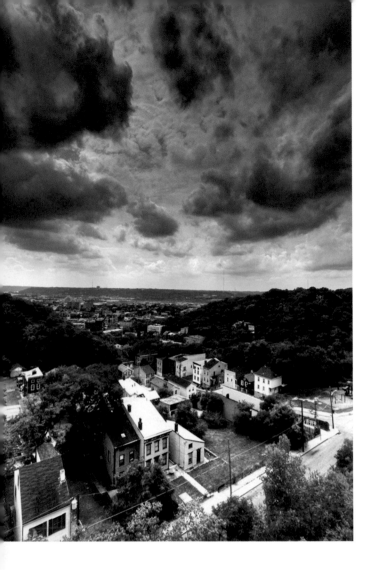

ABOVE ■ The Afternoon View: Taken from the top of the parking garage at Christ Hospital.

PHOTO BY WES BATTOCLETTE

RIGHT ■ Early Morning train heading toward Cincinnati, traveling along Route 8 below Ft. Thomas. PHOTO BY SAMUEL BIRKAN

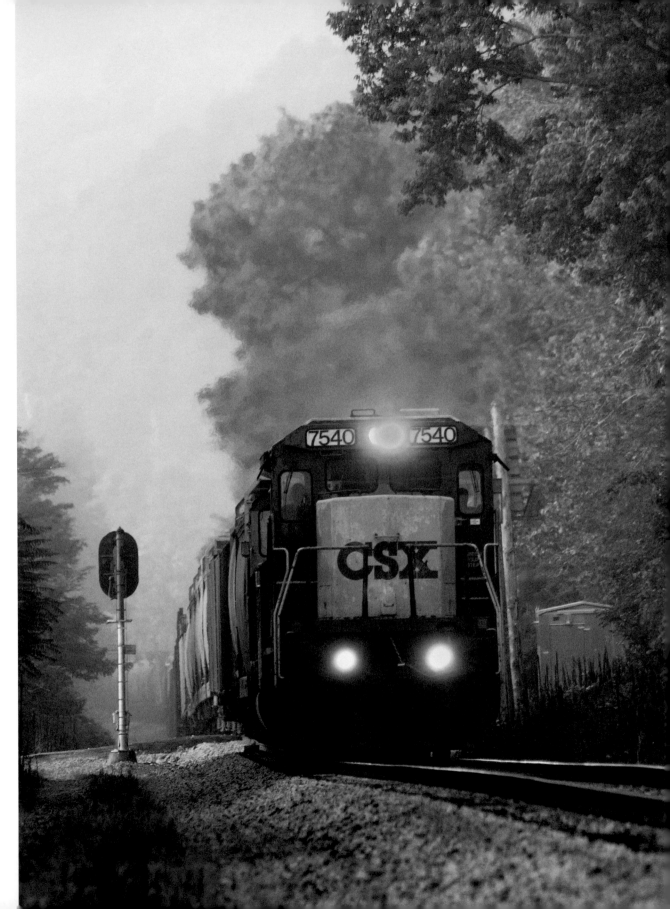

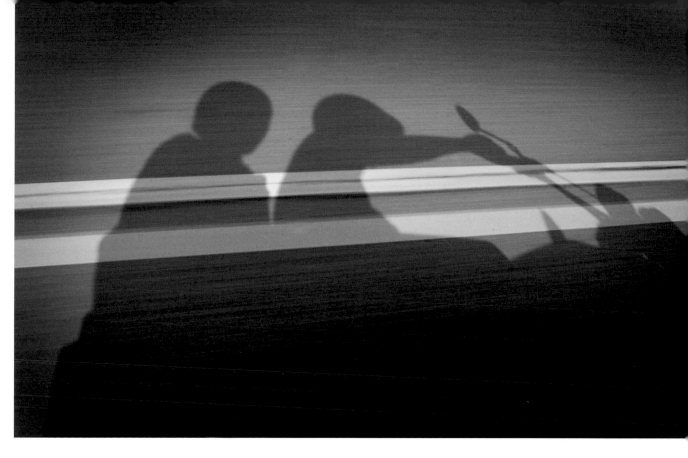

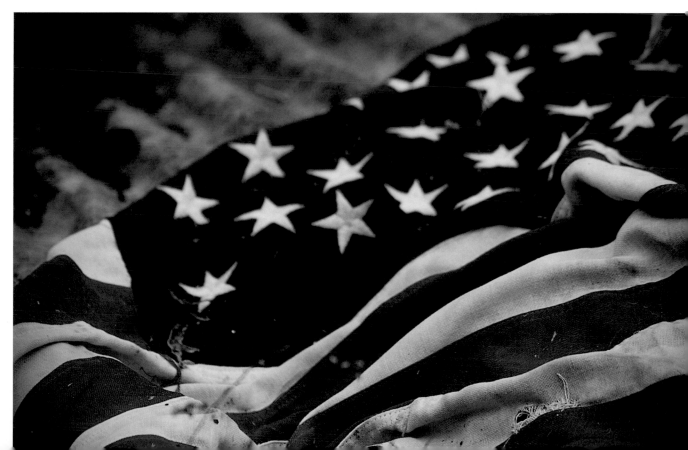

TOP ■ The air is still as the morning sun rises through the fog in Monroe. PHOTO BY DON DAKIN

ABOVE ■ I was walking along a trail in Sharon Woods and saw these beautiful weeds. I couldn't resist taking a picture of them. PHOTO BY CINDY TUCKER

TOP RIGHT ■ Biker Blur. PHOTO BY JULIE HUCKE

RIGHT ■ A Salute to the Ashes of American Flags: A flag found at an abandoned and dilapidated house in Maineville (Route 22 and Route 48)—which has now been razed for a shopping center. PHOTO BY PAUL ARMSTRONG

PREVIOUS LEFT ■ Mmmmm! Crawfish: Crawfish at a festival in Lawrenceburg, Ind. Not my thing but great color! PHOTO BY ROBERT WEBBER

PREVIOUS TOP ■ The Feel of Fall: Piatt Park, Cincinnati. PHOTO BY JULIE HUCKE

PREVIOUS BOTTOM ■ Simplicity: Taken at Krohn Conservatory. PHOTO BY PETE FOLEY

RIGHT ■ Dusters: Like little feather dusters in Ault Park. PHOTO BY CINDY ZULLA

OPPOSITE ■ It's Almost Spring: A spring crocus in my front garden. PHOTO BY SCOTT DUNGAN

BELOW ■ Summer Fades: Beauty in all seasons. PHOTO BY SCOTT DUNGAN

SEE CHANGE

If you've been downtown recently, you might have seen the bright colors on the opposite page on the facade outside Cadillac Ranch on Sixth Street. It's just one of the many changes going on in this city, which is – as it should be – in a perpetual state of progress.

New restaurants and bars. A revamped Fountain Square. Changes in the skylines on both sides of the Ohio River. All are inevitable and welcome sights.

This chapter notes a few improvements in key downtown areas, but there is progress throughout the region, from Mason and West Chester to Northern Kentucky.

For the Cincinnati skyline, the current era of change began when Paul Brown Stadium opened in 1999. The Cinergy Field implosion in 2002 (see below), the opening of Great American Ball Park in 2003 and then the opening of the National Underground Railroad Freedom Center in 2004 have continued to modify the view.

You have only to look to the Northern Kentucky side and see the Ascent to know that there is an ever-evolving scene on both riverfronts.

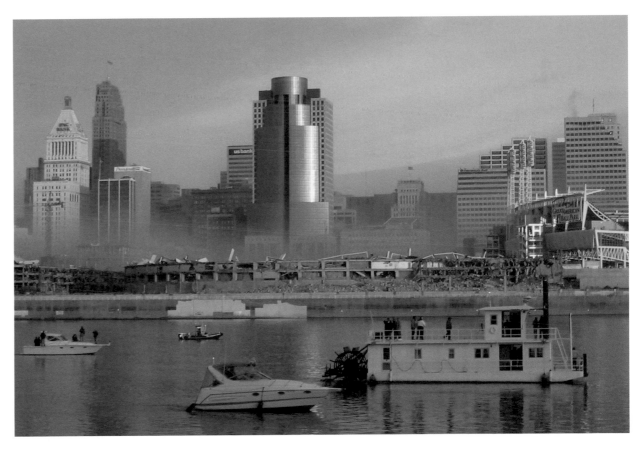

ABOVE ■ Changed Cincinnati Skyline: Skyline after Cinergy Field implosion. I got up a 3 a.m. and sat out in the cold for a few hours to get these photos of the implosion. This was taken a few minutes after it was over.
PHOTO BY BRENT MILES

LEFT ■ Working in Progress. PHOTO BY YIMING HU

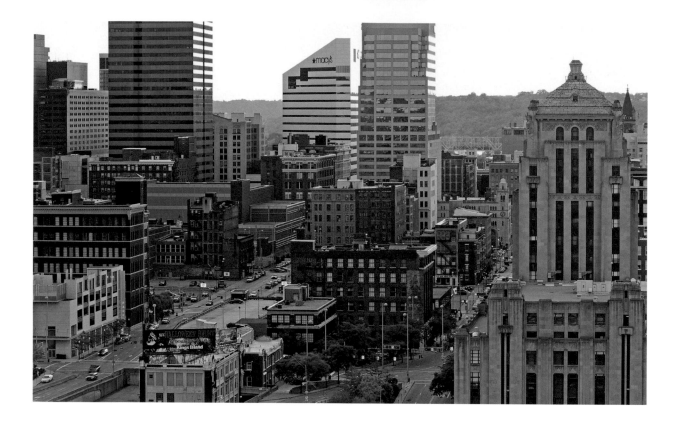

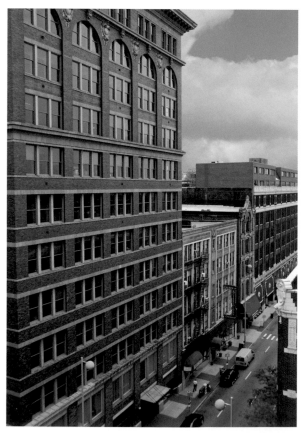

ABOVE ■ Always Changing: Downtown has a nice mix of old and new buildings. Photo by David Michell

LEFT ■ Looking west on Fourth Street as seen from Pogue's Garage. There are lots of good downtown views from garages. Photo by Peter Nord

TOP RIGHT ■ Living Color: A view of newly re-painted buildings in Over-the-Rhine, taken from the top floor of the Cincinnati Art Academy on a cold and wet December morning in 2006. It is nice to see bright colors and renewal in this historic part of the city. The colors cheered up a drab and chilly winters day. Photo by Pete Foley

MIDDLE RIGHT ■ Celebration: Celebrating the re-opening of Fountain Square. Photo by Alex Peppers

BOTTOM RIGHT ■ How the River Changes Us: This is an example of how the Ohio River has changed and changes us. Photo by Kevin Lush

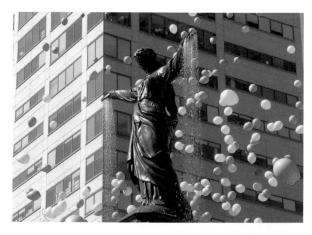

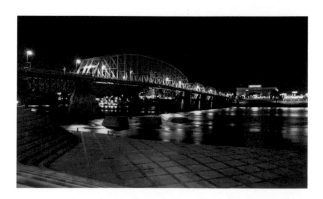

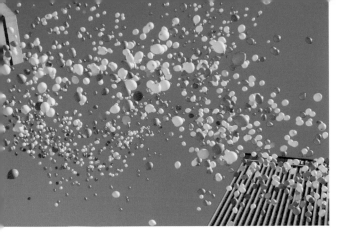

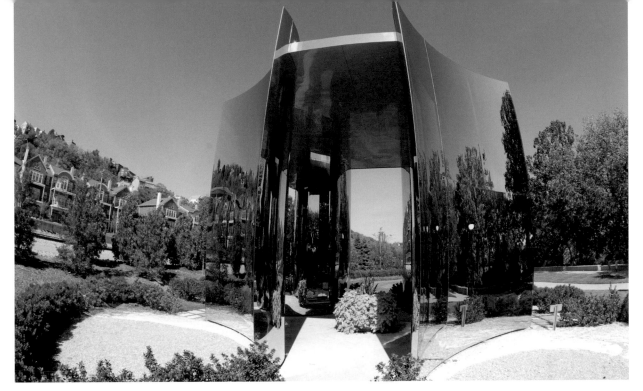

ABOVE ■ Release: Fountain Square reopening.
PHOTO BY LAURA MEYER

RIGHT ■ The Castle of Air at Theodore Berry International Friendship Park presents a mirrored image of its surroundings. This was donated by our sister city, Munich, Germany. PHOTO BY JOHN MICHELL

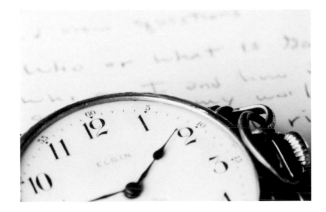

ABOVE ■ Use it Wisely: Time may appear to be constant but how we measure it may not. If we choose to, we can see the change in our children, our environment, and ourselves. PHOTO BY SCOTT DUNGAN

RIGHT ■ The Palisades of Mount Adams: Iron workers Curt Jarosak, left, and Johnnie Smother, with Capital City Group, erect supports for The Palisades of Mount Adams, a condominium project under construction on a hillside in Mount Adams overlooking downtown Cincinnati. PHOTO BY GARY LANDERS/THE ENQUIRER

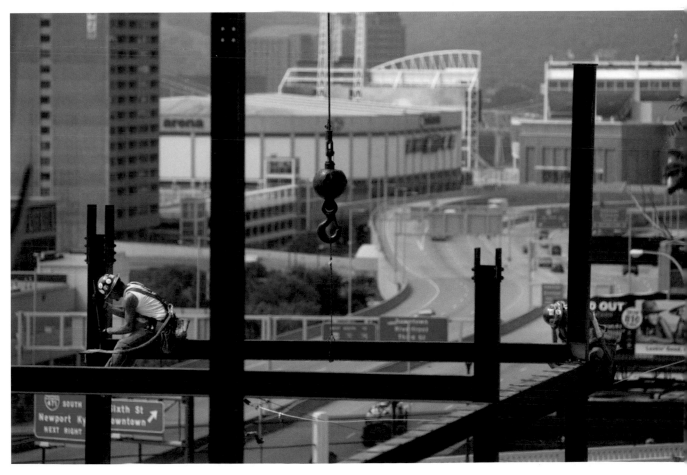

Capture Cincinnati was made possible by local photographers who were willing to share their talents with the rest of us. Here's a list of everyone you'll find in these pages and on the DVD. If you know any of these folks, give them a ring and say thanks for the great book! *(Photographers with Web sites on following pages.)*

Dave Abdon
David Abrams
Amanda Absher
Guy Adams
Stefanie Adams
Mary Jane A'hearn
Eric Aielli
Mark Albrinck
Sarah Alexander
Jim Allen
Anthony Alter
Catherine Ampfer
William H Anderson
Michael Anderson
Shannon Anderson
Jeffrey Anderson
Dann Anderson
Scott Anderson
Kevin Arey
Paul Armstrong
Samantha Ashcraft
Marc Atkins
Tom Auel Jr.
Fred Augustin
Breanna Avant
Melissa Back
Susie Backscheider
Kathleen Badinghaus
Paul Bailey
Shawn Baker
Deborah Baker
Bill Ballard
Patty Bamber
Ali Bandy-Enos
Rodney Barbour
Alison Barjaktarovich
Max Barker
Mike Barlage
Hannah Barone
Michelle Barrett
Jolene Barton
Sam Bascom
David Bass
Denise Bast
Jerome (Jerry) Bastian
Geoff Bastin
Wes Battoclette
Megan Baughman
Rev. Robert "Ashley" Beagle
Andrew Beattie
Andy Beck
Matt Beck
Kaylee Becker
Josh Beeman
Jeremy Begley
Kristen Bell
Andrew Benintendi
Melissa Bennett
Andrea Bernhard
John Berry
Joyce Berry

Bill Bertke
Teri Bertke
Kimber Bertsch
Jim Bertsch
Samuel Birkan
Adam Birkan
Ron Bizarre
Jason Blake
Lindy Blankenbuehler
Bob Bloom
David Blumenthal
Meggan Booker
Tonya Borgatti
Arlene Borock
Christian Boyles
Giuliana Braga
Anthony Braun
Ann-Marie Breen
Erika Bresee
Amy Bridewell
Andy Briggs
Rich Brilli
Melissa Brinck
Lisa Britton
Gene Brockert
Steve Broermann
Nancy Brossart
Brian Brown
Suzi Brown
Julie Brown
Eden Brown
Sarah Brown
Dannielle Browne
Kristina Bruce
Dan Brue
Carrie Burgan
Lynne Burke
Beth Buzek
Rick (Rico) Byam
Eric Byard
Bill Byers
Matthew C
Zay C
Kyle Caddell
Joann Calme
Celia Campbell
Timothy Cannon
Keith Carl
Melissa CarpenTer
Sandra Carper
Dante Carr
Dean Carroll
Tim Carter
Pam Carter
Erica And Lisa Cartier
Tara Cascella
Joan Cashwell
Helen Cassedy
Stacey Catanzaro
Katie Chambers
Brian Chambers

Jan Chambers
Reginald Chatman
Darren Clark
Rhiannon Clark
Tammy Clooney
Carrie Cochran
Lin Cohorn
Byron Cole
Ernest Coleman
Valerie Collett
Paul Collett
Brian Coning
Sheila Conley
Heather D Conley
Zoe Connors
Nic Corbett
Tyler Cordrey
Michelle Cordy
Pat Cornett
Jack Corwin
Alexandra Crabtree
Karen Cracchiolo
Rosellen Creighton
John CrEmons
Adrienne Crew
David Crotty
Kelly Crowe
Rachel Culley
Zack Culver
Rose Curtin
Don Dakin
Susanne Daleiden
Jerry Dalrymple
Melissa Daly
Nicholas Dames
Cheryl Damon-Greiner
Dion Daniels
Emily Daniels
Julie Daniels
Gina Daugherty
Daniel Davenport
Amanda Davidson
Jennifer J. Davis
Paul Davis
Deborah Davis
Michael Davison
Quinton Day
Doug Day
Trace Deaton
Genevieve Deering
Sam Deininger
Debora Del Valle
Kelly Demoss
Don Denney
Sister Marty Dermody
Nick Dewald
Joe Dezenzo
Jackie Diaz
Maggie Dickow
Kim Dobbs
Dan Doke

Benjamin Dorado
Patti Doubet
Joseph Douglas
Dale Doyle
Melanie Drake
Melody Draper
Tracy Drees
Liza Druck
Pat Dudsic
Brian Duffy
Liz Dufour
Andrew Dumont
Christi Durbin
Wayne K. Durrill
Barbara Easter
Janice Eddington
Lisa Eddy
Liz Effler
Leah Ehmen
Kindra Ehrat
Phyllis Eid-Nienaber
Chuck Eilerman
Ron Einhaus
Lacey Elam
Mason Elam
Gwen Elliott
Cassy Emery
Holly Emmorey
John Engelman
Izzie Englehart
Linda Erhart
Sarah Erwin
Burke Evans
Emily F
Priscilla F.
Victor P. Fabro
Kathy Farro
Mike Faul
PeG Fay-Feder
George Fecher
Meghan Fedders
Mary Feie
Billy Feld
Elisabeth Fennell
Rachel Ferree
Lori Field
Kevin Fishel
Cassondra Fisher
Sarah Flick-Baker
Teresa Foister
Tracy Foley
David Ford
Gretchen Forde
Ian Forsgren
Larry Fosse
Michael Frank
David Frederick Iii
Stephanie Freeman
Diana French
Lisa Frentzel
John Frey
Erv Friedrichs
Tom Friesz
Debra Frith
Josh Fritz
Jodi Fronczek
Kimberly Frondorf
Amy Fuller
William Fultz Ii

Joseph Fuqua Ii
Court Furber
Monica Furr
Melissa G
Erin Gabbard
Tyler Gabor
Dan GafFney
Chris Gagnon
Meghan Galvin
Gary Garbenis
Donald Gardner
Patti Gardner
Hayden Garry
Martha Geiser
Brenda Gentry
Jennifer Gentry
Angela Gibson
Lindsay Gibson
Jeff Giehl
Maggie Gieseke
Freddie Gilbert
Doug Gilham
Rob Gilson
Katie Gioielli
Jeff Girton
Michael Giuliano
Shelley Glapion
Jeff Glaspie
Lynn Goetzinger
Caeli Good
Jennifer Goodin
Meghyn Goodridge
Keith Gorman
Justin Goss
Lauren Gramke
Carol Graves
Jill Grech
Carrie Griehm
Murray Griess
Bill Griess
John Griess
Ryan Griffin
Samantha Griffith
Jayme Grimm
Steve Groh
Kevin Grothouse
Richard Grover
Holly Guard
Julie Gulley
Nicholas H
Evan H
Kara Habel
Katie Hageman
Linda Hahn
Bethany Hahn
Sarah Hall
Randy Hall
Christopher Hall
Joel R. Hall
Lloyd Hamilton
Allen Hamilton
Lori Hansel
Erica Hansen
Rufus Keith Hardnett
Amy Nichole Harris
Malinda Hartong
Glenn Hartong

Rha Hartwell
Matt Hassert
Katie Hatfield
Michelle Hathorn
Dale Hatten
Anne Heckman
Melissa Hensley
Ben Herche
Sarah Hessel
Renee Heymer
Janet Heywood
Andrew HigleY
Martha Hill
Melissa Hill
Daniel Hill
Kevin Hillman
Gregory Hladky
Emily Hobbs
Emily Hobbs
Michelle Hock
Tracie Hodge
Jalal Hoehler
Nikki Hohweiler
Chanel Hollin
Donna Holloway
Meredith Holthaus
Bill Hopkins
Samantha Horn
Clark Horning
Peter Horton
Steve Horton
Yiming Hu
Tina Huddleston
Jessica Huff
Terrence Huge
Jon Hunt
Dorron Hunter
Emily Huser
Christa Hyson
David Irwin
Michelle J
Everett Jackson
Trena Jackson
Sandra Jackson
Soumya Janardan
Chris Jancowskis
Tim Jeffries
Michelle Jessee
Lj Johnson
Jeff JOhnson
Jude Johnson
Mark Jones
Salli Jones
Shanon K
Cory Kalb
Emily Kamholtz
Paul Kaucher
Michael Keating
Rebecca Kelley
Sarah Kelley
Allie Kelly
Diana Kelly-Davis
Angela Kendall
Eric Kepf
Gina Kern
Kathy Kessler
Joel Kimling
Dama Kimmon
Sharon Kinderman

Kristin King
Karol King
Brandon Kinman
Melody Klein
Ted Kluemper
Erin Klumb
Linda Knicely
Anna Knierim
Lisa Knoffer
Christian Knoffer
Tim Knopp
Angel Knuth
Tom Kodger
Kelly Koeller
Aaron Kohlhepp
Lex Kolychev
Amanda Kool
Amanda Kothe
Jon Kramer
Larry Kramer
Jessica Kroger
Julie Gaw Kruzic
Jimmy Kunkel
Jenny Kunst
Allen Lade
Carol Ladrigan
Tyler Lallathin
Gary Landers
Jada Landrum
Keith Lanser
David Lanter
Charles Lauterbach
Christina Lawson
Kirsten Lecky
Chris Lecky
Christine Lefever
Kim Lentz
Glenn Lentz
Kelly Leon
Bruce Leonhardt
Vincent Leta
Angie Lewis
John Ley
Warren Liang
Larry Loar
Christian Long
Maurie Loomans
Mitch Lord
Robert Lowrey
Kevin Lush
Jenna Luthman
Jeremy Luthy
Nicole Luthy
Carla Luttrell
Paul Lynch
Mark Macioce
Chuck Madden
David Magenheim
Deena Maley
Tony Mannira
Jordan Mansour
Sandi Manuel
K.C. Markley
Stephen Marks
Alexis Marsh
Stuart Marsh
Laura Marsh
Shannon May
Paul McCarthy

Jordan McCrate
Brian McDermott
Venita McEwen
Amy McGill
Dave Mcgraw
Scott McHenry
Marilyn Mcintosh
Carissa Mcenzie
Alan Mclaughlin
Kevin Mcanus
Ed Mcmasters
Karen Mcnew
Monica Mcpeek
Mary Pat Mcquaide
Pat Mcquen
Charles Means
Mary Mecum
Samantha Meenach
Jeff Meiners
Lauren Meisman
Brenda A. Meister
Jason Mejia
Michael Meldon Jr.
Staff Member
Randa Menkhaus
Molly MEnninger
Robert Mention
Max Metsch
Anni Metz
Marilyn Meyer
Luke Meyer
Brenda Meyer
Rich Meyer
Marcie Michael
John Michell
John Mickler
Brent Miles
Paul Miles
James Miller
Jeffery Miller
Jolinda Miller
Joe Mirus
Janet Mitchell
Peter Mogavero
Jonathan Mogavero
Jon Mogavero
Frankie Moneyham
Mike Moody
Andrea Moore
Matt Moore
Dustin Moore
Michael Morehart
Nancy Morgan
Sandy Morgan
Michael Morris
Andrew Morris
Kristin Morris
Lisa Morrow
Kelly Morton
Kevin Moser
Joe Muck
John Muenz
Michelle Mullinger
Wayne Mullins
Corey Mullins
Becca Nachtrab
Emanuel Napolitano
Melody Nauman
Jason Neal

140

Angela Neal	Amanda Powell	Tiffany Sampson	Larry Snodgrass	Steve Tsuchiya
Jabe Nekula	Nathan Powell	Stephen Sandberg	Steffany Songy	Laura Turpin
Alicyn Nelson	Erin Powell	Jason Sanker	Adam Sonnett	Tammy Tyler
Keith Neltner	Jenny Powell	Marievee Santana	David Sorcher	Hannah Tytus
Keith Neu	Deborah Powers	Tonya Schalk	Miranda Sparks	Maggie Ungers
Sue Neufarth Howard	Sandra Preusche	Linda Schildman	Jennifer Spieser	Susan van Amerongen
Kristina Neumann	Barry Price	Eric Schira	Brett Stakelin	Thomas van Brunt
Kristen Ney	Jackie Prichard	Karen S. Schlachter	Judith Stallworth	Annie Varland
Jane Niehaus	Christina Pritchett	Joseph Schmidt	Scott Stanley	Lisa Ventre
Bill Nienaber	Mike Prus	Beverly Schmitz	Lisa Staton	Danielle Ventre
Wilma Noel	Steve Rahe	Michael Scholl	Marissa Starks	Alejandro Viademonte
Liz Noffsinger	Lori Rahn	Tanya Scholl	Shamus Staubach	Joanie Vidal
Peter Nord	Bev Ralston	Pam Schrenk	Linda Staubach	Nick Vonhoene
Shirley Nord	Phillip Ranly	Taunya Schroeder	Jim Stawitz	Jennifer Vonrissen
Paige Norris	Kathy Ray	Jennifer Schroer	Kristina Stegman	Mark Vorholt
Cindy Novack	Nathan Raymond	Kirk Schrotel	David Stephens	Amanda Wackerman
Cj Novack	Rebecca Reay	Andrew Schuler	Bob Stevie	Rachel Wagner
Frank Noyola-Izquierdo	Tudor Rebengiuc	Michael Schwartz	Tracey Stokely	Dain Wahl
Michael Noyola-Izquierdo	Patrick Reddy	Paul Schwartz	Laura Stolk	Tammi Wahoff
James Nulsen	Ronald Reynolds	Anne Schwing	Sheila E. Storck	Ian Walker
Bonnie Nutley	SaRah Rhyne	Courtney Secen	Bob Stothfang	Jenny Walker
Jeff Nye	Sarah Richardson	Jm Seta	Dottie Stover	Allison Wallace
Dave O	Troy Riegsecker	Joe Shafer	Samuel Stover	Beverly Wallrauch
Joe O'Gorman	Grant Riley	Ginger Shafer	Michael Suer	Eileen Ward
Ryan Oleary	Teresa Ripley	Cory Shafer	Toni Sulken	Sarah Ward
Jonathan Oliver	Dan Roark	Monica Shannon	Kate Sumpter	Margaret Warner
Paula Osborne	Katie Roberts	Ken Sharp	Richard Sunderhaus	Jen Warner
Steve Otis	Sheila Robinson	Mark Shavor	Dick Swaim	Elizabeth Wartman
Mary Ann Otto	Katrina Robke	Wren Shaver	Bill Swanson	Susan Weadick
Douglas Owen	Gaby Rodriguez	Jami Shay	Erik Swanson	Tabatha Webb
Cara Owsley	Michael Roedig	Michael Sholton	Leigh Taylor	Amy Weber
Randall Packer	Christopher Roehl	Bear Sheppard	Whitney Taylor	Marcia Weber
ClAire Paff	Krista Roettger	Kim Sherlin	MiChael Tedeschi	Diane Weber
Sandi Patterson	Christian Rogenski	Kim Sherwood	Chris Telling	Gail Webster
Lynn Payne	Kirk Rohling	Amber Shiveley	Gary Terwilleger	Michael Weigand
Cat Pentescu	Casey Roth	John Short	Sharon Thackston	Sandy Weitz
Alex Peppers	Eryk Rotondo	Cody Short	Lori Thaxton	Lori Wells
Amy Perrine	Diane Royer	Tracy Shuttleworth	Carey Theobald	Robert Wells
Michael Perry	Joe Ruh	Kim Simmons	Andrew Thiel	Chris Westermeyer
Ethan Perry	Barbara Ruh	Linda Simms	Seth Thomas	Charles R. Wetzel
Maddie Peters	Kevin Rumker	Brenda Simpson	Heather Thomas	Jean Wetzler
Shawna Peto	Patrick Rush	Melanie Sloan	Mary Thompson	David White
Josh Pfeifer	Joe Russell	Michael Smith	Linda Thompson	Randall Whitt
J.P. Pfister	Greg Rust	Debby Smith	Evan Thompson	Micah Whitt
Mike Pieper	Nick Ruter	NicolE Smith	Amy Thompson	Leah Wiethe
Andrea Pike	Heilman Ryan	Dana Smith	Gail Towns	Barbara Wilger
Becky Pogue	Sharon Ryan	Phil Smith	Quoc Tra	Aimie Willhoite
Daniel Polly	Kelly S.	Susan Smith	Dennis Tribby	Joe Williams
Florentina Popescu	Vince Salzarulo	Karen Smith	Amanda Trickey	Gwendolyn Williams
Maxwell Potluri	Jill Salzarulo	Dacia Snider	Tina Triplett	Jean Williams

CAPTURE CINCINNATI'S MOST ACTIVE GROUP:

Living in Cincinnati Flickr Group

Members of the Living in Cincinnati Flickr Group focus on capturing Cincinnati and the surrounding Tri-State area. Come see what we're up to at Flickr and join our group of over 400 photographers: flickr.com/groups/cincinnati The following members together contributed 717 photos and 20,474 votes to the Capture Cincinnati project:

Ed Allie	Julie Hucke	Amber Dale Sapp
Sonja Bennett	Rob Ireton	James Stapleton
Fabricio Braga	Bryn Lewis	Rick Stegeman
Lucrecer Braxton	Christina Lagan	Jerome Strauss
Carolyn Brookover	Eric Priebe	Jordan Thomas
Rich Campoamor	Lewis Riley	Ryan Thomas
Scott Dungan	Michelle Robenalt	Chris Thompson
Pete Foley	Chris Rose	Cindy Tucker
Blake Fox	Jana Rude	David Williams
Scott Herrmann	Earl S.	Cindy Zulla

Andrea Wise	Ashley Womack	Nancy Younce-Volmer
Melanie Wissel	Ray Wong	Dick Young
Paul Wissman	Fred Wood	Ashley Young
B A Witherow	Alex Woodward	Geoff Zimmerman
Katie WitticH	Pamela Worley	Amy Zimmerman
Sarah Wolf	David L. Worley	Dagna Ziolkowska
Otto Wolff	Mau-Yi Wu	Cindy Zurowick
Jason Wolgemuth	Maddi Yee	
Graham Wolstenholme	Beverly Yenke	
Amy Womack	Bob Yoder	

If you like what you see in the book and on the companion DVD, be sure to check out these photographers' Web sites. A few even sell prints so you may be able to snag your favorite photo from the project to hang on your wall.

Ryan Adcock
 ryanadcock.com
Keith Allen
 myspace.com/Krallen814
Ed Allie
 flickr.com/photos/ed_aisela
Brian Ambs
 brianambs.com

Matthew Anderson
 andersonphotography.org
Tom Arbour
 hiramtom.blogspot.com
Tess Avelland
 midnight-muse.com
Linda Averbeck
 cincyview.blogspot.com/

Debbie Avery
 betterphoto.com?avery
Lucrecer Braxton
 flickr.com/photos/ldb/
Kabir Bakie
 web.mac.com/kabirbakie/iWeb
Rick Barge
 bargephotography.com
Cassandra Barnes
 flickr.com/photos/celticfeminist/
Dan Becker
 pbase.com/ballhatguy
Walt Benn
 flickr.com/photos/14420393@N07
Sonja Bennett
 saycheesephotography.blogspot.com

Scott Beseler
 taketheday.com
Ami Beyer
 submit.shutterstock.com/?ref=70333
Sean Biehle
 withoutsound.com
Jaime Birecki
 knittingfaerie.blogspot.com/
Adrienne Bleh
 myspace.com/ohnonokidding
Fabricio Braga
 flickr.com/photos/7893789@N03/
Joni Brandyberry
 flickr.com/photos/fabfotophun
Chris Breeden
 myspace.com/breedenchris

Larry Bresko
 magicmomentsphoto.com
Michael Brocker
 michaelbrocker.com
Carolyn Brookover
 flickr.com/photos/carolyn_brookover/
Kendall Bruns
 kendallbruns.com
Bryan Busovicki
 bmbimages.com
Mark Byron
 museumofnyc.doetech.net/voyager.cfm
Dennis Camp
 denniscampphotography.com
Rich Campoamor
 flickr.com/photos/rcampoamor

Keesha Carnes
flickr.com/photos/keeshacarnes/sets/
Steve Carr
beitcarr.com
Ricky Carter
community.webshots.com/user/rjc1954
Francisco Castro
capturecincinnati.com/people/co2castro
Bradley Clifton
cliftonscreativedesign.com
RoAhnna Cobb Figgs
RoAhnna.Deviantart.com
Kim Cochrane
kimcats.deviantart.com
Kathryn Combs
flickr.com/photos/combs_family
Kelly Cowan
flickr.com/photos/kellinahandbasket/
George Crawford
metronationcincy.com
Debi Crowder
myspace.com/dixxee1972
Jennifer Cutter
hsus.org
Ben Dakin
rcaphoto.com
Bill Daniels
pbase.com/danielsphoto
Samuel Davis
myspace.com/fluellendavis
Elizabeth Dehne
flickr.com/photos/32948347@N00/
Jason Dick
photographybyjasonldick.com
Angi Dill
squintandsmile.smugmug.com/
Scott Dungan
scottdungan.com
Chris Dye
flickr.com/photos/12018157@N03/
Adam Eger
cincinnatisolutions.com
Rick Elliott
BreakWindImages.com
Mark Ferguson
markfergusonphotography.com
Thadd Fiala
flickr.com/photos/thaddfiala/
Melissa Fields
flickr.com/melissafields
Meg Fite
web.mac.com/megfite
Mike Florence
myspace.com/michaelseanflorence
Pete Foley
flickr.com/photos/petefoley/
Blake Fox
blakefox.blogspot.com
Sandra Freyler
sandrafreyler.com
Kaneto Fukuhara
ezlister.net/images/jc/kaneto/class/kgraphics/photo.htm
Kathleen Fuller
shelteredpaws.com
Michael Garrity
myspace.com/painterwriter
James Geyer
jamesgeyer.com
Aviroop Ghosh
flickr.com/photos/earthdomain
Robin Victor Goetz
GoRVGP.com

Jason Haley
jlogic_2000.studyphoto.com/
Kerri Haley
photokh.com
Alexander Hamling
myspace.com/alexhamling
Scott Harper
caringbridge.org/visit/reganharper
Amy Hartman
fotki.com/echoamy
Jason Hatfield
shoot2capture.com
Carl Heilmann
thinkingchicken.com
Jackie Herb
flickr.com/photos/jackielynnherb
Jan Herbert
herbertland.com
Mark Herrmann
markherrmann.com
Scott Herrmann
flickr.com/photos/eye4beauty
Brian Herron
myspace.com/cincinnatimansion
Kevin J. Hines
tagworld.com/dee-lite
Linda Hirsch
flickr.com/photos/97108909@N00/
Kelsi Howell
myspace.com/howie7
Julie Hucke
flickr.com/photos/jstar
Cheryl Huff
huff.com/cheryl.huff
Steven Huff
imaginethatcreativephotography.com
Katie Hulme
katydidnt.blogspot.com
Jason Husband
flickr.com/photos/jasonpics/
Rob Ireton
flickr.com/people/aoisakana/
James Jackson
cincinnati.com/
Rebekah Johnson
rebography.photoreflect.com
Rachael Jordan
rachaelljordan@gmail.com
Brian Joyce
flickr.com/photos/x_brian_x/
Dyah Kartikawening
flickr.com/photos/greenfirescape
Michel Keidel
admojo.com
Nicholas Keil
awinterbreeze.deviantart.com
Katie Kelley Schmid
archive.cinweekly.com/blog/brideblog/
Tim King
camtron.com
Jim Kramer
jim-kramer.com
Christina Lagan
flickr.com/photos/13034813@N07/
John Langdon
flickr.com/photos/shamous/
Jeff Lehman
kc8qch.com
Darrell Lenkner
flickr.com/photos/GreatGreyhounds/
Bryn Lewis
flickr.com/photos/lewisclanphotos/

Vince Liming
vinceliming.com
Billy Liner
liner-designs.com
Jamie Litchfield
caphiera.net
Adam Lovelace
aclphotography.com
Casey Lynn
flickr.com/photos/caseylynn
Rob Madden
thep03.sytes.net
Ian Martin
myspace.com/theeyeofian
Mark Mascolino
people.etango.com/~markm/
Phil Mastman
sandlotpictures.com/phil.html
Montgomery Maxton
MontgomeryMaxton.com
Andrea McClain
flickr.com/photos/amcclaiak
John McNamee
jibjib.wordpress.com
Ryan Mecum
myspace.com/zombie_haiku
Dave Mercer
digitalstormphotography.smugmug.com/
Tracy Metsch
rentabridesmaid.com
Elizabeth Metz
elizabeth-metz.com
Joe Metz
tscsales.ecrater.com/
Sharon Meyer
sharonmeyerphotography.com
Justin Meyer
justinmeyer.com
Laura Meyer
antelopebrown.blogspot.com/
Steve Michaels
flickr.com/photos/slim57/
David Michell
DavidMichellPhotography.com
Rene Micheo
renecito.com
Kendal R. Miller
photographybykendal.com
Kevin Monroe
kevinmonroephotography.com
Kaycee Mooney
myspace.com/boxnip
Brent Moore
brentkmoore.blogspot.com/
Stacey Morefield
flickr.com/photos/jesusfish/
Bryan Mullins
bcmullins.com
Karen Myers
Readinghighschool.org
Leslie Na
lesliena.smugmug.com/
Patti Needham
Take1Studio.net
Rick Neltner
neltnercreative.com
Mary Nemeth
marynemethphotography.com
Eric Noak
skatecrash.com
Michael Olano
pbase.com/mojomojo

Justin Olson
justinolson.com
Nikki Owen
showstylephotos.com
John Parr
wolfhunt.fotix.net
Donald Phelps
dpi2.com
Dale Pontz
theworldofdale.blogspot.com
Jenny Poole
flickr.com/photos/jlpoole/
Scott Preston
cincyphotos.com
Eric Priebe
flickr.com/photos/filmflood/
Mike Quijano
mikequijano.com
Jana Rude
flickr.com/photos/mikesma
Jonathan Raines
flickr.com/photos/jonathanir
Ravi Ramachandran
digitaldreamz.us
Sandra Ramey
logogurl.com
H. David Reid
hdavid.com
Kyle Reuss
pbase.com/kyle_m_reuss
Rachel Richardson
cincinnati.com
Lewis Riley
flickr.com/photos/lewisriley/
Tammy Riley
flickr.com/aperture
Derek Rillo
web.mac.com/drillo/site/
Michelle Robenalt
michellerobenalt.com
John Robenalt
robenaltphotography.com
Chris Rose
flickr.com/photos/13001301@N03/
Katie Ryan
flickr.com/photos/kryan683/
James Ryan
jryanphotos.com
Earl S
earlworld.blogspot.com/
K S
statonfam.com
Amber Dale Sapp
frecklepressphoto.com
Randy Sauer
flickr.com/photos/53509865@N00
Jennifer Schiller
poeticphotodesign.com
Bob Schlake
bschlake.com/
Yvette Scott
jyaatascott.blogspot.com
Chris Seelbach
YouTube.com/ChrisOTR
Jon Shapiro
cohocreative.com
Jen Shorten
cufd.com
Doug Siegel
dougsiegelphotography.com
Thomas Smith
estanbul.wordpress.com

Daniel Smyth
iseeincolor.wordpress.com/
Darrell Snodgrass
darrellsnodgrass.blogspot.com
Melissa Speelman
frecklephoto.com
Michael Spitz
mikespitz.com
James Stapleton
flickr.com/photos/ebbnflow/
Rick Stegeman
flickr.com/photos/rstegeman/
Richard Stewart
carriagehousefarmllc.com
Joe Stoner
joe-stoner.com
Jerome Strauss
flickr.com/photos/12915906@N00/
Jeremy Stump
jeremystump.com
Gerard Sychay
hellogerard.blogspot.com
Jason Tarvin
flickr.com/photos/13425275@N05/sets/
Mike Taylor
sordidpixel.com/
Conrad Thiede
ILiveDowntown.com
Jordan Thomas
c-m-h.net
Ryan Thomas
flickr.com/photos/ryanthomas
Chris Thompson
chris-amy.com
Cindy Tucker
flickr.com/photos/ctatunderground/
Ashley Waldmann
freewebs.com/amwphotography
Jeff Weaver
weaverskingdom.com
Susan Webb
susanwebbphotography.com
Robert Webber
webberimaging.com
Lance Webel
webel.net
Mike Wehrman
mandrphotoart.com
Ted Wiesman
dpchallenge.com/profile.php?USER_ID=25218
Brian Wilder
bwilder.smugmug.com
Kylie J. Wilkerson
professional-daydreamer.blogspot.com
Cristy Willard
flickr.com/photos/soccerbandkids
Jarrod Williams
myspace.com/jarrodwilliams81
David Williams
flickr.com/photos/waxinggibbous
Heather Wolff
mybluegrassbaby.com
Tom Woolery
cincinnatistills.com
Julie Young
creative-invites.com
Aleisa Yusko
theyuskos.com
Steve Zimmerman
szimages.com
Cindy Zulla
flickr.com/photos/zullazoo/

PRIZE CATEGORIES

Rather than give away prizes for the traditional first-, second-, and third-place winners, we came up with a few creative ways to reward photographers for their contributions. Here's how we broke it down:

Editors' Choice: This award went to the photo our editors determined to be the best in a chapter. Sometimes it was a photo that fit the chapter so well that it stood out above the rest. Other times it was a photo that was technically excellent.

Consensus Best: This is a combination of the voter's will and our editors' will, so it was a well-balanced and prestigious award. A complicated algorithm determined a photo's score.

This award took the photos the algorithm deemed great and pushed them to the top of the pile. Then our editors determined their favorite of that batch. In essence, it's the best of the best.

The Skunk: This is a fun award given to the photo that received the most "nix it" votes. Sometimes being good wins, other times being really bad wins. It's not meant to hurt anyone's feelings, but rather a chance to award a photo that otherwise wouldn't get much attention. Plus, the winner gets a prize which ought to ease the pain a bit.

Ninth Best: This award goes to the photo that garnered the ninth most "dig it" votes in a chapter. Why ninth place? We've all seen the first-place, blue, fancy-pants ribbon, and the second-place one, and third, and fourth, and so on. We've even seen an eighth-place ribbon. But we've never seen a ninth-place ribbon. Have you? We think it's time ninth place got some recognition.

The Polarizer: This award is given to the photo that received a high number of both "dig it" and "nix it" votes. To win, the photo needed to be viewed by a lot of people, then a high percentage of viewers needed to vote on it, then the vote balance needed to be fairly even. It's a way to say, "this photo is very moving, but no one can decide if it's moving in a good way or moving in a bad way."

Secret Surprise: Every contest needs a wild card. This is ours. We'd tell you what the parameters were, but we don't know ourselves. At some point a photo jumped out as the obvious Secret Surprise winner, and boom! a winner.

THE WINNERS

When picking from 11,891 photos, it's difficult to nail down what separates the best photos from the rest—especially when so many photos are so good. Luckily, we enlisted the help of thousands of local folks to vote for their favorites. The response was epic: more than 300,000 votes were cast. The voting helped shape what would eventually be published in this book. Please note The Enquirer and CiN Weekly photographers were not eligible for prizes. Along the way, the votes produced the following prize winners:

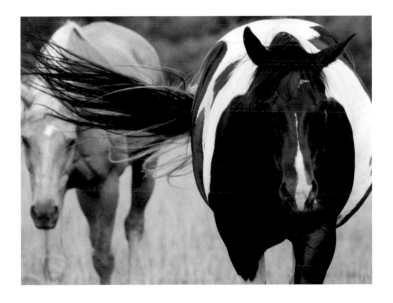

Grand Prize

Friends by Melissa Speelman (p.11)

People of Porkopolis

Editor's Choice: *End of Summer* by Lucrecer Braxton (p.25)
Consensus Best: *Harold* by David Williams (p.8)
Ninth Best: *It's a Hard-Knock Life* by Steve Carr (p.19)

Pets & Animals

Most Votes: *Yellow butterfly...* by Steve Horton (p.30)
The Polarizer: *Friends* by Carla Luttrell (top right)
The Skunk: *Mr. Bob* by Ray Wong (bottom right)

Schools

Most Votes: *We Did It* by Sharon Thackston (p.50).
Editor's Choice: *Go Bombers* by Terrence Huge (p.48).
The Polarizer: *Moving On* by Tracy Metsch (bottom left)

Simply Cincinnati

Consensus Best: *The Belle of Louisville* by Chris Thompson (p.52)
Editor's Choice: *Clock at Union Terminal* by Matthew Anderson (p.72)
Ninth Best: *Roebling Inside* by Chuck Madden (p.57)

News

Editor's Choice: *The Flood* by Michael Smith (p.77)
Most Votes: *Getting Old* by Rick Stegeman (p.75)
Consensus Best: *Bikes & Flags* by Jennifer Schiller (p.78)

Sports & Recreation

Consensus Best: *Cyclist round...* by Christine Lefever (p.85)
Most Votes: *Pete Rose Opening Day* by Scott Stanley (p.92)
Secret Surprise: *Self Portait* by John McNamee (p.89)

Places & Spaces

Most Votes: *Majestic Cypress Tree* by Bob Stothfang (p.109)
Secret Surprise: *Painted Ladies* by John Michell (p.122)
Ninth Best: *Mt. Adams Sunrise* by Mike Wehrman (p.107)

See Change

Most Votes: *Celebration* by Alex Peppers (p.138)
Editor's Choice: *Working in Progress* by Yiming Hu (p.136)
The Polarizer: *Changed Skyline* by Brent Miles (p.137)

ABOUT US

Community Driven.

The Enquirer is a multi-media provider of local news and information whose offerings include The Cincinnati Enquirer, The Kentucky Enquirer, the Cincinnati.Com network of Web sites, NKY.com, CiN Weekly, Our Town Magazine and more than 75 special publications ranging in coverage from sports to entertainment and more. More than 1,000 employees and almost 600 delivery agents come together every day to create and distribute these products.

The Enquirer's Sunday readership exceeds 808,500 people, while weekday readership is 562,100 Greater Cincinnati and Northern Kentucky residents. According to Scarborough Research, in a typical week, nearly one million people turn to The Enquirer and the Cincinnati.Com network.

Cincinnati.Com is the region's oldest, most-used, most-updated and most-honored local Web site. According to The Media Audit, Cincinnati.com reaches 45% of Web-using adults. On average, Cincinnati.Com delivers 40 million page views per month in 6 million visits. Since its launch in 1996, Cincinnati.Com has won more than 55 regional and national awards for content and innovation.

The Enquirer has published continuously since 1841. It is owned by the Gannett Co. Inc., the nation's largest newspaper company and publisher of USA TODAY. In Greater Cincinnati, Gannett also publishes 17 Community Press and 10 Community Recorder newspapers.

In October 2003, The Cincinnati Enquirer launched CiN Weekly, a free, full-color publication and Web site for young, professional adults primarily in their 20s and 30s. To ensure that CiN Weekly hit its mark, we conducted extensive research to find out what information this group wants that can help maximize their lifestyles.

We found that people in our targeted demographic want to know what's happening in their neighborhoods and around the city. They want tips on what restaurants, bars, and nightclubs to check out and they want fun ideas on how and where to spend their free time. Plus, they want to read about the core issues that affect them—from switching careers to buying a first home.

It's our mission to deeply connect people in their 20s and 30s to their community and each other. By delivering content that's both informative and entertaining, CiN Weekly and CiNWeekly.Com have grown into a recognized information resource and brand that young professionals value.

Our sponsors helped get the Capture Cincinnati Web site off the ground and provided some of the prizes for our contributors. With their help, we brought together a wide gamut of local photographers to participate in this exciting project.

DILLARD'S

William Thomas Dillard opened his first store in Nashville, Ark., on Feb. 12, 1938.

In 1944, William and Alexa Dillard began the tradition of what is now the largest family-owned fashion apparel and home furnishings retailer in the country.

In 1964, Mr. Dillard acquired a store in a shopping mall in Austin, Texas, which he recognized as a perfect place to develop his "fashion as value" message.

After the purchase of 103 Mercantile stores in Cincinnati, William Dillard would amass 320 stores in 29 states. He often stated, "the best looking stores are the ones filled with customers."

When William Dillard passed away Feb. 8, 2002, he had created a cherished legacy in American fashion retail and truly innovated "The Style of Your Life."

BLUFORD JACKSON & SON

Bluford Jackson & Son Hardwood Flooring was started in 1919 by Bluford Jackson. Upon Bluford's untimely death in 1970, the company confirmed its success under the direction of Bluford's son, John.

As the family grew, John's grandson, Ryan, started working in homes and is now successfully running the company as a fourth generation of Jackson's continue the professional installation and refinishing of hardwood floors in Cincinnati and the surrounding area.

JOSEPH-BETH BOOKSELLERS

Locally owned and operated, Joseph-Beth Booksellers is one of the nation's largest and strongest independent bookstores — growing from one small bookstore in Lexington, Ky., in 1986, to seven healthy bookstores today located in Ohio, Pennsylvania, Kentucky, North Carolina and Tennessee.

Neil Van Uum opened the first Joseph-Beth store in November 1986. What began as a small bookstore with 37,000 titles in a 6,500-square foot space now boasts a 40,000-square foot bookstore, located in the heart of the Mall at Lexington Green, with two stories of books and sidelines, expanded music and children's departments and a full-service restaurant. The Cincinnati Rookwood Pavilion location opened in 1993, followed by new stores in Nashville, Memphis, Cleveland, Pittsburgh and Charlotte.

Our growth is a success story and tribute to the innovation, hard work, and dedication of our owner and current and alumni staff. Because of this, we proudly call ourselves a "family of bookstores" headquartered right here in the Queen City.